12/96

D0164573

WITHDRAWN

 St. Louis Community College

Forest Park
Florissant Valley
Meramec

Instructional Resources
St. Louis, Missouri

GAYLORD

St. Louis Community College
at Meramec
Library

JAPANESE STUDIO CRAFTS

TRADITION AND THE AVANT-GARDE
RUPERT FAULKNER

THE UNIVERSITY OF PENNSYLVANIA PRESS
PHILADELPHIA

Opposite Stoneware jar and cover by
Miura Koheji (see plate 12)

COPYRIGHT © 1995 BY THE BOARD OF TRUSTEES OF THE VICTORIA & ALBERT MUSEUM
THE VICTORIA & ALBERT MUSEUM HAVE ASSERTED THEIR MORAL RIGHTS ACCORDING
TO THE COPYRIGHT DESIGNS & PATENTS ACT 1988.

FIRST PUBLISHED IN THE U.K. IN 1995 BY LAURENCE KING PUBLISHING
FIRST PUBLISHED IN THE UNITED STATES 1995 BY THE UNIVERSITY OF PENNSYLVANIA
PRESS

ALL RIGHTS RESERVED. NO PART OF THIS PUBLICATION MAY BE REPRODUCED OR
TRANSMITTED IN ANY FORM OR BY ANY MEANS, ELECTRONIC OR MECHANICAL,
INCLUDING PHOTOCOPY, RECORDING, OR ANY INFORMATION STORAGE AND
RETRIEVAL SYSTEM, WITHOUT PERMISSION IN WRITING FROM THE PUBLISHER.

DESIGNED BY DAVID FORDHAM

PRINTED IN SINGAPORE

FRONT COVER: 'WIND IMAGE II' BY KURIKI TATSUSUKE, 1987
BACK COVER: 'CANDLELIGHT' BY YOKOYAMA NAOTO, 1988

U.S. LIBRARY OF CONGRESS CATALOGING-IN-PUBLICATION DATA
FAULKNER, RUPERT.
 JAPANESE STUDIO CRAFTS: TRADITION AND THE AVANT-GARDE/RUPERT
FAULKNER.
 P. CM.
 ISBN 0–8122–3335–2
 1. DECORATIVE ARTS—JAPAN—HISTORY—20THCENTURY. 2. ARTISTS'
STUDIOS—JAPAN. I. TITLE.
NK1071.F37 1995
709'.52'09045—DC20 95–9789
 CIP

THE TEXT EXTRACT QUOTED ON PP.99–100 IS FROM *BASKETRY* BY HISAKO SEKIJIMA,
PUBLISHED BY KODANSHA INTERNATIONAL LTD. COPYRIGHT © 1986 BY KODANSHA
INTERNATIONAL LTD. REPRINTED BY PERMISSION. ALL RIGHTS RESERVED.

CONTENTS

ACKNOWLEDGMENTS

IN THE FIRST INSTANCE I SHOULD LIKE TO EXPRESS MY GRATITUDE to those institutions and private individuals in Japan who have so generously allowed me to reproduce their photographs in this book. Thanks are also due to the numerous artists who have answered my queries about their work and to the many others in Japan who have so unstintingly provided me with help and encouragement. I am particularly indebted to Hasebe Mitsuhiko, Hayashi Toshihiko, Kawashima Keiko and Shiraishi Masami, as well as to the curatorial staff of the Tokyo National Museum of Modern Art (Crafts Gallery) and the Kyoto National Museum of Modern Art. I should also like to thank the Metropolitan Center for Far Eastern Art Studies in Kyoto for providing me with the funds necessary to spend several weeks conducting research in Japan.

This book is an outcome of a series of initiatives that the Victoria & Albert Museum (V&A) has adopted in recent years to strengthen its representation of modern developments in art and design. These have included the staging of a number of major temporary exhibitions focusing on contemporary Japan. Among the first of these were 'Japan Style' and 'Japanese Ceramics Today', held in 1980 and 1983 respectively, the success of which encouraged the Museum's Far Eastern Collection to start buying examples of contemporary Japanese studio crafts. In 1986 the Toshiba Gallery of Japanese Art and Design was opened with a space specifically designated for the display of these new acquisitions. In the late 1980s a systematic programme of purchasing was initiated in order to establish a collection that would illustrate the full richness and diversity of work in this field. That the collection is still being developed is reflected in the fact that only half of the illustrations in the book are of objects belonging to the V&A.

In Britain I would like to thank Laurence King and Mary Scott at Laurence King Publishing for the enthusiasm they have shown towards the book, and to David Fordham for his highly imaginative design. The visual quality of the book also owes much to the skills of Ian Thomas, who took the wonderful photographs of the objects from the V&A. Thanks are due both to him and to Ruth Bottomley, who organized the photographic programme so efficiently. Rose Kerr, Curator of the Far Eastern Collection, has been unswerving in her support and encouragement over the years. My other colleagues in the Far Eastern Collection have given generously of their time, both in terms of reading and commenting on the text and in taking on many of my duties during the last few months of writing. I am especially indebted to Anna Jackson for her thoughtful observations on the text and for helping me to nurture the book into its final form.

The completion of the book would not have been possible without the support of family and friends, both in London and in Tokyo. Above all I would like to thank my wife Kyōko and our daughters Moë and Mayo for their kindness, patience and understanding. To them I dedicate this book.

RUPERT FAULKNER

CHRONOLOGIES

CHRONOLOGY OF PERIODS IN JAPANESE HISTORY

JAPAN

Jōmon period .. 10,500–300 BC

Yayoi period .. 300 BC–AD 300

Tumulus period .. 258–646

Hakuhō period ... 646–710

Nara period ... 710–94

Heian period .. 794–1185

Kamakura period .. 1185–1336

Muromachi period .. 1336–1573

Momoyama period .. 1573–1615

Edo period ... 1615–1868

Meiji period ... 1868–1912

Taishō period ... 1912–26

Shōwa period ... 1926–89

Heisei period .. 1989–present

CHRONOLOGIES OF PERIODS IN CHINESE AND KOREAN HISTORY MENTIONED IN THE TEXT

CHINA

Warring States period .. 475–221 BC

Eastern Han period .. AD 25–220

Tang period .. 618–906

Song period .. 960–1279

Southern Song period .. 1128–1279

Yuan period .. 1279–1368

Ming period .. 1368–1644

Qing period .. 1644–1911

KOREA

Chosŏn period .. 1392–1910

NOTES

NOTES ON JAPANESE NAMES AND PRONUNCIATION

Japanese names are given in Japanese order: family name followed by given name.

Consonants in Japanese words are pronounced much as they are in English, vowels as they are in Italian. There is a difference, however, between the short and the long u/ū and o/ō, the macron over the vowel indicating the longer form. The shorter form u is pronounced as in the Italian 'Umbria', the longer form ū as in the English 'hoot'. The shorter form o is pronounced as in 'not', the longer form ō as in 'ought'. Macrons have been used throughout the text except on the frequently found place names Tokyo, Kyoto and Osaka (strictly Tōkyō, Kyōto and Ōsaka).

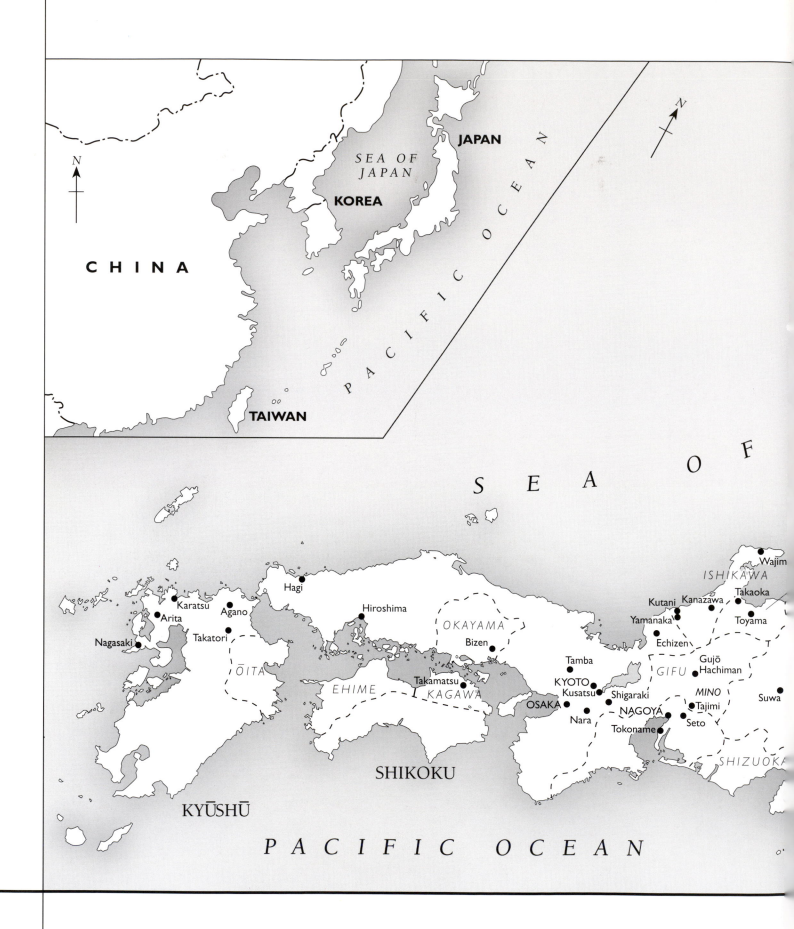

MAP OF JAPAN

The map includes the main place names mentioned in the text.

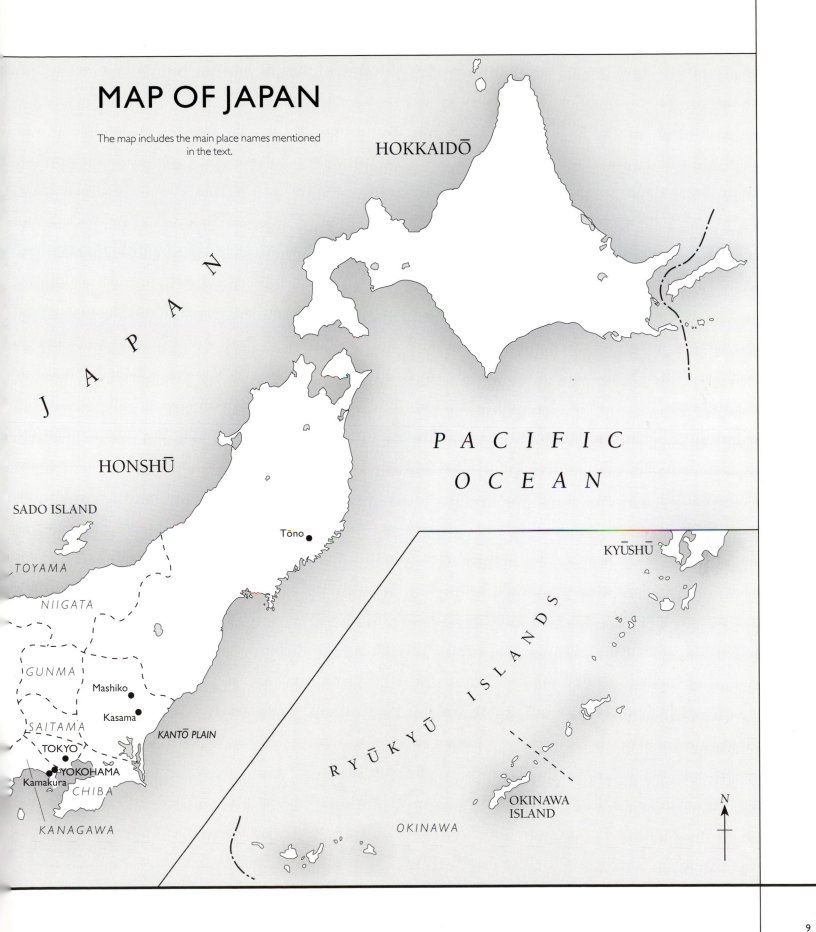

HOKKAIDŌ

JAPAN

HONSHŪ

PACIFIC
OCEAN

SADO ISLAND

TOYAMA

NIIGATA

Tōno

KYŪSHŪ

GUNMA

Mashiko

Kasama

SAITAMA

KANTŌ PLAIN

TOKYO

YOKOHAMA

Kamakura

CHIBA

KANAGAWA

RYŪKYŪ ISLANDS

OKINAWA
ISLAND

OKINAWA

N



INTRODUCTION



Wᴛʜ ᴀɴ ᴇxᴛʀᴀᴏʀᴅɪɴᴀʀʏ ᴡᴇᴀʟᴛʜ ᴏғ ᴡᴏʀᴋ emerging from the hands of an ever-increasing population of makers, Japan is the site of some of the most exciting developments in the world of contemporary studio crafts. That works by Japanese artists should have been selected for inclusion along with those by western makers in a recently published directory of international crafts indicates that Japan's importance in this field is beginning to be recognized as fully as it deserves.[1] Western appreciation of the richness of what Japan has to offer has increased as a result of the growing number of overseas exhibitions focusing on or including Japanese studio crafts. Japanese makers are also increasingly involved in international competitions in areas such as ceramics and fibre art. Awareness of the diversity of the interests pursued by contemporary Japanese makers is still, however, far from complete. It is as an attempt to redress this situation through the provision of a general introduction to the subject that the present book has been written.

The book has two main aims. The first is to examine contemporary Japanese studio crafts in terms of the broad differences in philosophy and artistic aspiration found among their makers. A distinction can be made between the activities of contributors to events such as the Traditional Crafts Exhibition and the more experimental interests of what are now very substantial numbers of ceramic sculptors, fibre artists, avant-garde metalworkers, contemporary jewellery makers and studio glass artists. A third area to be examined, although somewhat less extensively, is the work of makers belonging to organizations such as the Japan Craft Design Association.

The book's second main aim is to reveal the variety and sophistication of the technical processes used by contemporary Japanese makers. Although the objects discussed could have been organized in a number of different ways, the chapters have been divided according to media in order to emphasize the deeply rooted concern with the intrinsic potentialities of

Opposite 'Contained Mind VII' by Ikuta Niyoko (see plate 97)

materials and techniques which is the starting point for Japanese practitioners making even the most declaredly conceptual work.

Although the book touches on developments from the early part of the twentieth century onwards, it concentrates primarily on the last twenty-five years. Apart from the need to limit the coverage of a potentially enormous subject, this narrowing of focus is tenable and appropriate in historical terms. The surge in museum building, art collecting and exhibition programming that has accompanied Japan's recent economic ascendancy has been paralleled by the development of an essential base for the now buoyant situation in the Japanese crafts world. The early 1970s saw the maturation and diversification of avant-garde tendencies in fields such as ceramics and metalwork in competition with the relative conservatism of the traditional crafts movement. These years also saw the growth of new areas of activity such as fibre art, contemporary jewellery and studio glass.

The term 'studio crafts', which defines the scope of activity that this book addresses, can be understood as a conflation of several concepts.[2] The word 'studio' suggests objects that are consumed on the basis of their perceived 'artistic' value. This derives principally from their status as unique items that express and reflect the individuality of their makers. Such objects are, in effect, produced, marketed, consumed and criticized in an identifiable subworld that exists within the broader scope of production and consumption of artefacts in general. The word 'crafts' suggests both the primacy of hand-making and its implicit risks, and the difference in perception on the part of consumers towards hand-crafted products and those made wholly or largely by mechanical means. One of the main characteristics of crafts is the central concern for the inherent quality of materials, and the interest in the techniques required for the processing and manipulation of particular materials.

The notion of studio crafts as it is understood in Japan today embraces a diversity of activities, ranging from the making of essentially utilitarian vessel forms to the creation of sculptural works, usually of an abstract rather than a figurative kind. The emphasis on personal exploration of artistic and philosophical concerns that go beyond the more purely technical preoccupations of traditional craft work is seen in the existence of a Japanese vocabulary to express such differences. A contrast is made between the activities of *shokunin* and *sakka*. *Shokunin* means 'one who pursues a skill', with implications, if not necessarily of anonymity, at least of repetitive labour which allows little scope for individualistic expression. *Sakka*, on the other hand, means 'one who makes' and carries implications of individual creativity and originality. The term is broadly applied to painters and sculptors as well as to craft practitioners.

Japan's modern studio crafts movement came into being during the Taishō (1912–26) and early Shōwa (1926–89) periods. The addition of a crafts section to the government's prestigious *Teiten* exhibition (*Teikoku Bijutsu Tenrankai*; Imperial Arts Exhibition) is seen as a watershed symbolizing the re-evaluation of the place of the crafts within a hierarchy that had been established during the Meiji period (1868–1912) on the basis of western distinctions between the fine and applied arts. This took place in 1927 after almost ten years of lobbying by the crafts

community. Although it put the crafts on an equal footing with painting and sculpture, as an event backed by the state and with a tendency to promote establishment values it inevitably failed to recognize the views of more radical makers. Their concerns were expressed through the formation of a variety of alternative groups made up of small numbers of kindred spirits united by strongly felt ideals and commitments.

While many of these free-thinking artists looked to contemporary western art and design movements such as Art Deco, Constructivism and the Bauhaus for inspiration, there were others who believed that only traditional East Asian culture could provide a way forward. Various factors encouraged an increased awareness of the culture of the past at this time. Japanese art history was being studied in a systematized fashion, and archaeological excavations provided a growing body of physical evidence about the past. As well as being the subject of academic research, Japan's historical past provided the basis of the social ideology promoted by Yanagi Sōetsu (1889–1961) and other founders of the Japanese Folk Craft movement. Established in the course of the 1920s, this movement played a key role in the preservation and promotion of traditional craft practices during this critical period.[3]

The turmoil of the Second World War brought irrevocable changes to the social, economic and cultural landscape of Japan. This was the very different context in which the various concerns that had preoccupied artists in the prewar period were re-examined. The trauma of defeat followed by occupation by foreign forces triggered a new wave of interest in Japan's traditional past. There was a psychological need for the stability that a strong sense of cultural identity could provide. There was concern at the Americanization of Japanese culture and a deeply felt sense of loss at the destruction of so many historical buildings and cultural artefacts during the war. There was also the relentless decline of traditional craft production in the face of the continuing industrialization and mechanization so lamented by Yanagi since the 1920s.

Concerns of this kind led the Japanese government to undertake a major review of the laws relating to the protection of cultural properties.[4] The new code, which was promulgated and implemented between 1950 and 1955, drew together existing laws and extended them to cover not only Tangible Cultural Properties but so-called Intangible Cultural Properties as well. The latter were defined as 'intangible cultural products materialized through such human activities as drama, music, dance and the applied arts which have high historical or artistic value'. Following a nationwide survey carried out between 1950 and 1953, a list was drawn up of performing and applied art traditions that were felt to be both worthy of preservation and in danger of being lost. The scope of the law was extended in 1954 to cover traditional practices that were not necessarily in danger of extinction but that were nevertheless important for historical or artistic reasons. In 1955 a further system was set up for the appointment of individual holders or in some cases group holders of each of the identified Important Intangible Cultural Properties. It is these individual appointees who are popularly known as Living National Treasures.

Closely related to this system has been the staging of the Japanese Traditional Crafts Exhibition (*Nihon Dentō Kōgeiten*). This major group event has been held annually since 1954,

and since 1960 has been open to general submission by anyone with aspirations to establish themselves in the traditional crafts world. It is jointly sponsored by the Japan Crafts Association (*Nihon Kōgeikai*), an independent body whose main function is that of exhibition organizer, by the government's Agency for Cultural Affairs and by large media organizations such as the Japan Broadcasting Association (NHK) and the Asahi Newspaper Company.[5] In its current form its main sections are devoted to ceramics, textiles, lacquerware, metalwork, woodwork and basketry. There are also a number of regional and media-based subgroups operating within the Japan Crafts Association.

If Japan looked to its past to provide stability and a sense of national identity during the difficult years after the Second World War, there was also a pressing need to forge new structures that would guarantee the country's social and economic future. Good design was seen as an essential practice if Japan was to produce goods that would generate much-needed income. The 1950s saw the setting up of a plethora of organizations based on western models dedicated to promoting good design.[6] In the field of crafts this specifically led to the establishment in 1956 of the Japan Craft Design Association.[7] For makers belonging to this organization utility, affordability and a consciousness of contemporary lifestyles as well as originality of design and exploration of technique have been key considerations. The work produced by these artists represents a happy combination of sympathy for traditional Japanese aesthetics and interest in western modernist minimalism.

Japan's expanding role in the international arena during the postwar era also led to a greater exposure to western artistic trends. From the 1950s onwards an increasing number of Japanese artists travelled to, and worked in, the West. Japan itself became the venue for a number of important exhibitions that explored aspects of contemporary western art. The more avant-garde tendencies that these factors generated were catered for by the *Nitten* exhibition (*Nihon Bijutsu Tenrankai*; Japan Art Exhibition), the postwar equivalent of the *Teiten* exhibition which was first held in 1946 under the auspices of the Ministry of Education.[8] However, rather as the *Teiten* exhibition had tended to cater for the middle ground and to serve as the foil against which radical craft groups defined themselves during the prewar years, the orientation of the *Nitten* exhibition was, and indeed continues to be, rather unfocused. Many artists were prompted into forming their own small groups with more clearly defined objectives, one of the earliest and most influential being the *Sōdeisha*, an avant-garde ceramists group which was established in Kyoto in 1948.[9]

In 1961 craft practitioners belonging to the *Nitten* group formed the Association of Modern Artist Craftsmen (*Gendai Kōgei Bijutsuka Kyōkai*). The position adopted by this organization shows how influential the activities of the *Sōdeisha* and other avant-garde groups had become by the end of the 1950s. In defending themselves against the challenge posed by the then recently established Japan Crafts Association and its Traditional Crafts Exhibition, members of this new group decided to focus their energies on the making of 'creative crafts'. In contrast to the Japan Crafts Association, whose main aim was to preserve and build upon traditional practices, the

Association of Modern Artist Craftsmen placed primary importance on artistic self-expression. This manifested itself in a shift of emphasis from 'crafts for use' to 'crafts for contemplation'.[10] The factionalism for which Japan, its art world included, is notorious is reflected in the way in which in 1977 yet another group, the New Craft Artists Federation (*Nihon Shinkōgei Bijutsuka Renmei*), was set up as a breakaway group from the Association of Modern Artist Craftsmen.

Despite the inherent problems of the *Nitten* exhibition it is still a prestigious event which travels to museums around the country. Other exhibitions, including the Traditional Crafts Exhibition, are usually held in department stores. While holding an exhibition in a department store might be thought of as degrading in the West, this is not the case in Japan. Indeed, the role played by department stores in promoting studio crafts has been crucial. In staging large-scale group exhibitions department stores profit not only from the sale of the works on show but also from the increased turnover generated by the influx of customers. They are helped in this by the media coverage provided by the newspaper companies that invariably act as sponsors of such exhibitions. It is notable how Japanese newspaper companies, keen to promote their image through involvement with cultural activities, have been responsible for establishing several of the medium-specific competitive exhibitions that have become such an important aspect of the contemporary Japanese studio crafts scene.[11]

Department stores are also important for the solo studio craft exhibitions that they hold on a regular basis. Their virtual monopoly of this field has had much to do with the fact that in spite of the very substantial prices that studio crafts can fetch in Japan, major art dealers have found it more profitable to concentrate on the buying and selling of painting and sculpture. This being said, recent years have seen a considerable increase in the number of galleries that specialize in contemporary crafts. Unlike department stores, which tend to deal with well-established figures in their overriding concern for maximizing profits, these smaller galleries are more committed to encouraging the activities of up-and-coming artists. The economic freedom that the emergence of these galleries has helped to guarantee, coupled with increasing disenchantment at the hierarchical workings of many of the large group exhibitions, has led to an increase in the number of young artists who operate independently of the major craft associations. This is proving to be a healthy remedy to a situation in which the unfortunate effects of factionalism are all too readily discernible.

The enormous diversity of current studio craft practices in Japan precludes exhaustive coverage in an introductory book such as this. It is hoped, however, that the range of objects discussed will stimulate interest in what is an extremely rich, but from a western perspective relatively unexplored, aspect of contemporary Japanese culture.



CHAPTER I

CERAMICS



THE DEVELOPMENT OF CERAMICS into Japan's pre-eminent studio craft discipline has been one of the most conspicuous features of Japanese art and design in the postwar period. This is reflected both in the ever-increasing number of people working in the field and in the growing diversity of styles and artistic interests which they explore. That the number of individuals involved is large is evident from the fact that the initial working list for a recently published compendium of contemporary ceramics included over three thousand names, all of them established practitioners enjoying a substantial degree of critical acclaim.[1] Statistics from the Traditional Crafts Exhibition show that since the late 1960s ceramics have accounted for fifty per cent or more of all submissions, and have been up to five times more numerous than works in other categories. While these figures relate specifically to traditional crafts, they are indicative of the comparative strength of ceramics in the studio crafts world as a whole.

An important factor in the emergence of ceramics as Japan's most highly subscribed craft discipline has been the long-standing existence of a number of major competitive ceramics exhibitions. This is in marked contrast to the situation in other fields, in which the staging of regular large-scale competitions devoted to a single medium has been a relatively recent development. A key aspect of these ceramic competitions is that they are open to all artists regardless of craft organization affiliation. As well as making the ceramics of established practitioners available to new audiences, they have served an invaluable role in encouraging the activities of art college graduates and other young makers trying to gain recognition for their work.

There are four main competitions. The longest established is the Asahi Ceramic Art Exhibition (*Asahi Tōgeiten*). Organized by the Nagoya branch of the Asahi Newspaper Company, this has been held annually since 1963.[2] The second competition is the Japan Ceramic Art

Opposite 'Cloud Image' (detail) by Suzuki Osamu (see plate 29)

Exhibition (*Nihon Tōgeiten*). This is organized by the Tokyo-based Mainichi Newspaper Company and has been held biennially since 1971. Having been set up with the aim of attracting submissions on a nationwide basis, it is held in higher regard than the Asahi exhibition, which still retains the regional orientation that was officially promoted during the first twenty years of its history.

The third competition to be established was the Chūnichi International Exhibition of Ceramic Arts (*Chūnichi Kokusai Tōgeiten*). Sponsored by the Nagoya-based Chūnichi Newspaper Company and similar to the Asahi exhibition in having a strongly regional orientation, this was held annually from 1973 to 1988. It has since been reorganized into a biennial event and renamed the Ceramics Biennale (*Tōgei Biennale*). The last and most recently instituted competition is the International Ceramics Competition Mino (*Kokusai Tōjiten Mino*). This triennial exhibition was first held in 1986 in Tajimi, the centre of the Mino ceramics industry in southeastern Gifu Prefecture. A global competition to which scores of entrants from all over the world submit their work, it is Japan's answer to events such as Italy's Faenza International Ceramics Competition.

The categories for submissions used in these different exhibitions are revealing for what they tell us about the perceptions that surround the making and appreciation of ceramics in contemporary Japan. They have served as a useful starting point for drawing up the headings under which the ceramics discussed in this chapter are organized.

Until 1982 the Asahi exhibition solicited work under two thematic categories, 'Topic Work' and 'Free Work'. These were amalgamated into a single category, 'Free Creation Work', when the exhibition was opened up to submissions from throughout Japan in 1983. While there is no longer any formal categorization of works in the Asahi exhibition, comments by the judging panel make a distinction between 'works that stress tradition and the classic' and ' "objet" works devoted exclusively to form itself'.[3] The Chūnichi exhibition, in both its former and present incarnations, has solicited submissions under two categories, 'functional works in vessel forms' and 'sculptural works'.

The Mainichi exhibition, which is the most highly structured in its approach, solicits submissions under three categories, *dentō* (traditional), *zen'ei* (avant-garde) and *jitsuyō tōki* (utilitarian ceramics). The difference between traditional and avant-garde is defined not in terms of use of traditional techniques, adherence to traditional styles or degree of experimentation, but according to whether works are in vessel or non-vessel forms. 'Traditional' in the Mainichi exhibition context has a broader meaning than in the Traditional Crafts Exhibition, and includes vessel forms of an innovative and sometimes highly explorative kind. The third category, utilitarian ceramics, was originally called *mingei* (folk ceramics). While conservative works in folk craft styles harking back to country ceramics of the nineteenth and early twentieth centuries continue to dominate, the change of title since 1981 has prompted the submission of an increasing number of works in more contemporary idioms similar to those shown at the Japan Craft Design Association's Japanese Crafts Exhibition.

In the case of the Mino triennial, a distinction is made between 'Ceramic Design' and 'Ceramic Arts'. The latter, the equivalent of an amalgamation of the traditional and avant-garde sections of the Mainichi exhibition, includes both vessel and non-vessel forms of a primarily expressive nature. The former equates to the utilitarian ceramics section of the Mainichi exhibition to the extent that utility is the key defining factor. There is a major difference, however, in that no room is given to ceramics in folk craft styles. The tenor of this section is unequivocally contemporary, selected entries ranging from designs for industrial manufacture to hand-crafted items for limited series production.

The ceramics covered in this chapter correspond in the main to the types of work found in the Asahi and Chūnichi exhibitions, in the traditional and avant-garde sections of the Mainichi exhibition, or in the ceramic arts section of the Mino triennial. They have been arranged broadly into two groups – traditional and non-traditional. Traditional implies purposeful adherence to forms and styles with readily discernible precedents in the history of Japanese and other East Asian ceramics. In some instances the traditions involved are continuous ones that have survived unbroken to the present day. In most cases, however, reference is made to historical models whose manufacture ceased at some time in the past. Vessels are the norm, jars and large dishes being especially prevalent among submissions to the Traditional Crafts Exhibition and major ceramic competitions. Non-traditional implies, by contrast, the adoption of new styles and forms. Experimentation and innovation, although also an essential ingredient of contemporary ceramics in traditional styles, are particularly marked. Both vessel and non-vessel forms are used. In the case of vessel forms, functionality is usually subsidiary to considerations of decoration and sculptural effect.

The analysis begins with a discussion of ceramics in traditional styles. These are grouped according to the main historical traditions – Japanese, Korean and Chinese – by which contemporary makers are inspired. This is followed by a discussion of ceramics in what are categorized here as new decorative styles. The works described in this section are vessel forms of traditional and non-traditional types that are united in their concern for the exploration of new modes of decoration. The decorative schemes of the traditional examples are based on recognizable historical models, but much more indirectly than in the case of the ceramics discussed in previous sections. Those on the non-traditional examples do not rely on historical precedent. Taken as a group these ceramics suggest that there is a considerable overlap of interests between artists who contribute to the Traditional Crafts Exhibition and others who see themselves as more radical proponents of experimentation and change. The discussion of works in new decorative styles is followed by an examination of non-traditional works that explore the sculptural potential of the vessel form and of similarly abstract works in non-vessel forms that exploit the potential of the ceramic medium to a variety of new effects. The chapter concludes with sections focusing on two areas of particular interest in the field of non-traditional ceramics: first, primitivism, the primal nature of clay-working, and clay as symbol and embodiment of the passing of time; and, second, the subversion of political, social and aesthetic orthodoxies.

MEDIEVAL CERAMIC TRADITIONS AND THEIR ANTECEDENTS

THE RICHNESS OF JAPAN'S CERAMIC HERITAGE has become increasingly apparent through archaeological excavations carried out since the early decades of this century and through the systematic study of collections inherited from previous generations. Publications and museum collections abound, while exhibitions focusing on all aspects of Japanese and other East Asian ceramics are staged regularly throughout the country. Regardless of the extent and ready availability of this information and of the large number of practitioners involved, the world of traditional ceramics as represented by the variety of work shown in events such as the Traditional Crafts Exhibition is marked by a high degree of conformity to a relatively prescribed range of styles. The emphasis on the preservation of particular regional idioms, which has been a characteristic of the traditional crafts movement, goes some way to explaining this. The continuing tendency for younger potters to imitate the work of their teachers is another factor. This is found not only in the apprenticeship system of traditional ceramic workshops, but in the context of art college teaching as well. The canons of tea ceremony taste have also played a significant role in determining the range of styles pursued by contemporary makers.

The influence of prehistoric and early Japanese ceramics has been relatively minor in the realm of traditional ceramics. There are, however, a number artists such as Itō Sekisui V (b.1941) (PLATE 1) whose work revolves around the exploration of the *yōhen* (kiln change) effect as found on earthenwares of the Yayoi period (300 BC – AD 300). Yayoi earthenwares and their successors were fired in the open and owe their distinctive coloration more to chance than to calculation. Modern technology gives contemporary potters much greater control over the variations in kiln atmosphere required to produce the different areas of oxidized orange and reduced grey, so the effects they are able to achieve are that much more dramatic. The particular sensitivity that Itō brings to his work derives from the extensive experience in using the locally occurring iron-rich clay that the family pottery on the island of Sado off the coast of Niigata Prefecture has built up over successive generations. Itō succeeded to the family headship in 1977, the year after he became a member of the Japan Crafts Association.

The dish (PLATE 2) by Shimaoka Tatsuzō (b.1919) is an example of contemporary work inspired by the techniques of Jōmon period (10,500–300 BC) earthenwares. The term 'Jōmon' (cord pattern) is used by archaeologists to refer to the prehistoric cultures of Japan characterized by the making of earthenwares decorated with a rich variety of cord-impressed motifs. Shimaoka lives and works in Mashiko, which is located to the northeast of Tokyo towards the edge of the Kantō plain. His fascination with cord-impressed decoration is explained by the proximity of the numerous Jōmon sites for which this part of Japan is well known. Here he combined three different patterns on the same piece. The impressed decoration was then filled with white slip before being painted over with iron brown motifs and glazed.

These subsequent processes are, it should be noted, unrelated to Jōmon practices. The use of white slip is characteristic of Mishima (*punch'ŏng* in Korean) wares, one of the numerous

PLATE 1 *Opposite* Stoneware jar with *yōhen* (kiln change) surface colouring. 1980. *height 30.5cm (12in)*
Itō Sekisui V (b.1941)

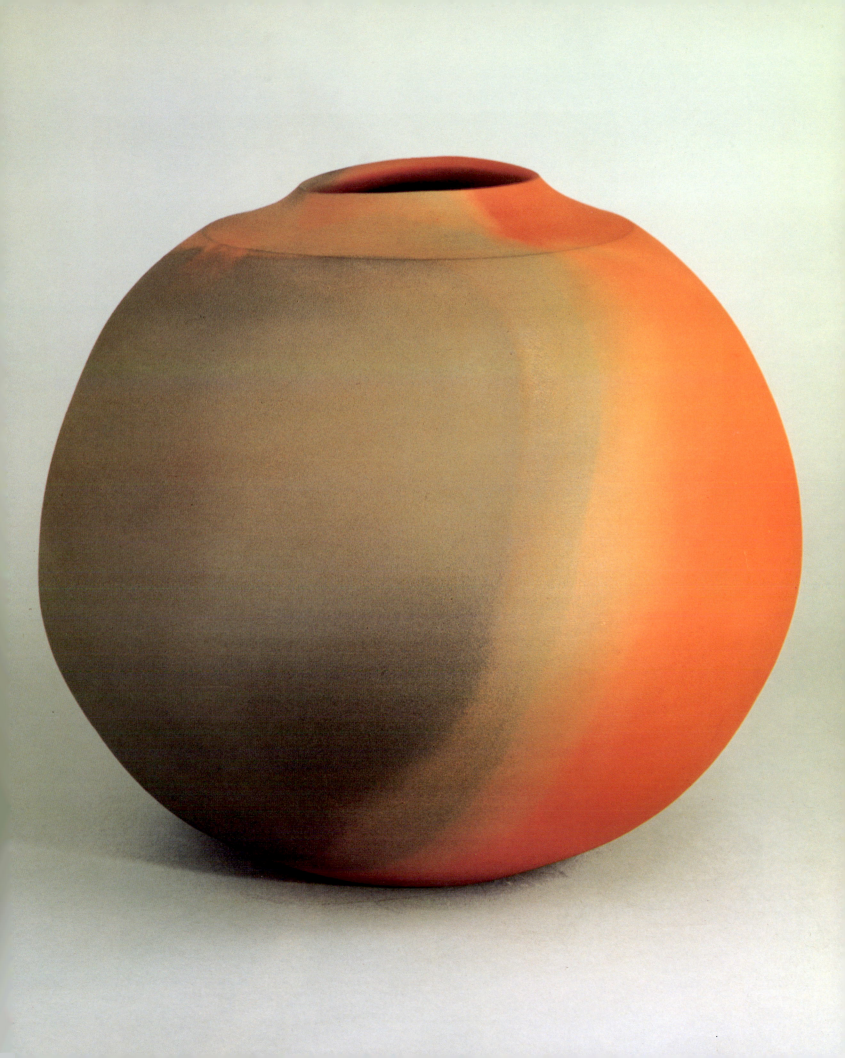

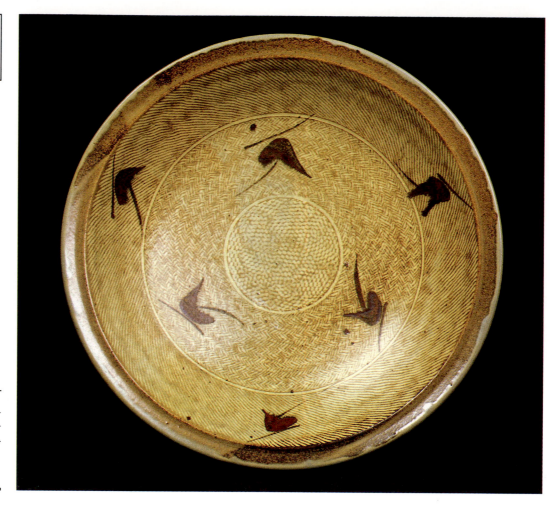

PLATE 2 Stoneware dish with under-glaze iron painting over cord-impressed and slip-filled ground. 1985. *diameter 57.4cm (22½in)* ***Shimaoka Tatsuzō (b.1919)***

varieties of Korean ceramics extolled by Yanagi Sōetsu (1889–1961), Hamada Shōji (1894–1978) and their associates in the Japanese Folk Craft movement. Given that Shimaoka was Hamada's foremost student and is now regarded as Japan's leading folk craft potter, his choice of slip-filling as one of the hallmarks of his work can be seen to have symbolic as well as aesthetic significance.

The two pieces discussed above notwithstanding, the earliest Japanese ceramics by which significant numbers of artists working in traditional styles are inspired date from the medieval period. Lasting from the late twelfth to the mid-sixteenth century, this was the age of the so-called 'six old kilns' of Bizen, Shigaraki, Tamba, Tokoname, Echizen and Seto. With the exception of Seto, these kiln groups produced rugged, unglazed stonewares in a simple repertory of storage jar and mixing-mortar shapes.

Seto, which is situated to the east of Nagoya, differed in that it produced glazed stonewares in imitation of imported Chinese ceramics prized by the upper echelons of Japanese society during the Kamakura (1185–1336) and Muromachi (1336–1573) periods. The fact that Seto wares were made as copies of superior Chinese ceramics has militated against their being taken up as the starting point for contemporary work other than in the form of fakes and reproductions. As will be seen below, artists working in Chinese idioms tend to look directly to Chinese models for inspiration.

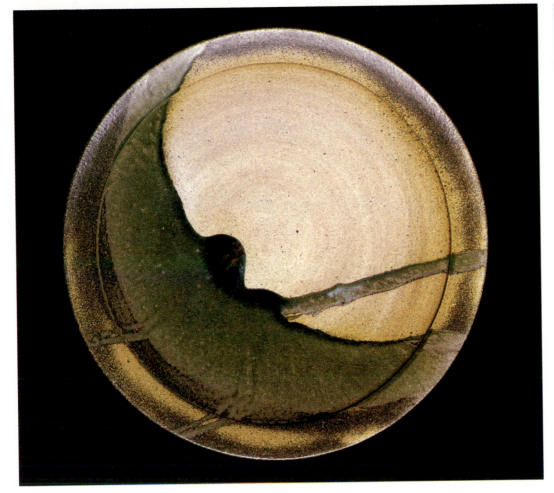

PLATE 3 Tokoname type stoneware dish with partial covering of ash glaze. 1980. *diameter 53.6cm (21in)* ***Takeuchi Kimiaki (b.1948)***

The notion of the six old kilns took hold during the 1950s, largely as the result of findings by local scholars that the areas in which they lived had histories of continuous ceramic production dating back to the medieval period.[4] Archaeological excavations carried out during the last twenty-five years have shown that in reality there were several dozen kiln groups active in medieval Japan. However, the hegemony of established ceramic-making centres has not encouraged the development of new work inspired by recent discoveries about Japanese ceramics of the medieval or indeed any other period.[5] Bizen, Shigaraki, Tamba, Tokoname and Echizen are well represented in the membership of the Japan Crafts Association, and eminent artists from these and other regional centres are regularly involved as jurors in the Traditional Crafts Exhibition. In the innately conservative climate of the traditional crafts world, this has not made it easy for artists attempting to create new ceramics based on alternative regional styles to gain more than local recognition for their work.

The dish (PLATE 3) by Takeuchi Kimiaki (b.1948), a contributor to the Traditional Crafts Exhibition since 1969, is an example of contemporary work inspired by medieval stonewares from Tokoname. Tokoname is located on a peninsular to the south of Nagoya and thrived historically on account of its ready access to sea transport. It is known today for the manufacture of tiles and other industrial ceramics, and also for the production of highly wrought, unglazed

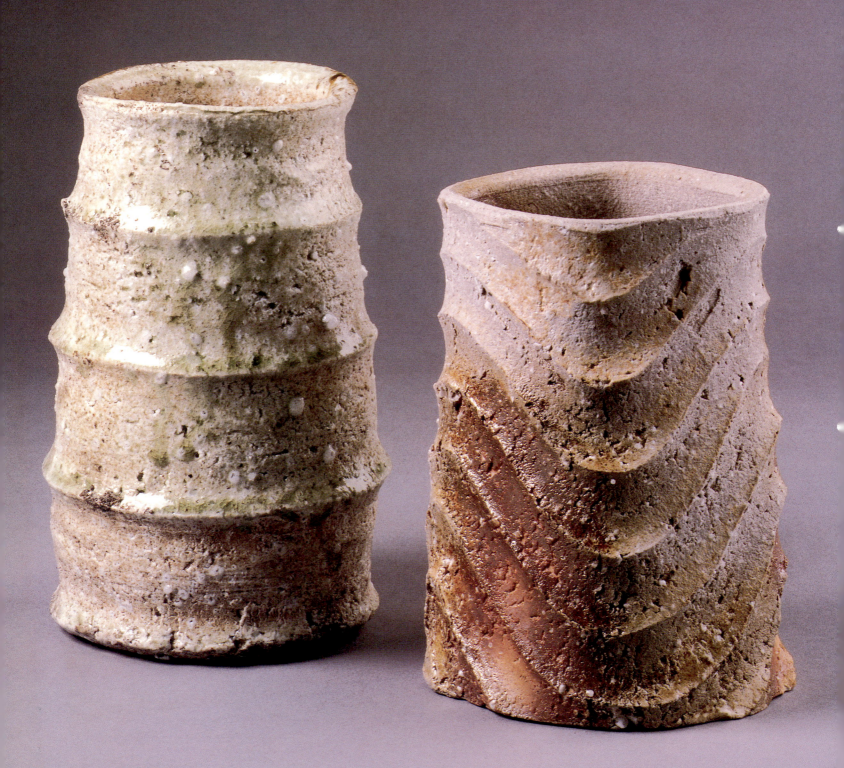

tablewares made from fine red clay. By comparison, medieval Tokoname wares were extremely crude. The larger forms were usually coil-built in slightly irregular shapes, and the use of large, single-chambered tunnel-shaped kilns gave rise to slumping and the uneven depositing of fly ash on otherwise unglazed surfaces. These rough and unfinished looking pots, whose distinctive qualities are the natural result of the limitations of medieval ceramic technology, have had a particular appeal to artists working in the increasingly industrialized environment of modern Tokoname.

One of the first Tokoname-based potters to look to such wares for inspiration was Esaki Issei (b.1918), an influential figure under whom Takeuchi studied as a teenager. Takeuchi's ceramics, like those of his teacher, are characterized by a high degree of technical control. The potting of the dish shown here is sharp and well defined, and the application of the ash glaze has been carefully calculated. While making direct reference to medieval sources, Takeuchi imbues his work with a cool austerity that is unambiguously contemporary in feeling.

The two Shigaraki type vases (PLATE 4) by the Mino-based potter Yoshida Yoshihiko (b.1936) explore the rugged qualities of medieval stonewares in a more immediate and organic way. Yoshida's work is distinguished by a profound sensitivity towards the materials and techniques he uses. Understated and contemplative, his pots have a quiet grandeur that has brought him considerable recognition in recent years. Yoshida does not belong to the Japan Crafts Association or any other such organization. Furthermore, unlike most artists working in traditional styles, who tend to focus on a single idiom, he is something of a polymath. As the foremost student of the Arakawa Toyozō (1894–1985), under whom he worked from 1956 to 1968, he is a master of Shino (see below, PLATES 6 and 7) and Black Seto wares. He is also well known for his so-called *kohiki* wares, stonewares covered in white slip and clear glaze in a style reminiscent of Chosŏn period (1392–1910) Korean ceramics of the fifteenth and sixteenth centuries. His experiments with Shigaraki clay are a fairly recent development, as is his exploration of burnished earthenware.

The distinctive surface carving of the vases shown here was inspired by wooden utensils from Africa and the Philippines, and reflects Yoshida's long-standing interest in the art of pre-industrialized societies. The variation in colour between the two pieces is the result of differences in firing techniques. In the piece on the left the pale green colour of the natural ash glaze and the greyish colour of the clay body were achieved by removing the vase from the kiln at the height of a reduction firing and causing it to cool instantly. This is essentially the same as the technique employed in Mino to fire Black Seto teabowls. The technique used on the vase on the right is unique to Yoshida and was developed by him specifically for firing wares made of Shigaraki clay. The contrasting grey and orange coloration was effected by partial freezing of the clay after the completion of a reduction firing. The areas of grey were achieved by allowing fine streams of air to strike parts of the vase's surface immediately after the end of the firing cycle and to freeze them into a reduced state. The rest of the vase was allowed to cool in the normal manner and to oxidize an orange colour.

PLATE 4 *Opposite* Two Shigaraki type stoneware vases with natural ash glaze (left) and scorched surface colouring (right). 1989. *heights 23cm (9in) (left) and 20.2cm (8in) (right)*
Yoshida Yoshihiko (b.1936)

MOMOYAMA TEA WARE TRADITIONS

DURING THE 1920S AND 1930S YOUNG ARTISTS looking for new means of expression turned for inspiration to tea ceramics of the Momoyama period (1573–1615). Commentaries on this formative era in the history of Japanese studio crafts describe how a widespread sense of frustration had grown up against the legacy of official promotion by the Meiji government of what were seen as technically elaborate but artistically barren works for European and American consumption.[6] The obsession with virtuoso craftsmanship that had been a characteristic of ceramic and other craft production during the late nineteenth century continued well into the interwar period, entries to the crafts section added to the *Teiten* exhibition[7] in 1927 being judged primarily on technical grounds.

The urge among more adventurous makers to break free from this mould led them to explore a number of new avenues. Some looked to current trends in the West, assimilating the styles of Art Deco, for example, and absorbing the principles of modernism. Others turned to their own cultural heritage. In its concern over the destruction of traditional values and practices resulting from Japan's rapid industrialization in the interwar years, the Japanese Folk Craft movement sought in the arts of the common people the basis for artistic and social reform. The discovery of Momoyama period tea ceramics, and their identification as the manifestation of a uniquely Japanese aesthetic, was the starting point for another series of initiatives which represented a significant furthering of Japanese cultural nationalism during this period.

At this time scholarship into Japanese ceramic history had hardly begun and museums were few and far between. Because the enjoyment of tea utensils and other art objects was the preserve of a small élite, potters had little access to information about the ceramics formerly produced in the areas in which they worked. This began to change in the 1920s and 1930s. While potters lacked the resources necessary to collect tea ceramics themselves, the movement of such objects among wealthy industrialist collectors generated much publicity.[8] At the same time scientific methods of archaeology were applied to regional kiln sites. Many of the excavations carried out in these early years were organized by local potters. The knowledge they gained was through sherds, and the ceramics they were most drawn to were those produced as tea wares in the Momoyama and early Edo (1615–1868) periods. The aesthetic that determined the making of these ceramics, and that was effectively rediscovered by potters working in areas such as Mino, Bizen, Hagi and Karatsu, had its roots in the *wabi*-style tea ceremony.

Wabi is a literary term suggestive of the idea of material deprivation. In the context of the tea ceremony it has come to mean the rejection of luxury and a taste for the simple, the understated and the incomplete.[9] The pivotal notion of the quest for spiritual fulfilment through devotion to the humble routine of daily life has its roots in the philosophy of Zen Buddhism.[10] The *wabi*-style tea ceremony reached its mature form at the hands of the tea master Sen no Rikyū (1522–91). Its tenets have been disseminated to subsequent generations through the activities of three tea schools – the Urasenke, the Omotesenke, and the Mushanokōji Senke – established in the

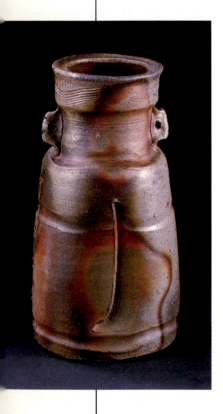

PLATE 5 *Above and opposite (detail)* Bizen type stoneware vase with scorched surface colouring. About 1950. *height 24.5cm (9¾in)*
Yamamoto Tōshū (1906–93)

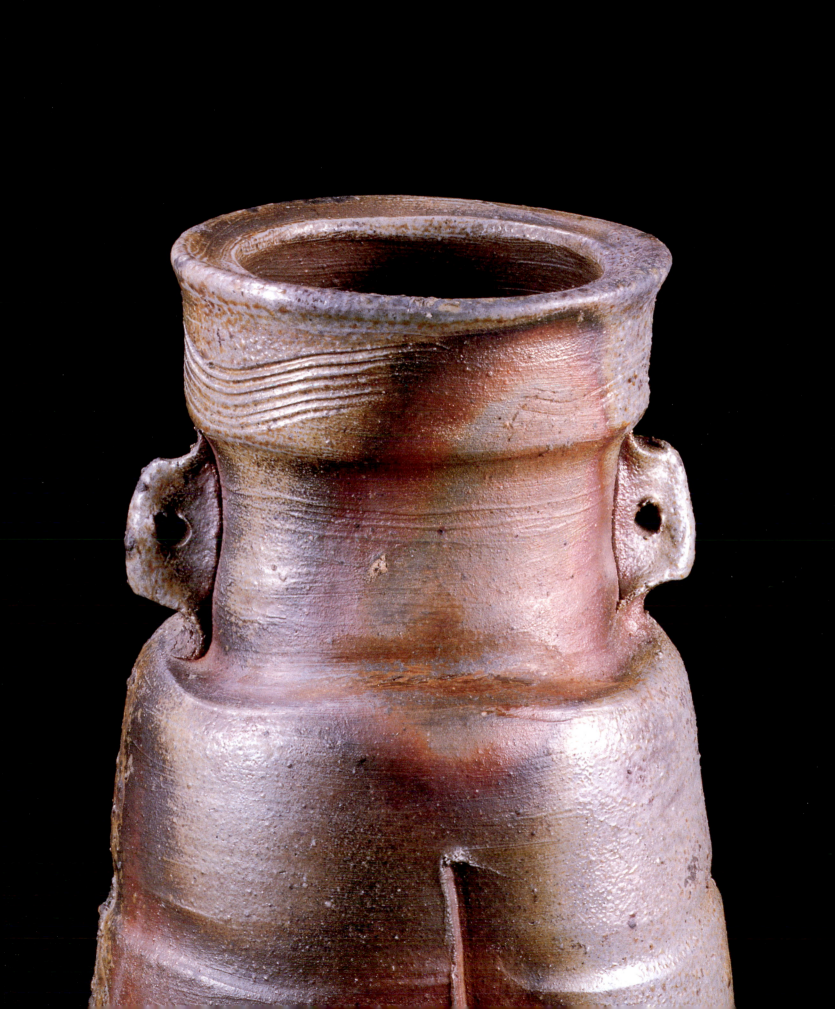

seventeenth century by the sons of Rikyū's grandson Sen no Sōtan (1578–1658). These still thrive today, the Urasenke being particularly well known on account of the numerous overseas branches it has set up in recent years.

The incorporation of the *wabi* aesthetic into the tea ceremony dates back to the time of Murata Shukō (1423–1502). Shukō's initiatives were furthered by Takeno Jōō (1502–55), under whom Rikyū studied as a young man. The ceramics that Shukō and Jōō introduced to complement the existing repertory of Chinese celadon and iron-glazed wares are sometimes described as 'found wares' because of the way in which they were adapted to, rather than being made specifically for, the tea ceremony.[11] They included Chinese, Korean and Japanese country ceramics that were characterized by a rough spontaneity which contrasted markedly with the refined elegance of their traditionally appreciated Chinese counterparts.

It is notable that both Shukō and Jōō had a particular affection for unglazed stonewares from Shigaraki and Bizen. There is a substantial group of ceramics known as 'Jōō Shigaraki' believed, although in some cases erroneously, to have been used by Jōō or his associates in the early sixteenth century.[12] There is also a much quoted statement by Shukō about the harmonizing of Japanese and Chinese tastes that specifically mentions the 'chilled and withered' qualities of Bizen and Shigaraki wares.[13]

The subversion and expansion of the parameters of tea taste through the adoption of these and other roughly formed ceramics was a revolutionary development in the history of the tea ceremony. It challenged tea devotees to go beyond the collecting and appreciation of acknowledged Chinese masterpieces and to exercise their imagination in the creation of a more personal and dynamic aesthetic. The growth in popularity of the tea ceremony led in time to the placing of orders at Japanese kilns for purpose-made tea wares. Beginning on a small scale during Jōō's lifetime, this practice became firmly established during the last two decades of the sixteenth century.

The tea ceremony flower vase (PLATE 5) by Yamamoto Tōshū (1906–93) is a classic example of a piece of modern Bizen ware closely fashioned after Momoyama period models. The form is heavily sculpted and the clay surface is dramatically scorched. Like its late sixteenth- and early seventeenth-century prototypes, it exploits the innate potential of traditional Bizen technology, first recognized by early tea masters, to deliberately artistic ends. The encouragement of a freely explorative approach to the expressive possibilities of functional forms has been one of the tea ceremony's greatest contributions to Japanese ceramic culture. The emphatic style for which Bizen tea wares are best known is usually described as being in the taste of Furuta Oribe (1544–1615), a follower of Rikyū who succeeded his master as leading tea master of the day and was particularly active in commissioning tea wares from different Japanese kilns.

Yamamoto became a member of the Japan Crafts Association in 1959 and was made a Living National Treasure in 1987. He was the third Bizen-based artist to be awarded this title. His predecessors were Kaneshige Tōyō (1896–1967; appointed Living National Treasure in 1956) and Fujiwara Kei (1899–1983; appointed Living National Treasure in 1970). It was the former's

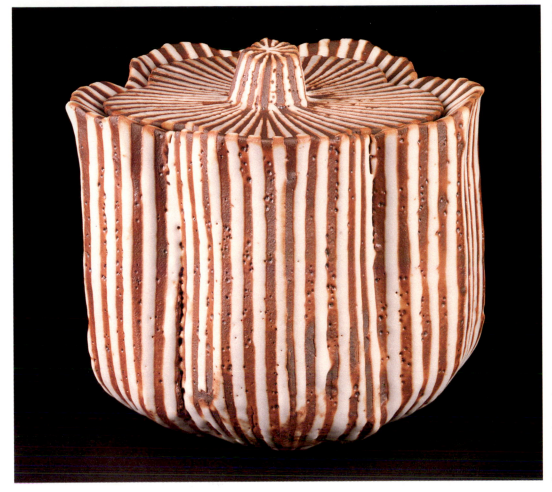

PLATE 6 Stoneware fresh-water jar with resist-applied Shino type glaze over iron slip. 1989. *height 20.4cm (8in)*
Suzuki Osamu (Kura; b.1934)

pioneering work in the interwar years that led to Bizen being singled out among the six old kilns as meriting recognition under the system of Intangible Cultural Properties when it was established during the early 1950s.

Suzuki Osamu (b.1934), who made the tea ceremony fresh-water jar (PLATE 6), is a leading Mino-based artist specializing in Shino wares. Shino wares are distinguished by the use of a highly feldspathic, semi-translucent glaze on a whitish stoneware body, frequently in combination with the application of iron slip or underglaze iron painting. The technology of Shino wares was originally developed in Mino in the late sixteenth century. It was used primarily to produce imitations of imported Chinese porcelain, but it was also harnessed to the making of an important body of tea wares.

The discovery that Shino wares were made in Mino rather than Seto is a familiar episode in the history of modern Japanese ceramics.[14] It occurred in 1930 when Arakawa Toyozō (1894–1985), recognizing a similarity between the stilt mark on a Shino incense burner shown to him by a Nagoya art dealer and those he had seen on iron-glazed fragments excavated at the Ōhira kilns in Mino some years before, started to explore some of the other kiln sites in the area. His suspicions were confirmed when he found Shino shards at Mutabora in the village of Ōgaya. Arakawa, who had been running Kitaōji Rosanjin's (1883–1959) kiln in Kamakura since 1927,

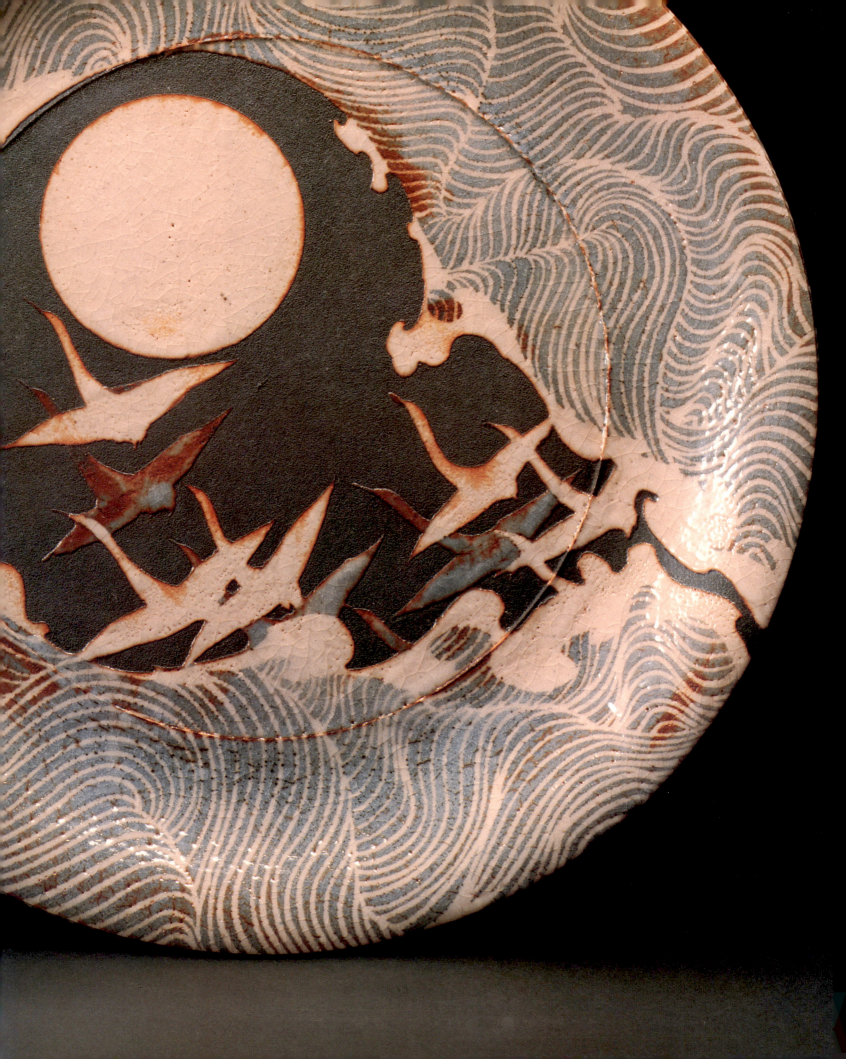

moved to Mino in 1933 and set up a workshop on the site of the old Mutabora kilns. He was a driving force behind the numerous kiln site excavations that were carried out in Mino over the following years. The reputation he established for his Yellow Seto, Black Seto and Shino wares led to his being appointed a Living National Treasure in 1955.[15]

The legacy of Arakawa's efforts has been such that there are now scores of Mino-based potters who make Momoyama tea ceramics the starting point for new work. Suzuki, who has been a member of the Japan Crafts Association since 1962, is one of the most successful of these many practitioners. As can be seen in the example of his work shown here, his forms have the dynamism of the best of Momoyama period prototypes without being imitative. He also has a formidable ability to manipulate his materials and firing methods to achieve very precise ends. This is the result of many years of experimentation conducted in a strictly scientific manner. Suzuki was appointed a Living National Treasure in 1994.

The dish (PLATE 7) by Wakao Toshisada (b.1932) is a further example of contemporary Shino ware by a leading Mino-based artist. A member of the Japan Crafts Association since 1970, Wakao has made a speciality out of so-called Grey Shino wares. Grey Shino wares were a relatively unusual product made at only a small number of Momoyama period kilns. The original technique involved the application of iron slip over a white stoneware body and the subsequent cutting away of areas of the slip coating to reveal the underlying clay. When covered in Shino glaze and fired, the revealed areas would show white and the areas coated in iron slip would show grey. Where the glaze was thin the grey tended towards red.

Wakao has developed this basic technique into a highly sophisticated form of resist decoration. His use of liquid latex as a resist material is crucial to his work, for it enables him to achieve an intricacy and clarity of line that would not be possible through more traditional means. The first step in the decoration of this particular dish involved the resisting out of the areas of white before the application of iron slip. Once the slip had dried, the latex was peeled away to expose the white clay below. Latex was then applied to those areas of iron slip across the centre of the dish that are unglazed in the final product. The dish was then glazed and the secondary application of latex resist was removed before firing. The sharpness with which the moon, the white geese and the white edges of the waves are set against the matt darkness of the iron slip is the result of the exact matching of the edges of the first and second applications of latex resist.

Although in technical terms Wakao's work makes reference to Momoyama period tea wares, his imagery derives from Japanese literary traditions celebrated in the work of artists and designers of the Rinpa school. The combination of motifs on this particular dish is suggestive of autumnal melancholy and a sense of impending loss and desolation. The Rinpa school developed in early seventeenth-century Kyoto under the patronage of wealthy merchants and members of the court aristocracy who were aggrieved by the political and economic strictures imposed on them by the military government of the time. Through the adoption of imagery drawn from the golden age of Heian period (794–1185) court culture, Rinpa artists created for

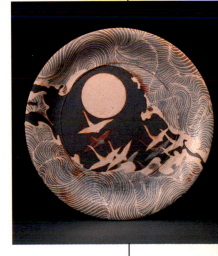

PLATE 7 *Above and opposite (detail)* Stoneware dish with resist-applied Shino type glaze over iron slip. 1989. *diameter 50.5cm (20in)* **Wakao Toshisada (b.1932)**

their patrons an artistic style that was radically and symbolically different from that promoted in official circles.[16]

The Rinpa style, the product of a moment in history when protest was expressed through the evocation of nostalgia for a bygone era, is notable for how it manifested itself not only in painting and calligraphy, but also in book design, textiles, lacquer and ceramics. While in the context of Kyoto ceramics it subsequently gave rise to wares such as those produced by the Kenzan workshop in the early eighteenth century, there is no evidence of any historical links between the Rinpa style and Mino ceramics. Understood in this light, Wakao's achievement may be seen as lying in his skilful and potent blending of two disparate but quintessentially Japanese artistic traditions.

The large bucket-shaped vessel (PLATE 8) by Takauchi Shūgō (b.1937) is an example of contemporary work inspired by Oribe wares, another important variety of Mino ceramics produced during the Momoyama period. Although it is uncertain whether the tea master Furuta Oribe was ever directly involved in overseeing their manufacture, the fact that Oribe wares bear his name is a measure of his influence in the early years of the seventeenth century when they replaced Shino wares as Mino's main form of high quality product. Oribe wares are typified by an experimental approach to form combined with a playful use of painted decoration. The most common variety, known as Green Oribe wares, had areas covered in copper green glaze juxtaposed against areas of white decorated in iron brown under a thin translucent glaze. The less common variety of so-called Monochrome Oribe wares, to which Takauchi's massively sculpted work illustrated here refers, were totally covered in copper green glaze and had no painted decoration.

Takauchi, who has contributed to the Traditional Crafts Exhibition since 1972, lives and works in Mashiko. His exploration of the Oribe aesthetic, one of several interests he has pursued during his career, is an unusual instance of an artist from one part of the country working in a style closely associated with another. In the early days of Japanese studio ceramics the eclectic approach of artists such as Kitaōji Rosanjin (1883–1959), who worked freely in a wide range of regional and historical styles, was relatively common. In recent years, however, regional styles have tended to become the preserve of local artists, who have not looked favourably on their adoption by outsiders. The emergence of figures such as Takauchi and Yoshida Yoshihiko (see above, PLATE 4) who ignore the barriers of regionalism is encouraging, especially when one considers that Takauchi's work is as powerful as anything in the Oribe style being produced in Mino today.

Given the discontinuities between contemporary works and their historical prototypes, all of the ceramics discussed so far are the products of what might be called re-created traditions. In this respect they differ from the teabowl (PLATE 9) by Raku Kichizaemon XV (b.1949). Born into a Kyoto family that has specialized in making tea ceremony wares since the time of Sen no Rikyū in the late sixteenth century, Raku succeeded to the family headship in 1981.[17] Before this he had studied in the Department of Sculpture at Tokyo University of Arts and had spent

PLATE 8 *Opposite* Stoneware vessel with Oribe type copper green glaze. 1992. *height 56.1cm (22in)*
Takauchi Shūgō (b.1937)

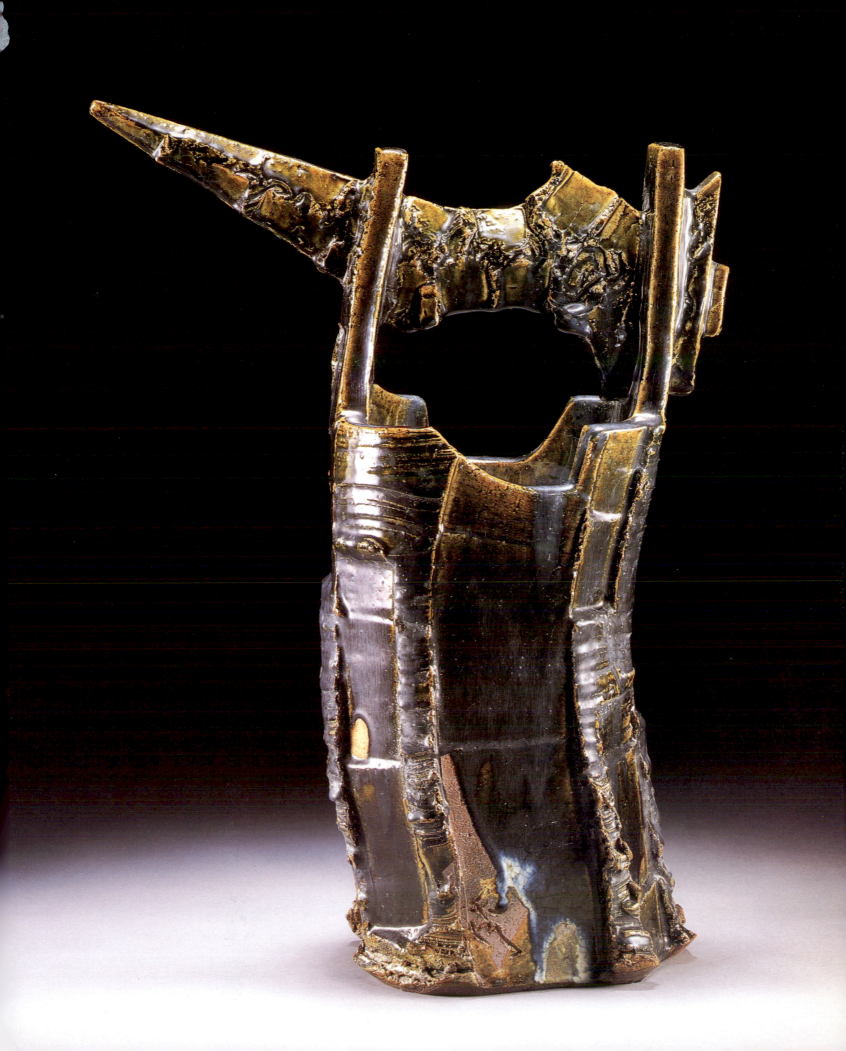

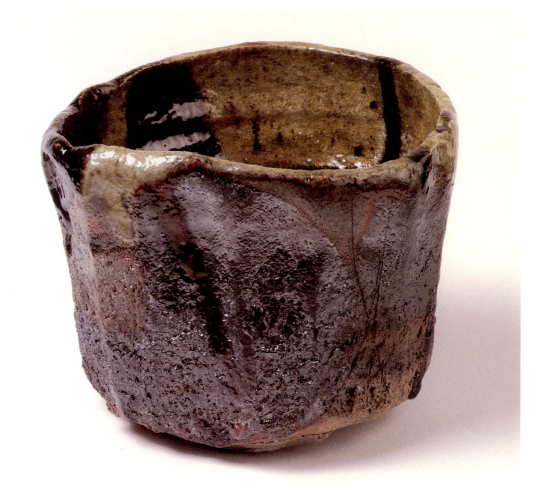

PLATE 9 Black Raku type stoneware teabowl with black and ash green glazes over applied copper leaf. 1992. *height 10.3cm (4in)*
Raku Kichizaemon XV (b.1949)

two years in Italy at the Accademia di Belle Arti di Roma. The challenge to which Raku has so masterfully risen has been to channel his creative ambitions into the making of teabowls, one of the most highly prescribed of vessel formats, by means of forming, glazing and firing methods that have been transmitted down the centuries from one generation of his family to the next.

The work shown here is a striking demonstration of how Raku manages to combine a highly individualistic approach to the exploration of colour, texture and form with the making, by traditional means, of functional items that meet the stringent requirements of the tea ceremony. The teabowl was modelled by hand (*tebineri*) from clay laid down, like fine wine, by his great-grandfather. The faceting on the walls extends, rather unusually for a teabowl, on to the foot. Although not obvious to the eye, this and the continuation of the scratched and pin-pricked patterning would immediately be felt by someone holding the teabowl to drink from it. The patches of intense metallic black result from copper foil having been placed on the clay surface before biscuit firing. The glazes were applied by brush in the traditional manner, the green glaze being derived from wood ash and the black glaze from locally occurring Kamogawa stone. The streaks and flecks of red are the product of areas of the copper reducing in the presence of the ash glaze during the main firing. In keeping with Raku family practice, firing was carried out in a

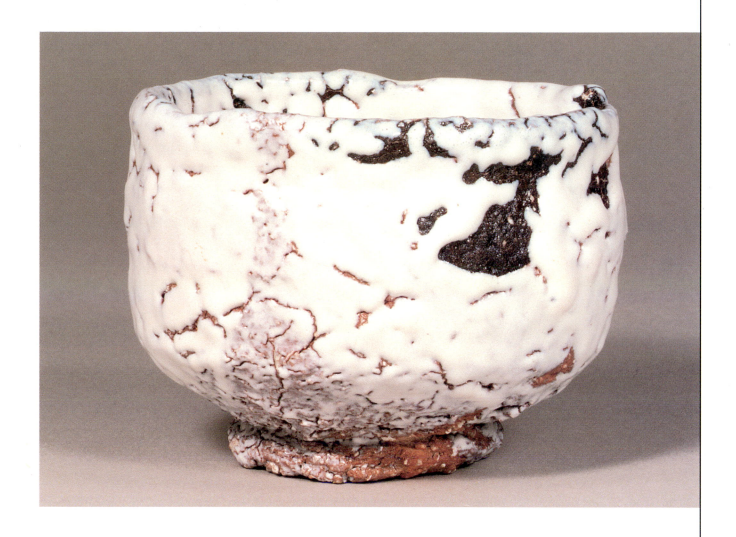

small charcoal-fuelled kiln. At a temperature of 1200°C (2190°F), when the glazes had matured and begun to flow, the teabowl was removed from the kiln with long-handled tongs and cooled instantaneously in the outside air. It is this particular aspect of the Japanese Raku tradition – the drawing of the ware from the kiln at the height of the firing – that lies at the heart of western Raku practice.

KOREAN CERAMIC TRADITIONS

THE RAKU FAMILY is only one of several Kyoto ceramic-making families with extended lineages, and workshops going back many generations can be found in most parts of the country. It is particularly in western Japan, however, that such families abound. The family of Miwa Kyūsetsu XI (b.1910), the artist responsible for the large teabowl with heavily crawled and fissured glaze (PLATE 10), is a typical example. His ancestors reputedly built their first workshop in Hagi in the extreme west of the main island of Honshū during the Kanbun era (1661–73).[18] The Miwa kiln formed part of a ceramic industry set up under the patronage of the powerful local Mōri family at the turn of the seventeenth century.

PLATE 10 Stoneware teabowl with partial covering of iron slip under Hagi-type glaze. 1988. *height 12.2cm (4¾in)* *Miwa Kyūsetsu XI (b.1910)*

Hagi was one of numerous kiln groups established in western Japan by Korean potters brought back in the aftermath of the failed attempts of Toyotomi Hideyoshi (1537–98) to invade Korea during the 1590s.[19] The subtle colours and spontaneous forms of many early stonewares from these kilns appealed strongly to a market governed by the aesthetics of the tea ceremony. Indeed it is frequently argued that one of the reasons so many kiln groups were set up in western Japan at this time was that widespread interest in the tea ceremony among military rulers led them to encourage the local production of wares similar to the imported Korean ceramics so avidly collected by tea devotees since the late Muromachi period. Through the late seventeenth and eighteenth centuries, however, Hagi wares, like their counterparts from other Japanese kilns patronized by the feudal élite, became increasingly mannered in style. Freedom of decoration and shape were no longer the desired qualities, taste having changed in favour of more highly finished products.

Despite the continuity of the family line since the Edo period, Miwa Kyūsetsu's work, which harks back to Hagi tea ceramics of the early seventeenth century, conforms to the pattern of re-created tradition above. The key figure in Hagi's classical revival was Miwa Kyūsetsu's elder brother, Miwa Kyūwa (1895–1981), who was appointed a Living National Treasure in 1970. The elevation of Kyūwa and then Kyūsetsu, who became a Living National Treasure in 1983, to the top of the Japan Crafts Association hierarchy has been part of Hagi's remarkable growth as a ceramics centre over the last thirty years. Formerly a quiet town on the Japan Sea coast, Hagi now has scores of potteries vying with each other in the production of softly glazed off-white stonewares. These are sold both locally and nationally, every level of the market being catered for. Hagi itself is full of shops selling modestly priced wares to satisfy the tens of thousands of tourists who visit the town each year. At the same time there are plenty of works by individual artists on which pottery enthusiasts and tea ceremony devotees can choose to spend more substantial sums of money. There have been ceramic booms in many parts of Japan, but rarely have they been so pronounced as in Hagi.

The revival of classical stonewares in Hagi and other western kilns such as Karatsu,[20] Takatori and Agano is only one manifestation, and a somewhat indirect one at that, of Japanese interest in Korean ceramic styles and techniques. It has been noted how direct reference to Korean stoneware prototypes is made by artists such as Shimaoka Tatsuzō and Yoshida Yoshihiko (see above, PLATES 2 and 4). In the case of the faceted jar (PLATE 11) by Takenaka Kō (b.1941) it is Korean porcelains of the Chosŏn period that are the source of inspiration.

Takenaka began his career in 1961 as an apprentice to Kondō Yūzō (1902–85; appointed Living National Treasure in 1977), a Kyoto-based artist famous for his powerful style of underglaze painting. He first contributed to the Traditional Crafts Exhibition in 1966 and four years later built his own workshop in Yamashina in the eastern outskirts of Kyoto. Takenaka's white porcelains are especially successful, their subtle textures and robust forms capturing the essence of their models in a most appealing way. The slight ridge that is visible around the middle of this jar indicates that it was thrown in two pieces. The faceting, which continues right

PLATE 11 *Opposite* Faceted porcelain jar with clear glaze. 1992. *height 38.6cm (15in)*
Takenaka Kō (b.1941)

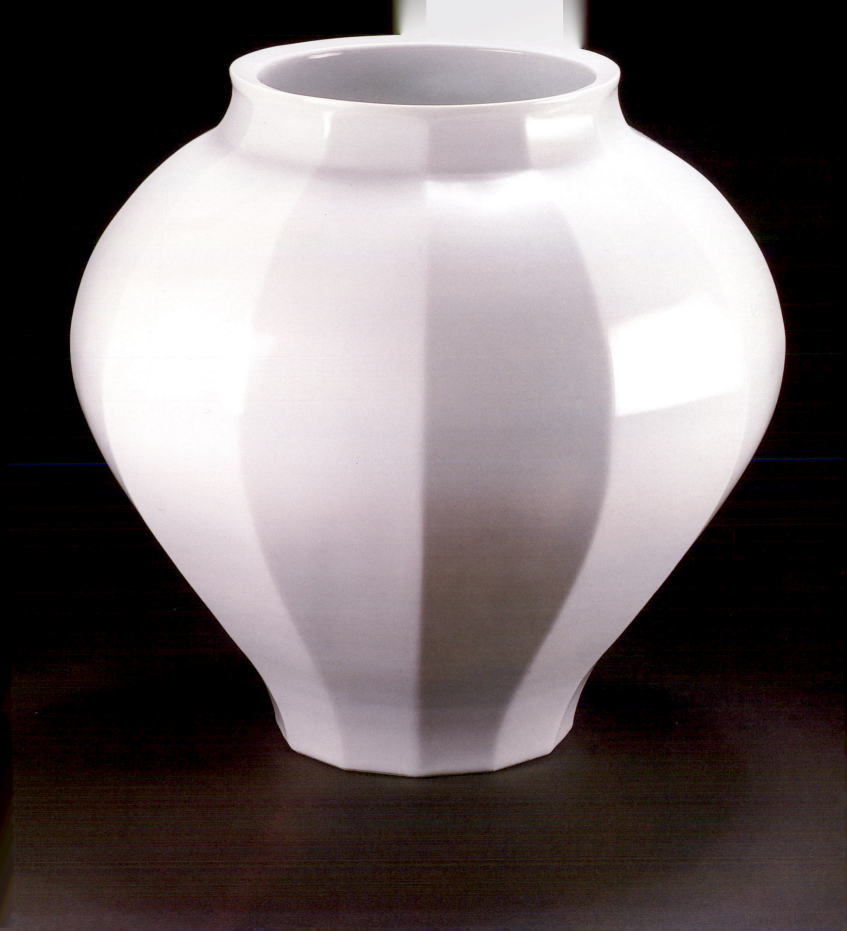

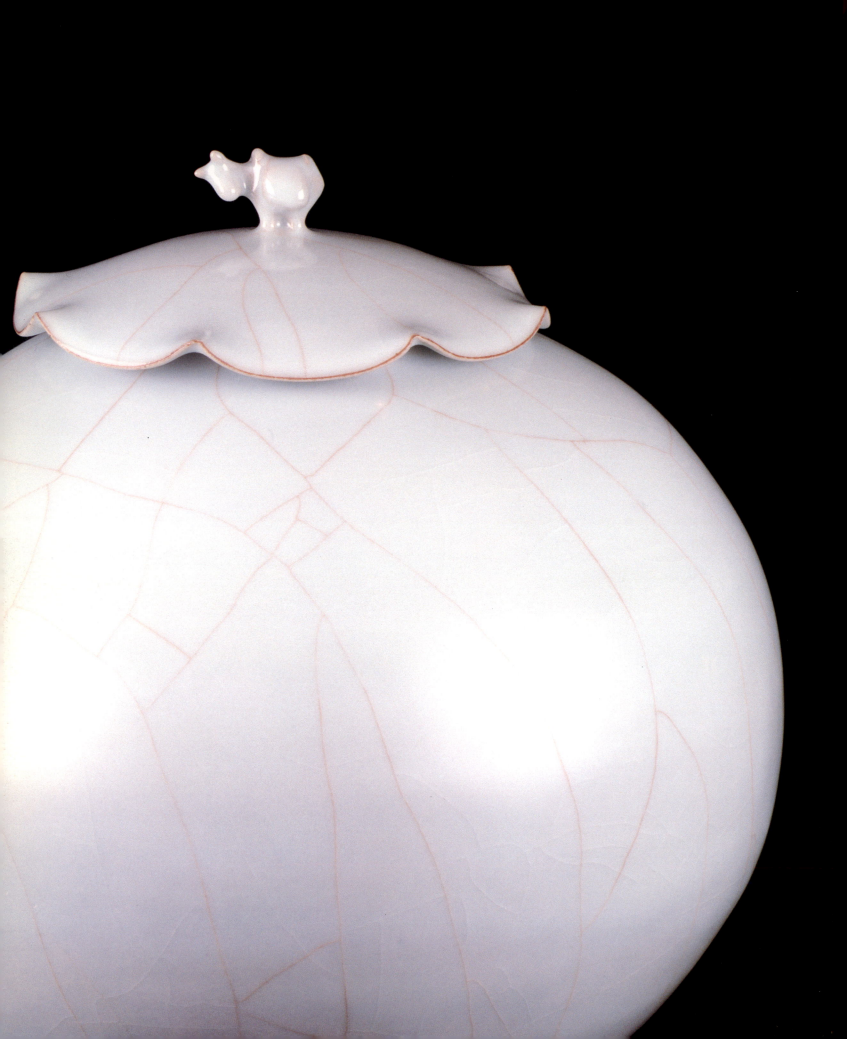

up to the mouth-rim, gives definition and interest to the generously proportioned form. The jar was raw-glazed and fired in an electric kiln. The reducing atmosphere needed to produce the faint blue tinge of the glaze was achieved by the introduction of pine wood during the latter part of the firing.

Japanese knowledge of Korean ceramics other than the various kinds of teabowl used in the tea ceremony from the sixteenth century onwards was initially gained during the period of Japan's annexation and occupation of Korea between 1910 and 1945. Systematic research by Japanese historians and archaeologists was accompanied by the building up of collections covering all periods of Korean ceramic history. One of the more important of these early collections was that formed by Yanagi Sōetsu (1889–1961) and now housed in the Japan Folk Crafts Museum in Tokyo.

As Bernard Leach observed in his introduction to *The Unknown Craftsman*, Yanagi's particular love for Chosŏn period porcelains had a great influence on the work of makers associated with the Japanese Folk Craft movement.[21] Tomimoto Kenkichi (1886–1963) is an important case in point. Although in time he distanced himself from Yanagi and is now best remembered for the lavish gold, silver and polychrome porcelains he produced during the last years of his life (and for which he was made a Living National Treasure in 1955), during the 1920s and 1930s he made a substantial number of both blue-and-white and plain white porcelains. Masterpieces of understatement, Tomimoto's interpretations of the Korean porcelain tradition have been a major source of inspiration for subsequent artists working in the idiom.

CHINESE CERAMIC TRADITIONS

THE INTEREST IN KOREAN CERAMICS shown by Japanese artists today is largely due to the enthusiasms of the founding members of the Japanese Folk Craft movement. It is notable, for example, that although many makers now working in Korean ceramic styles have no formal connections with the Folk Craft movement, their output conforms closely to Yanagi's canon of taste.

The situation with modern Japanese ceramics in Chinese styles is more complicated. Broadly speaking there have been two areas of activity. The first is work based on early Chinese ceramics, mainly those of the Song (960–1279) and Yuan (1279–1368) periods. The second is work based on decorated porcelain styles of the Ming (1368–1644) and Qing (1644–1911) periods. In both cases artists have had access to historical sources existing within Japan, either actual Chinese ceramics or Japanese interpretations thereof, and to new material emerging from archaeological and historical research conducted in China and elsewhere since the early part of this century.

The lidded jar (PLATE 12) by Miura Koheiji (b.1933) is a prime example of contemporary Japanese work based on Song period celadon originals. The bluish-green glaze and widely spaced brown crackle make direct reference to so-called *guan* (official) wares. These were made in the

PLATE 12 *Above and opposite (detail)* Stoneware jar and cover with crackled celadon glaze. 1985. *height 27.7cm (11in)* **Miura Koheiji (b.1933)**

39

vicinity of Hangzhou in Zhejiang Province to the order of the Chinese imperial court during the Southern Song period (1128–1279).[22] The globular shape of the jar is an ideal vehicle for the softly textured glaze, while the fluted rim of the lid accentuates and draws attention to its thickly unctuous quality. Miura's work is rarely without a touch of playfulness – in this case the donkey-shaped knob which is based on sketches made during one of his numerous trips to Central and South Asia. He fires in an electric kiln into which pine wood is introduced to create the necessary reducing atmosphere.

Miura is justly regarded as one of Japan's leading makers of celadon wares. He first contributed to the Traditional Crafts Exhibition in 1966 and has been Professor of Ceramics at Tokyo University of Arts since 1990. He caters to an aspect of Japanese taste that has its origins in the Kamakura and Muromachi periods. Along with iron-glazed stonewares and white porcelains, celadons were shipped to Japan in large quantities and avidly consumed by the medieval élite. The scale on which they were imported is reflected in the enormous number of Japanese consumer sites from which they have been excavated in recent years.[23]

The current interest shown by Japanese makers in exploring early Chinese ceramic styles goes back to the first decades of this century, when the excavating and looting of Chinese archaeological sites brought to light an extraordinary variety of ceramic types that had been largely forgotten over the centuries. Just as these caught the imagination of western connoisseurs – notably George Eumorfopolous and his fellow founders of the Oriental Ceramic Society in London – they became the focus of intense study among Japanese scholars and collectors. For artists disenchanted with the legacy of Meiji period (1868–1912) export ceramics, they were a source of inspiration as fresh and exciting as the Korean ceramics and Japanese tea wares to which their eyes were similarly opened during the interwar years.

The large jar with contrasting areas of white and metallic black glazes (PLATE 13) is by Shimizu Uichi (b.1926), a leading Kyoto-based artist who has been a member of the Japan Crafts Association since 1958. Shimizu was appointed a Living National Treasure in 1985, thereby achieving equality with his former teacher and mentor Ishiguro Munemaro (1893–1968; appointed Living National Treasure in 1955), Japan's most celebrated exponent of early Chinese ceramic styles.

Shimizu's career has been marked by a series of important technical and artistic breakthroughs, most notably in the fields of celadon and iron-glazed wares. The sturdy potting for which he has always been known has assumed a particular confidence in recent years. This is evident in the ample form and boldly thrown mouth-rim of the jar illustrated here. The juxtaposition of white and black glazes is an interest that, although explored with relative restraint on this piece, has been the starting point for the series of expressionistic exercises in which Shimizu is currently engaged.

Celadon and iron-glazed wares are by no means the only kinds of early Chinese ceramic prototype on which Japanese makers base their work. White porcelain wares in more highly finished Chinese as opposed to looser Korean style, for example, are also quite prevalent among

PLATE 13 Stoneware jar with overlapping white and *tenmoku* glazes. 1990. *height 32cm (12½in)*
Shimizu Uichi (b.1926)

contemporary Japanese ceramics.[24] Celadon and iron-glazed wares are, however, the most important. The legacy of medieval Japanese taste in tea wares has undoubtedly been a factor in this. Between the thirteenth and fifteenth centuries, before the development of the *wabi*-style tea ceremony, the most highly prized types of tea ceramics were either green or brown glazed wares from southern China. Many of these have been handed down in collections of tea utensils and, being extensively published and regularly included in exhibitions and museum displays, are well known to contemporary makers and their public.

Historical documents show that Chinese *tenmoku* teabowls from the Jian kilns in Fujian Province were highly favoured during the medieval period and were subject to a detailed system of categorization and ranking. It is not insignificant that Ishiguro's decision to begin working with Chinese-style glazes was inspired by his encounter with the 'Inaba' *tenmoku* teabowl.[25] This was in 1927, nine years after it made the headlines when auctioned at the Tokyo Arts Club (*Tokyo Bijutsu Club*) for a record sum of money.[26] Now in the collection of the Seikadō Library in Tokyo, this teabowl, with its extraordinary iridescent coloration, is one of the great wonders of Song period ceramics. Just as importantly, being of a type specifically recorded in early documents as the rarest and most valuable of all classes of *tenmoku* teabowl, it is also the supreme manifestation of medieval Japanese taste in Chinese ceramics.

In focusing on celadons and iron-glazed wares, contemporary Japanese makers are not simply reaffirming historical Japanese preference for certain kinds of Chinese ceramics. They are also invoking a sense of pride in their own culture and the sophistication it has shown in appreciating classical forms of Chinese ceramics since long before they were known about in the West and, in the case of *tenmoku* teabowls, for long after they had been forgotten about in China. As with contemporary work inspired by Korean teabowls first collected by early devotees of the *wabi*-style tea ceremony, a process of appropriation has taken place, the Japanese laying claim to non-indigenous ceramic traditions on the basis of historical consumption of the products of those traditions.

The ewer (PLATE 14) by Kawase Chikushun (b.1923) is an example of contemporary Japanese work inspired by decorated porcelain styles of Ming and Qing period China. The technique used is a particularly demanding one that involves the filling in with enamel colours of an outline previously executed in underglaze blue. Known in Chinese as *doucai* ('dove-tailing colours'), the technique was perfected during the Chenghua era (1465–87) of the Ming period and used, most notably, in the making of so-called 'chicken cups'.[27] Although *doucai* wares have been among the most highly collectable of ceramic types in China from the late Ming period onwards, they were not known about in Japan until this century.

Kawase follows in the footsteps of his father, Kawase Chikuō (1894–1983), in his time one of Japan's most talented makers of Chinese-style blue-and-white porcelain. His son, Kawase Shinobu (b.1950), is well known for his work in the style of Southern Song period celadons. The Kawase family have lived in Ōiso near Yokohama since 1949. Before this they were based in Kyoto, where Chikuō trained with Miura Chikusen III (1900–90), a leading maker of Chinese-style ceramics with well-established links to the world of steeped tea (*sencha*) drinking.

The practice of drinking steeped tea dates from not later than the middle of the seventeenth century. From the outset there was a close connection between steeped tea drinking and the development of Japanese interest in Chinese literati culture.[28] In the late eighteenth century it reached a height of popularity among intellectuals, artists and connoisseurs, especially those living in Kyoto. They saw it as a radical alternative to the tea ceremony, which had become so formalized that it offered little scope for relaxation or creativity.

While literati ideals of informality and unaffectedness were maintained in the context of so-called scholar's tea (*bunjincha*), the early nineteenth century saw a growth of interest in steeped tea drinking among ordinary townspeople accompanied by a process of codification similar to that undergone by the tea ceremony earlier in the Edo period. As in the tea ceremony, various schools sprang up, each with its own set of rules and procedures. One of the most influential of these schools of what the literati disparagingly referred to as commoner's tea (*zokujincha*) was the Ogawa school, founded by Ogawa Kashin (1786–1855). The ceremonialized forms of steeped tea drinking championed by Ogawa and others increased in popularity during the nineteenth century and are still practised in Japan today. Scholar's tea, on the other hand, had largely declined by the middle of the nineteenth century.

Plate 14 *Opposite* Porcelain ewer with *doucai* (dove-tailing colour) style decoration in underglaze blue and overglaze enamels. 1985. *height 25.8cm (10¼in)*

Kawase Chikushun (b.1923)

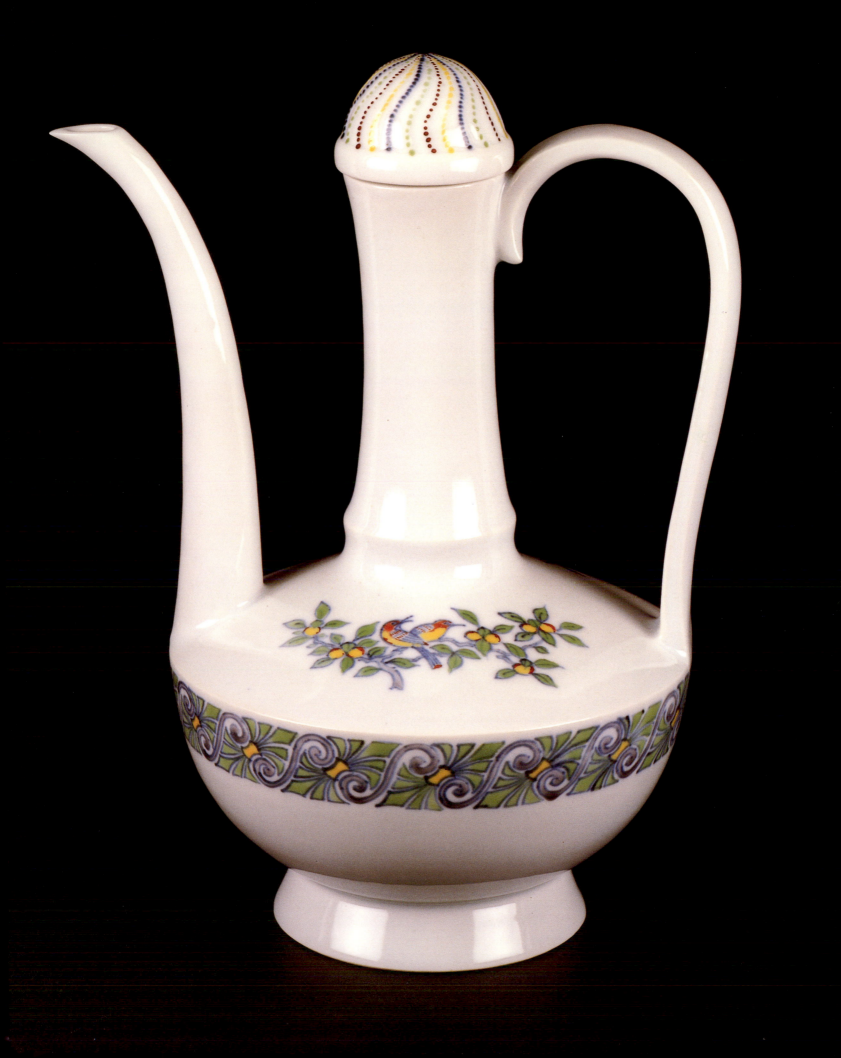

In the early days of steeped tea drinking the demand for suitable utensils was met by imports from China. From the late eighteenth century onwards, however, demand became so great that Japanese substitutes had to be found. In Kyoto, the main centre for steeped tea drinking, this had a major impact on the local ceramics industry.[29] In addition to the tea ceremony and other high quality ceramics in earthenware and stoneware that had long been the mainstay of Kyoto's various potteries, a rich diversity of porcelains decorated in Chinese styles began to appear. While technical and stylistic interpenetration between tea ceremony and steeped tea drinking utensils rapidly ensued – many of the leading figures in early nineteenth-century Kyoto produced both kinds of utensils in stoneware, earthenware and porcelain – the link between *sencha* and decorated porcelains in Chinese styles remained close. It is to this relatively recent and unbroken tradition that Kawase Chikushun, via his father and Miura Chikusen III, is heir.

Japanese Porcelain Traditions

KYOTO'S RISE AS A MAJOR PORCELAIN PRODUCING CENTRE in the early nineteenth century was paralleled by the emergence of numerous other porcelain industries, both large and small, in different parts of Japan. This marked the end of an era in which porcelain manufacture had been largely dominated by kilns in and around Arita on the western island of Kyūshū. Japanese porcelain was first produced in Arita in the early years of the seventeenth century, mainly in the form of blue-and-white wares aimed at the domestic market. The middle of the seventeenth century saw the introduction of overglaze enamelling techniques together with the beginning of the manufacture of porcelains for export to Europe.[30] This was shortly followed by the emergence of the key decorative styles by which Arita porcelains are best known today.

The growth of local interest in the richness of Arita's past and the more general development of scholarly research into Japanese ceramic history have led, as in other parts of Japan, to a revival of former styles and techniques. The two main focuses of concern have been Kakiemon wares and Nabeshima wares. Kakiemon wares reached a peak of sophistication during the Genroku era (1688–1704), the finest examples being decorated in soft enamel colours over a milky white body. They were the most valued among export porcelains and were widely imitated during the eighteenth century at factories in Holland, France, Germany and England.[31]

If Kakiemon wares were the ultimate in Arita export products, Nabeshima wares were the finest among porcelains for domestic consumption. They were made as presentation pieces for the Nabeshima family, the military rulers of the Arita area, and developed into a mature form during the late seventeenth and early eighteenth centuries.[32] The majority of surviving Nabeshima wares are round dishes decorated in a combination of underglaze blue and overglaze enamels. The quality of potting and decoration is typically very high.

The large octagonal dish with stylized chrysanthemum design (PLATE 15) is by Imaizumi Imaemon XIII (b.1926), the present head of an important Arita family employed during the Edo

PLATE 15 *Above and opposite (detail)* Octagonal porcelain dish with Nabeshima-style decoration in underglaze blue and overglaze enamels. c.1980. *diameter 41.2cm (16in)*
Imaizumi Imaemon XIII (b.1926)

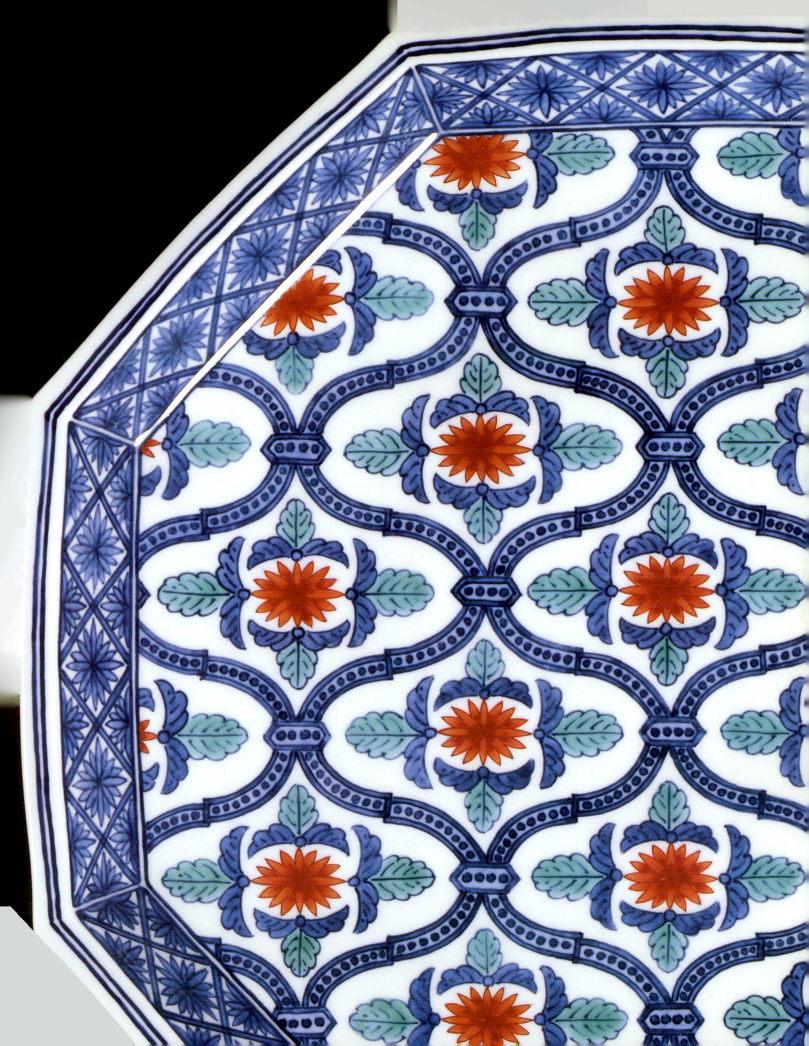

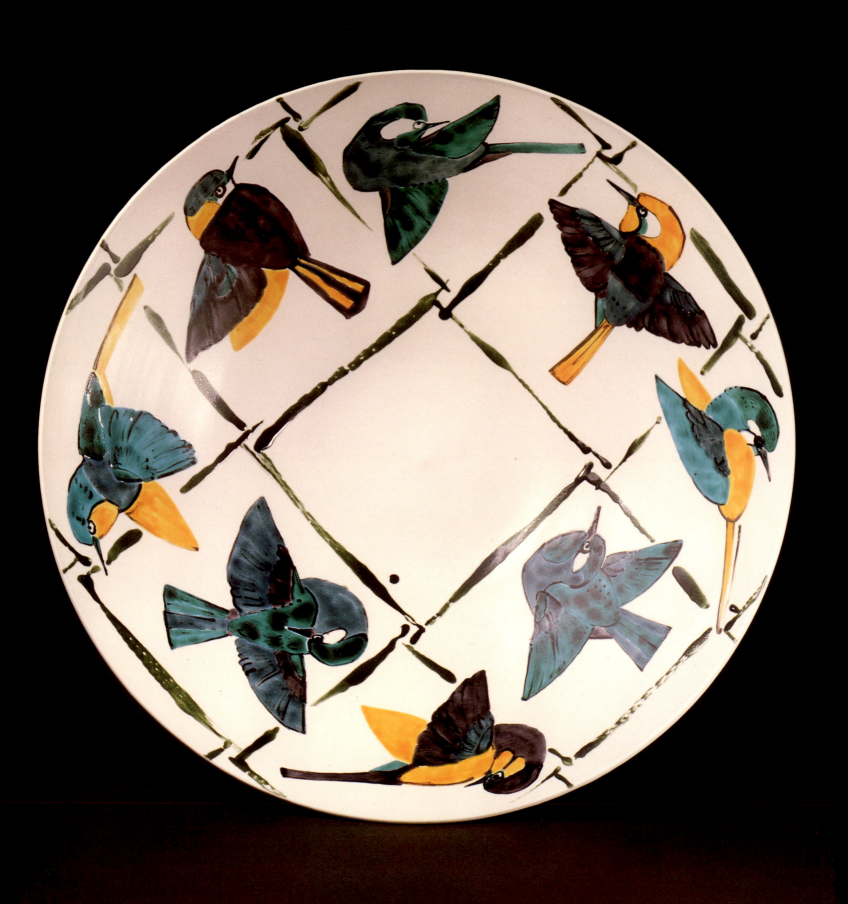

period as the official decorators of Nabeshima wares. During the postwar period the Imaizumi family has become increasingly involved with the preservation of historical Nabeshima styles and techniques. In 1971 the ambitions of Imaizumi Imaemon XII (1897–1975) were realized when the Society for the Preservation of Enamelled Nabeshima Techniques (*Iro-Nabeshima Gijutsu Hozonkai*) was established and designated as Group Holder of the title of Important Intangible Cultural Property. On the death of his father in 1975, Imaemon XIII succeeded to the family headship and to the chairmanship of the preservation society.[33]

If Imaemon XII was responsible for preserving the Nabeshima tradition, Imaemon XIII may be credited with the introduction of artistic and technical innovations that have taken it forward into the late twentieth century. The dish illustrated here combines classical Nabeshima features, such as the precise shading of the underglaze blue and the particular hue of the turquoise enamel, with a shape and patterning whose geometric formality has been inspired by Islamic models. Imaemon XIII's achievements were rewarded in 1989 when he was made a Living National Treasure. This was a personal appointment over and above his position as chairman of the preservation society.

The large dish with bird and lattice design in Kutani-style overglaze enamels (PLATE 16) is by Hasegawa Sojin (b.1935), a Kanazawa-based artist who has been a member of the Japan Crafts Association since 1974. The palette of rich yellow, green, blue and aubergine is characteristic of a distinctive type of seventeenth-century Japanese porcelain which was the model for one of the numerous varieties of ware produced at the Kutani kilns in southern Ishikawa Prefecture during the nineteenth century. While it is now believed that the earlier wares were actually made in Arita, the traditional view – hence the term Old Kutani wares[34] – was that they were made in Kutani. The strength of feeling behind regionalist claims to the Old Kutani tradition is reflected in the enormous amounts spent by the local government in building up the impressive collection of seventeenth century wares in the Ishikawa Prefectural Museum of Art.

If the Old Kutani style has been the basis for extensive commercial exploitation by local ceramic manufacturers, it has also been the starting point for new work by individual artists in the Kanazawa and Kutani areas. In this respect Hasegawa is heir to interests pursued during the prewar years by leading figures such as Kitade Tōjirō (1898–1968) and Tokuda Yasokichi I (1873–1957).[35] His contribution to this legacy lies in his powerful sense of design and, more particularly, in his boldly calligraphic approach to enamel painting. This is especially apparent in the execution of the lattice pattern within which the more solidly depicted birds are disposed.

New Decorative Styles

ALL THE WORKS EXAMINED SO FAR make purposeful reference to clearly identifiable regional and historical ceramic styles. Contemporary Japan also has many artists making functional works recognizably but more loosely based on traditional models and others

PLATE 16 *Opposite* Porcelain dish with Kutani style decoration in overglaze enamels. 1980. *diameter 45.2cm (17¾in)* **Hasegawa Sojin (b.1935)**

who have developed their own innovative modes of expression. The use of one technique or a combination of techniques in the pursuit of decorative effect is a common feature of many of these works. Underglaze and overglaze painting are the most frequently employed methods, but there are numerous others besides.

A key factor behind the growth of ceramics in what are broadly categorized here as new decorative styles has been the large increase in the teaching of ceramics at art colleges during the last thirty years. This has allowed individuals from established ceramic-making families to gain exposure to a much greater range of artistic influences than they would have experienced through traditional methods of training. It has also, more importantly, meant that anybody with the inclination and aptitude to do so has been able to obtain sufficient knowledge and experience to become a professional maker. Just as many leading figures in the early decades of this century were from families with no prior involvement in ceramic making, many of Japan's best contemporary practitioners have benefited from not being weighed down by the baggage of family or regional precedent.

This being said, the tendency for teachers not only to accept student imitation of their own work but actively to encourage it has led to the proliferation of clutches of artists producing similar-looking works in styles immediately recognizable as the products of particular art colleges. What has happened is that a succession of new 'mini-traditions' has sprung up, each growing out of the oeuvre of one of a relatively small number of influential makers. This has taken place in the context of both the Japan Crafts Association and the *Nitten* group, the latter's hierarchical structure having been especially conducive to this kind of development.

The phenomenon has been particularly marked at Tokyo University of Arts, the Ceramics Section of which has remained unswervingly allied to the Japan Crafts Association since being set up in 1963 under the headship of Katō Hajime (1900–68; appointed Living National Treasure in 1961). Katō's main achievements lay in the field of decorated porcelains in Chinese Ming period styles. His emphasis on painted decoration has been characteristic of the work of many of his successors. Even Miura Koheiji (see above, PLATE 12), renowned though he is for the purity and elegance of his celadon wares, uses overglaze enamel decoration on some of his work.

The lidded box depicting a kingfisher by a stream (PLATE 17) is by Fujimoto Yoshimichi (1919–92), formerly Professor of Ceramics and then President of Tokyo University of Arts. The design is based on sketches made on the banks of the river that flows past the Fujimoto family home just outside Tokyo. Stylistically it is rooted firmly in the world of traditional Japanese bird and flower painting (kachōga). The box dates from the last of several transitional periods in Fujimoto's career when he moved away from a realistic but relatively formal mode of painting in clear enamel colours to the much more expressive style of his last years.[36]A student of both Tomimoto Kenkichi (1886–1963) and Katō Hajime, Fujimoto was made a Living National Treasure in 1986 for his work in decorated porcelain. One of his greatest contributions was the development of enamel colours that could be applied one on top of the other to give an effect similar to painting in watercolours. The sophistication of this technology is reflected in the

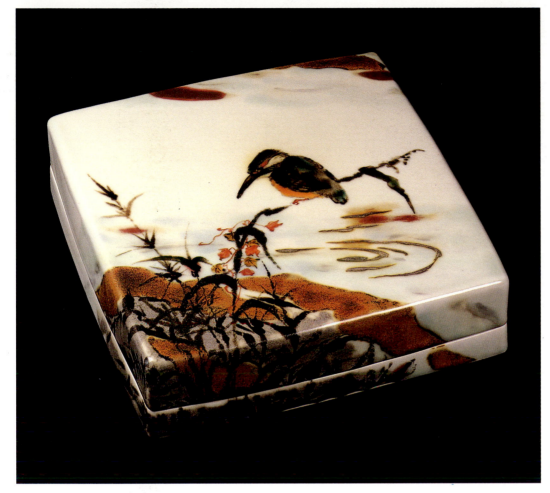

PLATE 17 Porcelain box with under-
glaze and overglaze decoration. 1983.
*width 26.7cm (10½in); depth 26.4cm (10¼in);
height 7.4cm (3in)*
Fujimoto Yoshimichi (1919–92)

treatment of the kingfisher, with a similarly painterly approach to the use of underglaze pigments being evident in the depiction of the flowing stream.

The jar with marbleized floral patterning (PLATE 18) is by Matsui Kōsei (b.1927), a Kasama-based artist who has the unusual distinction of having combined his career as a ceramist with that of being a Buddhist priest. The technique of marbleizing (*neriage*) originated in Tang period (618–906) China and was used extensively at the Cizhou kilns in Hebei Province during the Song period.[37] There is little history of its use in Japan until the twentieth century, when artists such as Kawai Kanjirō (1890–1966) began to experiment with it. Matsui's interests, inspired primarily by Cizhou ware models, developed during the 1960s.[38] He was encouraged to specialize in the technique by Tamura Kōichi (1918–87; appointed Living National Treasure in 1986) of Tokyo University of Arts, with whom he studied in the late 1960s.

Over the last twenty-five years Matsui has made a series of remarkable innovations using a rich palette of often vibrantly coloured clays. The work shown here is relatively restrained in its use of shades of blue, grey and cream, and the regularly disposed floral patterning is intricate without being overwhelming. Its smooth surface is more reminiscent of its historical prototypes than the rich textures of the works he produced until the mid-1980s. Matsui was made a Living National Treasure in 1993.

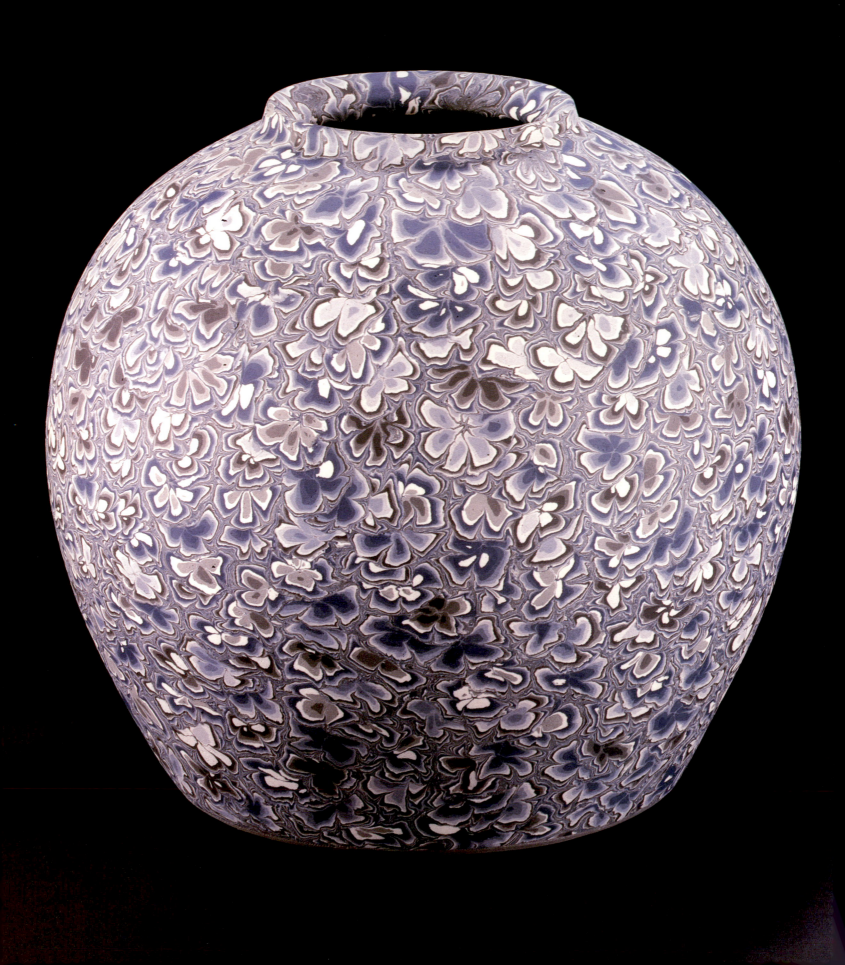

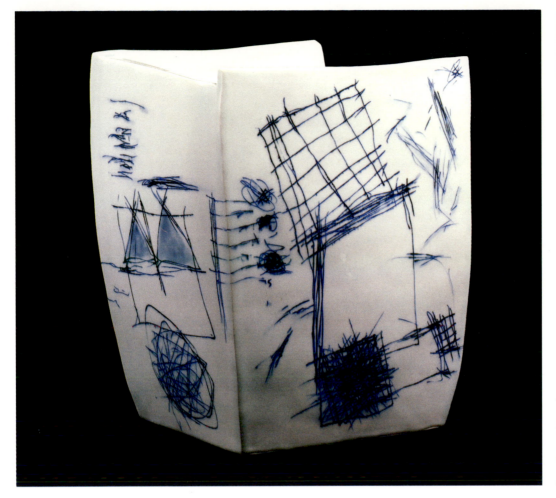

PLATE 19 Porcelain vase with incised decoration filled with underglaze blue. 1989. *height 36.8cm (14½in)* **Yoshikawa Masamichi (b.1946)**

Fujimoto and Matsui are prime examples of contemporary ceramists who make recognizable but generalized reference to traditional models. Fujimoto's work is distinguished by his choice of subject matter and style of painting, Matsui's by his choice of technique. The elevation of these two artists to the top of the Japan Crafts Association hierarchy was in honour of their dedication to the pursuit of artistic and technical innovation within the realm of traditional practice.

Yoshikawa Masamichi (b.1946), the Tokoname-based maker of the porcelain vase decorated in underglaze blue (PLATE 19), is an artist with rather different ambitions. Unlike subscribers to the Japan Crafts Association, for whom the establishment of a reputation outside Japan may be a bonus but is rarely a concern, Yoshikawa has always operated in a more international context. While he still maintains the interest in ceramic sculpture he originally pursued under the tutelage of Sugie Junpei (b.1936) in the late 1960s,[39] his energies have increasingly turned towards the making of functional ceramics. He is especially interested in the ways in which utensils interact with one another when used in combination and how they relate to their contents. This has led him not only to exhibit jointly with makers working in other media, but also to collaborate with specialist chefs in the staging of carefully orchestrated 'food and tableware' performances.

Given Yoshikawa's interests it is not surprising that he should point to early seventeenth-century Oribe wares, the ultimate in recherché tablewares of their time, as an important source of

PLATE 18 *Opposite* Stoneware jar with marbleized (*neriage*) patterning. 1988. *height 28.1cm (11in)* **Matsui Kōsei (b.1927)**

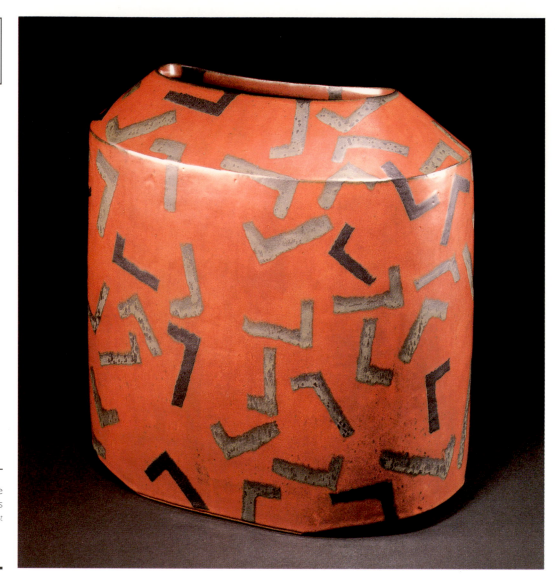

PLATE 20 'Dancing Crowd.' Stoneware vase with resist-applied glaze motifs over an iron red ground. 1985. *height 36.7cm (14½in)*
Morino Taimei (b.1934)

inspiration. This should be understood less in terms of the specifics of technology and style than in terms of the underlying freedom of spirit that imbues his loosely formed shapes and playfully abstracted designs. The liveliness of Yoshikawa's decoration belies the painstaking technique by which it is achieved. This involves inlaying different shades of cobalt blue into lines that have been scratched into the unfired clay surface. The use of needles and lengths of piano wire on porcelain that has been allowed to dry out to a precisely determined degree gives rise to the ragged quality of line that so effectively enhances the etching-like nature of the compositions.

The vase entitled 'Dancing Crowd' (PLATE 20) is by Morino Taimei (b.1934), a leading Kyoto-based artist who has built up an enviable reputation for his meticulously crafted exercises in form and colour. It was hand built with great precision from pale stoneware clay, the geometry of the flattened cylindrical form being relieved by the large, oval mouth, which rises gently from the centre and is set slightly askew across the width of the vase. The interior and exterior are covered in a thick red glaze which shows black where it breaks at the shoulder and mouth-rim. Over this

PLATE 21 Stoneware vase with resist surface patterning. 1969. *height 28.5cm (11¼in)*
Kamoda Shōji (1933-83)

are scattered the dancing L-shaped motifs from which the work derives its title. These were applied by means of a resist technique and vary in colour from greenish-grey to bluish-black.

While Morino's vessels are imbued with an elegance and sophistication that one might associate with traditional Kyoto culture, his interest in abstraction and the vocabulary of symbols he uses are the products of his exposure to modern western art. This was initially gained during two periods of teaching at the University of Chicago in 1962–3 and 1966–8. Since his return to Kyoto he has been a regular contributor to exhibitions in Japan, Europe, Australia and North America. He has been a leading figure in the *Nitten* group, his first submission to the *Nitten* exhibition having been made as early as 1957 when he was still a student of ceramics at Kyoto City University of Arts.

Kamoda Shōji (1933–83), the maker of the faceted stoneware vase (PLATE 21), was senior to Morino by two years at Kyoto City University of Arts. They both studied under Tomimoto Kenkichi, who had been in charge of the ceramics course since its establishment in 1950, and

have been described as joint heirs to the mantle of great designer that he left.[40] Kamoda's early death from leukaemia deprived Japan of one of its most talented artists of recent decades. Starting in 1970, by which time he had moved his workshop from Mashiko to Tōno in the extreme northeast of the main island of Honshū, he produced a remarkable group of highly organic forms which he used as vehicles for a constantly evolving series of colourful surface designs.

In contrast to Morino, who in his vessel forms concentrates on how glazes work together in combination, Kamoda's interest lay more in the clay body itself and in its relationship to the decorative elements inlaid into or applied over it. The vase shown here dates from 1969.[41] It belongs to a seminal period between his abandonment of the making of works inspired by early Japanese stonewares of the Nara (710–94) and Heian periods such as he had submitted to the Traditional Crafts Exhibition between 1961 and 1966 and his adoption of polychrome decoration. His decision to move on from his earlier style, highly acclaimed though it was, culminated in his withdrawal from the Japan Crafts Association in 1968.[42]

Kamoda's hunger for new materials led to his visit to Tōno and his discovery there of the clay used in local factories for the manufacture of roof-tiles. Highly plastic, rich in iron and full of particles of silica, Kamoda was to use this clay in its unrefined state for the rest of his career. Its roughness was a key factor in his decision to change from wheel-throwing to hand-building.[43] Like the vase shown here, most of the works he produced during this transitional period were in faceted forms. He pursued his growing interest in surface decoration in the most subtle of ways, in this case through the use of a resist technique to give added definition to the polyhedral structure. He abandoned his wood-fired tunnel kiln in favour of an oil-fired kiln to give himself greater control over temperature, rate of firing and the reducing atmosphere he favoured. The tension in his works of this period lies not only in their forms. It also derives from the contradiction inherent in his pursuit of primitivism through the application of precise technical means. It was Kamoda's continuing anxiety in the face of this dilemma, coupled with the fear that his work would become mannered, that drove him to change his style of ceramics with such dizzying speed during the last years of his life.[44]

THE VESSEL AND BEYOND: NEW POSSIBILITIES IN CLAYWORKING

THE CERAMICS DISCUSSED IN THE PREVIOUS SECTION are characterized by their emphasis on decorative effect. The non-traditional works of Yoshikawa, Morino and Kamoda also demonstrate a degree of experimentation with form. For other artists the manipulation of the vessel structure itself is the primary focus of concern. Alternative possibilities of an even more radical nature are being explored by artists who create non-vessel abstract works.

Highly sensitive to the potential of the vessel form, Kuriki Tatsusuke (b.1943) is an artist who has pursued his aims with techniques of ever-increasing refinement. Born into a traditional

PLATE 22 *Opposite* 'Wind Image II.' Stoneware with resist-applied slip decoration and thin silver glaze. 1987. *height 85cm (33½in)*
Kuriki Tatsusuke (b.1943)

ceramic-making family in Seto, he developed his interest in ceramic sculpture as a student at Kyoto City University of Arts, from which he graduated in 1966 and to which he returned to teach in 1984. During the last ten years his work has revolved around two main themes. In his silver and green series he explores the use of wide interlacing bands of silver on round, slightly asymmetrical forms. In his silver and red series he examines the cylinder as a fundamental shape. It is to the latter series that the work shown here (PLATE 22) belongs.

Starting from a round base, the front slopes inwards to a line a quarter of the way up the height of the vessel. Above this level the shape is that of a gradually tapering aileron. The sharpness of the right-hand edge is accentuated by the gently curving profile of the overall form. The surface pattern has been worked out with extreme care, each element of the resist design having been precisely positioned with the aid of a paper stencil. The application of iron-bearing slip followed by a thin layer of silvery glaze gives the work its subdued but distinctive coloration. The trunk-like shape and leaf-like patterning of this and other works in Kuriki's silver and red series may be read on one level as a straightforward expression of his fascination with the natural world. More profoundly, however, they are a reflection of his interest in the processes of creation and the evolution of forms in relation to the nature of their materials.

If Kuriki's sculpture is impressive for the serenity of its form and the lyricism of its decorative scheme, Yanagihara Mutsuo's (b.1934) work is striking for its blend of dynamism, colour and wit. A leading figure among Kyoto artists, Yanagihara has taught at Osaka University of Arts since 1968. The piece shown here (PLATE 23) was hand-built from off-white stoneware clay and consists of a wide, swelling foot supporting a tall, flattened cylinder capped by a thickly lipped mouth-rim.

Yanagihara's application of brightly coloured abstract motifs to vessel forms with anatomical, sometimes sexually explicit features – a combination with which he first experimented in the late 1960s and early 1970s[45] – has been a characteristic of his work for the past fifteen years. As in the case of Morino Taimei (see above, PLATE 20), a close friend and exact contemporary at Kyoto City University of Arts in the late 1950s, Yanagihara has been considerably influenced by the experiences he gained during two periods of teaching in the United States in 1966–8 and 1972–4. His use of gold and silver – a wry comment, he has explained, on the decaying values of contemporary society and the corruption of Japan's political system – echoes the extravagant style of certain North American artists.

The work of Yanagihara and others shows how the use of hand-building techniques has allowed them to explore the potential of the vessel format to much more diverse effect than is possible with wheel-throwing, the staple forming method of the majority of artists working in traditional styles. For Takiguchi Kazuo (b.1953), the young Kyoto-based maker of the large stoneware vessel (PLATE 24), the development of a personal sculptural idiom has been closely associated with the pioneering of a particular method of hand-building.

The technique involves preparing a large sheet of extremely thin clay that is then folded and joined in a dynamic sequence of movements into a structure immediately resembling that of the

PLATE 23 *Above and opposite (detail)* 'Laughing Mouth Vessel' or 'Vessel with Golden Cosmic Pattern.' Stoneware decorated with gold lustre over blue and yellow glazes. 1985. *height 48.8cm (19¼in)*
Yanagihara Mutsuo (b.1934)

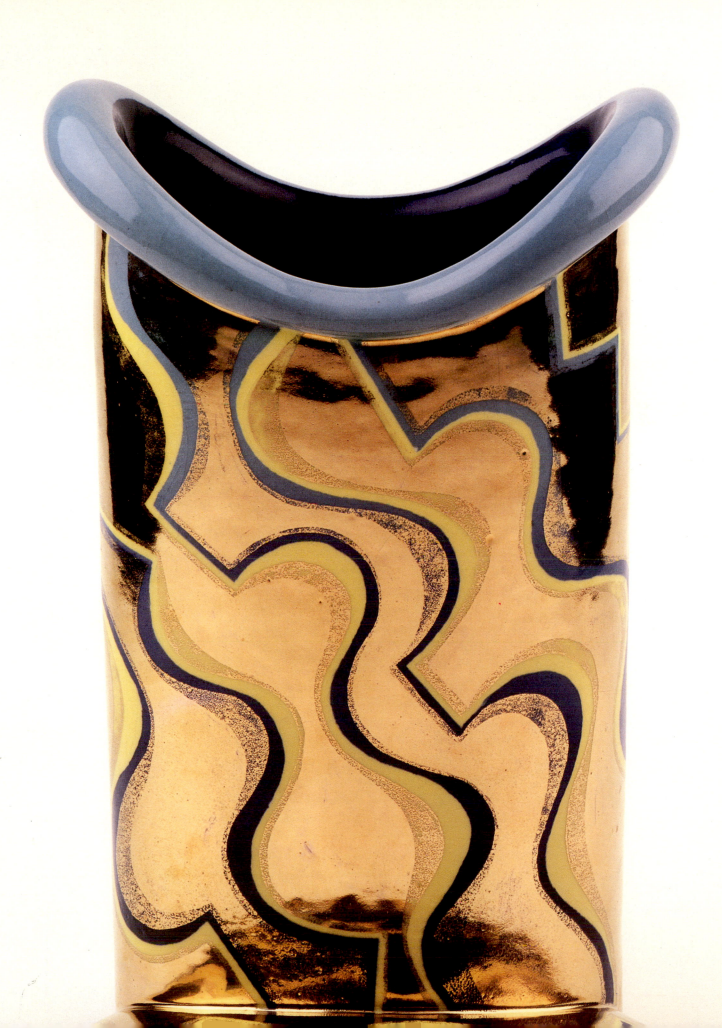

PLATE 24 Stoneware vessel with powdery green glaze. 1988. *width 78cm (30¾in)*
Takiguchi Kazuo (b.1953)

intended final form. In the mid-1980s, when Takiguchi first used the technique, he lifted the clay up from the floor. Because this limited him to rather box-like shapes he went on to develop a way of draping the clay over moulds made from loosely assembled components and making his forms upside down. The new method allowed him to achieve the greater sense of fullness that he sought. At the same time the possibility of rearranging the components of the moulds allowed him to experiment with a much wider range of shapes than before. Having made a basic form, Takiguchi uses a number of secondary techniques to give it definition and character. These include pushing the walls out from the inside, compressing them from the outside, and cutting and joining, sometimes with the addition or removal of segments of clay.

The piece shown here was made in 1988, the year Takiguchi began making his forms upside down, and relates closely to a series of works exhibited at the Kuroda Tōen Gallery in Tokyo in early 1989. While he has since gone on to experiment with many new shapes, the juxtaposition of rounded and protruding elements and the generation of tension through the use of arching forms are features common to much of his subsequent work.

Takiguchi's exploration of formal issues of shape, colour and texture through the making of individual works has been accompanied by his growing interest in the relationship between his sculptures and the surroundings in which they are displayed. When he is preparing for an

exhibition he begins by making an exhaustive study of the venue using sketches, photographs and videos. It is only then that he starts to make any work. He develops his forms with the aim of creating an environment in which sculptures and surroundings are integrated into a single whole. The nature of a given series of work is determined by the process of planning for a particular exhibition and the total installation, usually incorporating an arrangement of props especially prepared for the occasion, is presented as an artistic statement in its own right.

Although Takiguchi has not yet embarked on making fully fledged multimedia sculptures, his installations have become increasingly elaborate in recent years.[46] That he should have used a period of study at the Royal College of Art in London in 1991–2 to arm himself with a range of metalworking and glassworking skills suggests that this could be the direction in which his work will ultimately develop.

Takiguchi's propensity towards 'installing' spaces is typical of the approach of many artists of his generation working in ceramics and other media. Widespread interest in environmental art has been a key factor in this. There has also been the need for artists, particularly those working in large formats, to meet the challenge posed by the majority of Japanese galleries of having to work in cramped and restricted spaces.

The potent blend of aestheticism and technical sophistication seen in Takiguchi's vessel forms is also found in the work of Fukami Sueharu (b.1947), the maker of the tall blade-like porcelain sculpture (PLATE 25). Fukami's achievement lies in his mastery not so much of hand-building techniques as of slip-casting in large plaster moulds. Consisting of components as heavy as can be moved about the workshop, these moulds can weigh 150–200kg (330–440lb) when assembled. They are used to produce limited editions, not usually exceeding eight casts, from an original hand-modelled ceramic form. Liquid porcelain is forced into the moulds under high pressure, compaction of the clay particles preventing the warping that would otherwise occur during firing. Once a cast is dry enough to be removed from its moulds, scrapers and other implements are used to smooth and sharpen it into final form. Firing is carried out, one piece at a time in the case of large works such as the one illustrated here, in an electric kiln. The reducing atmosphere needed to produce the pale blue colour of the glaze is achieved by the burning of liquid propane gas during the latter part of the gloss firing.

Fukami, like Takiguchi, was born into an established Kyoto pottery making family specializing in high quality tablewares. This is reflected in the elegant wheel-thrown vessels he produces in parallel with his slip-cast sculptural works. Fashioned from porcelain covered in pale blue glaze, they make indirect but unmistakable reference to the sharply potted forms of Chinese Song period *qingbai* wares from the Jingdezhen kilns in Jiangxi Province.

The use of plaster moulds is also a characteristic of the recent work (PLATE 26) of Yamada Hikaru (b.1924), an important Kyoto-based artist who is well known as one of the founding fathers of Japan's avant-garde ceramics movement. While Fukami slip-casts in moulds in order to produce large-scale porcelain forms that do not warp during firing, Yamada's current interest lies in the effects that can be achieved by flattening damp clay on to roughly textured sheets of

PLATE 26 'Wall.' Stoneware with silvery glaze. 1988. *height 31.3cm (12¼in)*
Yamada Hikaru (b.1924)

plaster. These are made by pouring liquid plaster into ceramic moulds that have themselves been produced by means of pressing clay on to sheets of styrofoam into which patterns have been shallowly incised. The final work is thus the product of multiple transpositions, via clay and plaster, of the surface of an original sheet of carved styrofoam. Yamada uses a layering technique to build up the thickness of his sculptures and fires them unglazed to about 1250°C (2280°F). They are then painted over with either a black or, as in the case of the piece shown here, a silvery colourant, which is fused on during a second, lower temperature firing.

Although Yamada began exploring this particular method of surface detailing only in the late 1980s, his use of upright planar forms with titles such as 'Monument', 'Window', 'Screen' and 'Wall' has been a consistent feature of his work since the mid-1960s.[47] His concern with non- or anti-traditional ceramics dates back to the immediate postwar period, when he and a number of young Kyoto-based artists formed the Ceramic Group of Youth (*Seinen Sakutōka Shūdan*) in 1946.[48] Railing against the conservatism of the established ceramic-making community, he and

PLATE 25 *Opposite* Blade-shaped sculpture of porcelain with pale blue glaze. 1988. *height (including base) 1.30m (4ft 3in)*
Fukami Sueharu (b.1947)

his associates boldly declared their intention 'to pay more attention to social trends at home and abroad and to promote a new beginning based on a deeper social consciousness'.[49] Although internal disagreements soon led to the disbanding of the group, some of its key members, among them Yamada, Yagi Kazuo (1918–79) and Suzuki Osamu (see below, PLATE 29), went on to form a new group, the *Sōdeisha*, in the summer of 1948[50].

The *Shikōkai*, which Hayashi Yasuo (b.1928) helped to found in 1947, was another Kyoto-based group born out of the desire among young ceramists to find new modes of expression relevant to the changed circumstances of the postwar era. Although this group was relatively short lived and had lost most of its members by the time Hayashi resigned in 1957, it played an important role in encouraging the development of avant-garde ceramics during the period when members of the *Sōdeisha* were struggling to find a direction for their work[51]. Yagi Kazuo's seminal 'The Walk of Mr Zamza' was shown in 1954, settling the issue of if and when to close the neck of the vase and paving the way for the *Sōdeisha*'s subsequent fostering of abstract sculptural ceramics during the critical years of the late 1950s and early 1960s.[52] Hayashi, by comparison, began exhibiting non-vessel ceramic forms in 1948.[53]

Hayashi was also involved in the *Shikōkai*'s imaginative sponsoring of an exhibition in 1950 of ceramic sculptures by Isamu Noguchi (1904–88). The primitivism of Noguchi's works shown in this and another exhibition held in 1952 at the newly opened Kanagawa Prefectural Museum of Modern Art in Kamakura struck a deep chord among young Japanese makers.[54] It encouraged them to look to prehistoric Japanese ceramics as a parallel source of inspiration to the avant-garde works of influential European figures such as Picasso, Brancusi, Ernst, Miró and Klee.

The example of Hayashi's work shown here (PLATE 27) is of a type with which he began experimenting in the early 1980s. It was hand-built with the aid of a mould from slightly open-textured stoneware clay before being totally covered in black slip. A series of operations involving the masking out of areas of the slip covering and the spraying on of glaze by air-gun was then used to build up the illusionistic surface patterning. While this particular piece consists of an upright half-cylinder sitting on a flat elliptical base, most of Hayashi's recent sculptures are more severely angular in form.[55] In all cases, however, they are remarkable for the way in which real and suggested depth are used to produce complex, often multi-layered, three-dimensional structures.

The use of geometric shapes is also a characteristic of the oeuvre of Miyanaga Rikichi (b.1935), another Kyoto-based artist with a well-established reputation for his sculptural ceramics (PLATE 28). Like Hayashi, he plans his work carefully in advance and leaves very little to chance. His concern for abstraction and coolness of effect has determined his choice of porcelain as a working medium. Any harshness of appearance is moderated, however, by the glazes and colourants he uses. The gradated tones of underglaze cobalt blue, which he began to use in the late 1980s, for example, considerably soften the geometry of his forms. More recently even the forms themselves have become less severe in their precision.

PLATE 27 *Opposite* Stoneware sculpture with black slip and resist-applied clear glaze. 1988. *height 34.7cm (13¾in)*
Hayashi Yasuo (b.1928)

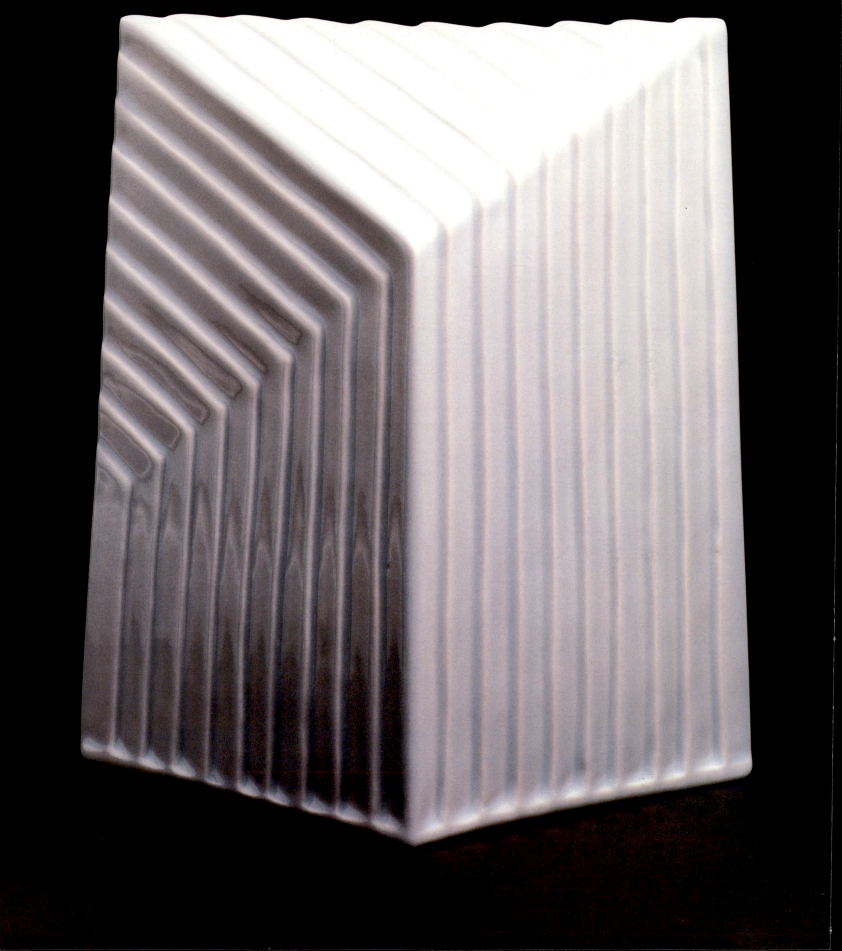

The piece shown here, one of a group of twenty works Miyanaga made for an exhibition that toured Australia in 1987–9, has a pale blue glaze evocative of Chinese Song period *qingbai* wares.[56] The illustration shows the front of a heptagonal form, all but the two narrow side panels of which have been carved with low-relief ridges. The sculpture may be viewed from any angle, but it is only when seen as shown here that the front so clearly appears to consist of four rather than three actual panels. This is the result of the way in which the ridges, which run in parallel from right to left, have been made to meet at a line on the left-hand panel so as to form a shape mirroring that of the triangular top.

Miyanaga belongs to what is sometimes described as the 'second generation' of avant-garde Japanese ceramists.[57] The term is used to refer to artists who established themselves during the late 1960s and 1970s, building on the achievements of the 'first generation' members of the *Sōdeisha*, the *Shikōkai* and the Modern Art Association (*Modern Art Kyōkai*) to bring Japan's avant-garde ceramics movement to maturity. The last of these, the Modern Art Association, was set up in 1950 with sections devoted to painting and sculpture. Photography and crafts sections were added in 1954.[58]

The late 1950s and early 1960s were a formative period which saw the intermingling of a diversity of internal and external influences and concerns. Exposure to modern and contemporary European art was coupled, as has been seen, with an increasing interest in primitive art, especially prehistoric Japanese ceramics. There was also a growing awareness of Abstract Expressionism and other avant-garde movements in the United States. While Japanese ceramic sculptures from the second half of the 1950s were often little more than Cubist constructions executed in clay, the problem of finding shapes and methods of treatment sympathetic to, and in keeping with, the intrinsic qualities of the medium began to be resolved during the early 1960s.[59]

Comments by critics writing at the time suggest that 1957 was the year in which the *Sōdeisha* first came to be seen as a serious union of talented makers rather than just a band of anti-traditionalist rebels.[60] National recognition of its importance came in 1959 when works by its members were given pride of place in a section devoted to avant-garde ceramics at an exhibition of contemporary Japanese ceramics held at the Tokyo National Museum of Modern Art. Works by *Sōdeisha* members were equally prominent at a similar exhibition held at the Kyoto National Museum of Modern Art in 1963.

Although Japanese artists travelled abroad and showed their work in overseas exhibitions with increasing frequency from the early 1950s onwards, the internationalization of Japan's ceramics world did not get fully under way until the second half of the 1960s. The turning point came with a travelling exhibition organized by the Tokyo National Museum of Modern Art at the time of the Tokyo Olympics in 1964.[61] In addition to ceramics by over a hundred Japanese makers, the exhibition included works by over ninety artists from nineteen other countries. It was the first major international ceramics event ever to be held in Japan, and its effect was to shatter Japan's complacency about the superiority of its contemporary ceramics and to stir

PLATE 28 *Opposite* 'Temple Roof.' Porcelain with pale blue glaze. 1987. *height 27.7cm (10¾in)* *Miyanaga Rikichi (b.1935)*

Japanese makers of all persuasions into examining their activities within a much broader context than that to which they had been accustomed. The vitality of American West Coast ceramics struck critics and artists with particular force, but considerable interest was also shown in the work of French and Italian makers.

Further international ceramics exhibitions were held at the Kyoto National Museum of Modern Art in 1970 and 1971. The first featured contemporary work from Japan and Europe. The second, which was also shown in Tokyo, focused on work from Japan, Canada, the United States and Mexico. Another important event of this period was the 'Thinking Touching Drinking Cup International Exhibition' which opened in Kanazawa in 1973.[62]

The process of internationalization that took place during the late 1960s and early 1970s was an integral part of the coming of age of Japan's avant-garde ceramics movement marked, as we have noted, by the emergence of its second generation of makers. Many of these younger artists were included in an exhibition entitled 'The New Generation of Contemporary Ceramics' (Gendai Tōgei no Shinsedaiten), which was organized by the Kyoto National Museum of Modern Art in 1968. A significant feature of this exhibition was the fact that the participants were selected from all over Japan and, in contrast to the exhibitions of 1959 and 1963, without regard to group affiliation.

The attempt at objectivity made by the organizers of the 1968 exhibition served as an important precedent when the Mainichi Newspaper Company established its biennial Japan Ceramic Art Exhibition (Nihon Tōgeiten) in 1971. As we have seen, this was set up as a nationwide competition open to artists from all parts of the country. Equally important was the decision that it should be judged solely by critics, academics and museum curators. Artists were excluded from the judging panel because of worries about the potentially distorting effects of group and regional factionalism.[63]

By providing a forum in which artists can compete regardless of which group, if any, they may be affiliated to, the Mainichi exhibition has been instrumental in weakening the one-time stranglehold of the Nitten and its related organizations on the one hand and the Japan Crafts Association on the other. Through its inclusion of a section specifically entitled 'avant-garde' (zen'ei), it has also given unequivocal support to artists working in sculptural modes. Until recently most experimental makers have had to supplement their incomes by teaching at schools or art colleges and producing functional ceramics of a more readily accessible nature. Now, however, the market for sculptural ceramics has developed considerably and public interest in such works is widespread.

In addition to the solo or group shows that most artists hold on a regular basis in galleries and department stores, the last fifteen years have seen a remarkable succession of museum exhibitions partially or totally devoted to sculptural ceramics.[64] If the rapid proliferation of new museums and the pressures they are under to stage innovative exhibitions have been factors in this, there is no question about the underlying direction that curatorial, critical and public interest has been taking. Ironically the effect of the economic pressures that resulted in larger

numbers of Japan's first and second generation avant-garde artists going into teaching than might otherwise have done so has been that relatively few students graduating from art colleges through the 1980s and 1990s have emerged as makers of traditional ceramics. Tokyo University of Arts continues to be a leading bastion of conservatism, but even there the winds of change are beginning to blow.

PRIMITIVISM, BLACK FIRE AND THE WORKINGS OF TIME

AMONG THE NUMEROUS MUSEUM EXHIBITIONS just referred to, the 1990 inaugural exhibition of the Museum of Contemporary Ceramic Art in Shigaraki was one of the most notable.[65] Inspired by the exhibition ' "Primitivism" in Twentieth Century Art' held at the Museum of Modern Art in New York in 1984, it sought to reveal the influence that prehistoric Japanese ceramics have had on Japanese makers of the postwar era. Although the links suggested were in some instances somewhat tenuous, the exhibition's demonstration of the extent to which postwar makers, particularly those involved in sculptural ceramics, have been indebted to early Japanese earthenwares was very striking.

Suzuki Osamu (b.1926), the Kyoto-based maker of 'Cloud Image' (PLATE 29), is widely known in Japan and abroad for the monumental quality and minimalist purity of his sculptural forms. His interest in primitive art initially manifested itself in the early 1960s in a series of works distantly based on Jōmon period ceramic figurines with titles such as earthen figure (*dogū*) and clay image (*deizō*).[66] His mature style developed in the late 1960s when he made the first of his famous horses modelled after *haniwa* tomb figurines of the Tumulus period (258–646).[67] The work shown here belongs to a period in the early 1980s when he was experimenting with themes such as wind, clouds and sun.

Although Suzuki also works in porcelain, he is chiefly known for his warmly coloured stoneware forms. The combination of Shigaraki clay, iron-bearing slip and ash glaze fired in an oxidizing atmosphere is a formula that he has used consistently since the mid-1960s. The severely geometric composition of this particular piece, the symmetry of which is emphasized by the clear delineation of its central axis, is softened in a manner typical of Suzuki's work by the irregular tooling of the clay surface.

Suzuki's importance in the world of contemporary Japanese ceramics has been considerable. It has been seen that along with Yagi Kazuo and Yamada Hikaru (see above, PLATE 26) he was a founding member of the *Sōdeisha* and has been at the forefront of Japan's avant-garde ceramics movement since its earliest days. Following Yagi's premature death in 1979 he took over the teaching of ceramics at Kyoto City University of Arts. He taught there until his retirement in 1992, when he assumed the title of Professor Emeritus. As with other figures of his standing, he has participated in a large number of exhibitions in Japan and abroad, and has been the recipient of numerous domestic and international prizes.

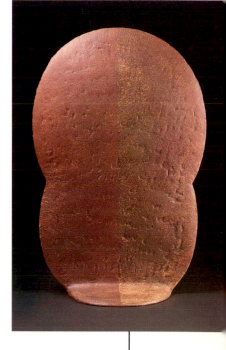

PLATE 29 'Cloud Image.' Stoneware with iron slip and ash glaze. 1981. *height 57.4cm (22½in)*. See also page 16. *Suzuki Osamu (Ji; b.1926)*

Suzuki's sculptures derive their power from the references they make to the ritual practices of our ancestors and the elemental forces of nature. The works of Katō Kiyoyuki (b.1931), although different in formal terms from Suzuki's, evoke comparable feelings of awe and wonder at man's primitive past (PLATE 30). Born as the heir to a long-established tile-making business in Seto, Katō studied ceramics at high school. His main interest lay in painting and sculpture, however, and it was only when he was in his late twenties that he began to work in ceramics. He made his first submission to the *Nitten* exhibition in 1958.[68] Having set out with an interest in producing well-designed utilitarian ceramics in keeping with the principles of the then newly established Japan Craft Design Association, he soon turned his hand to the making of sculptural ceramics. Katō's development as a ceramic sculptor owed much to his friendship with Teshigahara Sōfu (1900–79), the former head of the Sōgetsu school of flower-arranging.[69] Rather as avant-garde tendencies in the world of flower-arranging led Hayashi Yasuo (see above, PLATE 27) and other members of the *Shikōkai* to produce so-called '"objet" flower vases' in the late 1940s and 1950s,[70] Teshigara's experimental interests encouraged Katō to explore his sculptural ambitions in vessel as well as non-vessel formats.

While Katō has also worked in porcelain since the early 1980s, the bulk of his oeuvre has been executed in iron-rich stoneware clay from Echizen. As in the example shown here, metallic oxides and ash glaze are applied in a seemingly spontaneous but in reality quite controlled manner involving the use of an air-gun. Reduction firing is carried out in a gas kiln. Although he is extremely fluent on the wheel and is similarly accomplished at coil-building, Katō's greatest talent lies in his facility as a slab-builder. It can be seen how the piece illustrated was constructed from numerous sheets of clay which were scratched, pricked, perforated and torn to produce a complex and richly textured structure. The tall finned shape is reminiscent of Yayoi period bronze bells known as *dōtaku*, the forms and primitive decoration of which have long been sources of inspiration for Katō and other artists. The inclusion of internal partitions and panels reflects a parallel interest in ruined buildings and similarly evocative remnants of human civilization.

Katō's sculptures, like Suzuki's, are typical of the kinds of solutions found by many of Japan's first- and second-generation avant-garde artists in meeting what they felt to be the central challenge of devising modes of expression appropriate to the ceramic medium. They are, first of all, highly tactile objects whose formal qualities can be achieved only through the use of ceramic materials and processes. Second, by referring to man's prehistoric past and the early origins of clayworking, these and works like them make a fundamental equation between 'earth', nature and human experience.

The black earthenware sculpture by the Kyoto-based Hoshino Satoru (b.1945) (PLATE 31) explores these connections in a particularly compelling way. A representative work from a series he began in 1989, the indistinct form emerging from a large mass of clay is suggestive of the first stirrings of life on earth and, more specifically, of the potentiality of human engagement with clay. Coupled with these feelings of latent power is a sense of immediate energy which comes

PLATE 30 *Opposite* Stoneware sculpture with metallic oxides and ash glaze. 1980. *height 64.2cm (25¼in)*
Katō Kiyoyuki (b.1931)

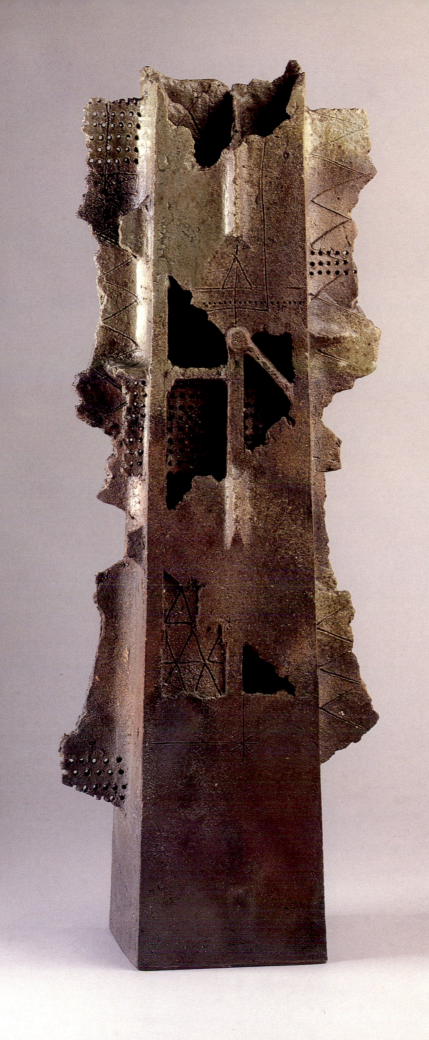

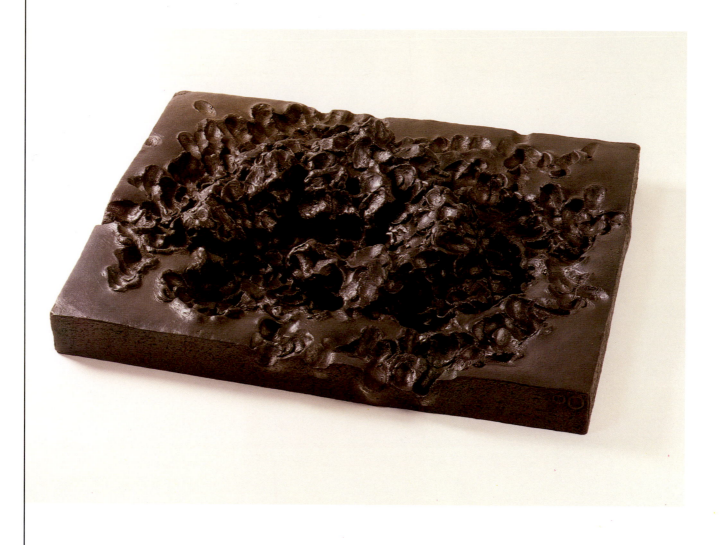

PLATE 31 Sculpture, 'Appeared Figure'
series. Carbon-impregnated earthen-
ware. 1991. *width 74cm (29¼in)*
Hoshino Satoru (b.1945)

from the way in which the sculpture is composed entirely of the thrusting marks of the artist's fingers working at the clay. It is a form of action painting executed in ceramics that both points to and draws upon the symbolic significance of clay as a creative medium.

The intensity of Hoshino's work is enhanced by his use of 'Black Fire' (*kokutō*, literally 'black ceramics'). This technique, which involves burning large amounts of carbonizing material in an earthenware firing, was originally pioneered by Yagi Kazuo in the early 1960s.[71] He developed it in reaction to the reliance on, and taste for, chance and accident, a pervasive feature of Japanese ceramic culture against which he campaigned with a mixture of fascination and abhorrence throughout his career.[72] Black Fire is now used by large numbers of makers and is one of the mainstays of Japanese avant-garde ceramics. Its attraction lies both in its evocation of the ceramic technologies of pre-industrialized societies and in the manner – so important to Yagi – in which it allows artists to give direct and uncompromised expression to their formal sculptural intentions. The potentially obfuscating effects of glazes are avoided, as are the inevitable structural movements and colour changes that take place during high-temperature firings. Shapes modelled out of clay can be rendered without distortion into permanent ceramic forms, their blackness giving them an added monumentality at the same time as being a negation of decoration and colour.

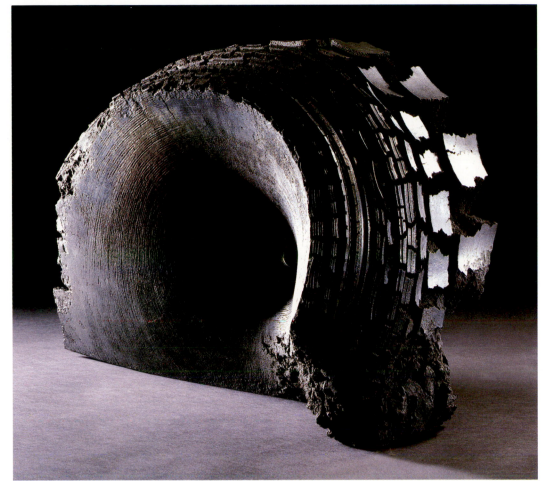

PLATE 32 'Geological Age V.' Carbon-impregnated earthenware. 1992. *width 94cm (37in)*
Akiyama Yō (b.1953)

Hoshino fires in an electric kiln and uses pine needles for the especially lustrous blackening effect they give. His interest in Black Fire developed during his period of involvement with the *Sōdeisha* from 1973 to 1980 and first manifested itself in a mature form in his 'Surface–Depth' series of 1978–81.[73]

Hoshino's concern with the primordiality of clay and clayworking and his interest in geological structures and their embodiment of the passage of time are also found in the work of Akiyama Yō (b.1953). Akiyama is a leading 'third generation' artist who currently teaches at his *alma mater*, Kyoto City University of Arts, where he mastered the techniques of Black Fire as a student of Yagi Kazuo in the mid-1970s. Since 1985 he has won a series of prestigious prizes in Japan and abroad for his striking large-scale sculptures with characteristically cracked and fissured surfaces.

Leaving aside his remarkable ability to wield enormously heavy structures of great fragility, the particular quality of Akiyama's work derives from his use of a blow-torch to cause unfired clay to split and break apart at controlled intervals. In the case of the piece shown here (PLATE 32), he began by preparing a number of flat clay rings of different thicknesses and diameters. These were then blow-torched and the broken sections of each ring reversed so that the inner surface appeared on the outside as a series of concave curves separated by regularly spaced

fissures. Reconstituted in this manner, the rings were stacked and modelled into a large, wedge-shaped form, the interior of which was then filled with two opposing cones of clay meeting at a small central hole. The precise turning of the inner surfaces contrasts with the ragged fracturing of the sculpture's exterior and gives emphasis to the work's rotational dynamism. Extensive polishing adds to the drama of the form.

Akiyama's use of rings of carbon-impregnated clay to create densely stratified compositions is a relatively recent development, his work of the mid- to late 1980s being characterized by the use of large and usually flatter expanses of black with cracked rather than deeply fissured surfaces. He is reported to have described his work as being about the geology of our planet – the earth's crust, clouds and the surface of the sea – and to have spoken of his indebtedness to Beuys's philosophical position on the use of materials.[74] Speaking of how essential it is for him to use clay to express his concerns, he has stated that 'as clay is to earth, so too is a kiln to the earth's core'.

If Akiyama focuses on the materiality and symbolic significance of clay, Nishimura Yōhei (b.1947), another important third-generation artist who has also voiced his esteem for Beuys, is more concerned with the actual process of firing and how it affects different kinds of objects and materials (PLATE 33). He interprets yakimono, the Japanese term for 'ceramics', in the broader and more literal sense of 'burned things'.[75] In view of his use of metal, stone, wood, paper and other substances, often without the inclusion of clay, his position in the world of Japanese ceramics is somewhat anomalous.[76] The interests he has pursued since graduating as a student of sculpture from Tokyo University of Education have led some critics to call him a conceptual rather than a ceramic artist. He is, nevertheless, closely involved in the use of clay as a result of teaching ceramics at a school for visually handicapped children in Chiba Prefecture to the east of Tokyo.

By subjecting everyday articles to the heat of the kiln Nishimura transforms them into strange, other-worldly objects that play on our perceptions of time and physical reality. Much of his recent work revolves around the firing of books, newspapers and magazines so that they are rendered into fossil-like objects whose essential structures remain but whose meanings, embodied in the words and images they bear, have been largely or totally obliterated.

The work shown here is made up of two separate elements prepared at different times. The 'clay container', which consists of a solid mass of clay with a shallow hole in its top, was made first. It was fired in an electric kiln to about 1000°C (1830°F) before undergoing a secondary lower temperature Black Fire-type firing. It was then left outside in the open to weather and age. The 'mummified newspaper' was made a year later, after the container had developed a sufficient patina. It consists of no more than a roll of newspaper fired in a smoky atmosphere. The bizarre imagery of the assembled whole – shaped in the form of a giant egg, the container may be read as an agent of regeneration as well as a receptacle for mummified remains – derives, according to Nishimura, from impressions gained during a visit to the British Museum in the late 1980s.

PLATE 33 Opposite 'Clay Container for Mummified Newspapers.' Carbon-impregnated earthenware and fired newspaper. 1991. width 31cm (12¼in) Nishimura Yōhei (b.1947)

The Subversive Tendency

THE MYSTERIES OF BIRTH, DEATH AND THE WORKINGS OF TIME that Nishimura points to in such a hauntingly poetic way are also the subject of the work by Koie Ryōji (b.1938) (PLATE 34). Made from a plaster mould taken from the artist's face, it is one of a sequence of sixteen masks showing the gradual disentegration of his features into an anonymous mound of clay. 'Returning to Earth' is among the most powerful of the many 'messages' that Koie has conveyed to the world during a remarkable career, which has seen him contribute with legendary verve and originality to a wide diversity of domestic and international events. It is a theme to which he has returned time and time again, a similar sequence of seven masks shown at the Kyoto National Museum of Modern Art's 1971 international ceramics exhibition having helped to put him on the map as one of Japan's most innovative avant-garde ceramists.[77]

Koie's facility with clay owes much to his early training in Tokoname, first at high school, then with a tile-manufacturing company and finally, from 1962 to 1966, at the Tokoname Municipal Ceramics Research Institute (*Tokoname Shiritsu Tōgei Kenkyūjo*). His functional pieces – plates, cups, teabowls, vases and other vessel forms – have an extraordinary spontaneity about them. His highly intuitive approach and the way he breaks every rule in the potter's book to produce works of great fluidity and expressive intensity were admirably demonstrated to a non-Japanese audience at the time of third International Potters' Festival at Aberystwyth, Wales, in July 1991.

Koie's love of experimentation has manifested itself in many other ways. Since the early 1980s he has been involved in a number of 'ceramic happenings'. These emphasize the processes rather than the products of the creative act and have included firing clay on the open ground, digging clay from riverbeds and filtering it, or simply blow-torching the earth.[78] He is equally well known for the numerous ceramic sculptures and installations he has created over the last twenty-five years. Many are strident statements about the horrors of the modern world – Hiroshima, Nagasaki, Nanking, Auschwitz and, more recently, Chernobyl.

While Koie is unusual among his peers for his continuing use of ceramics as a vehicle for overt social and political comment, the radical years of the late 1960s and early 1970s saw the production of many provocative and sometimes subversive works in ceramics and other media. Among these, the sculptures of Kumakura Junkichi (1920–85) are some of the best known (PLATE 35). Born in Kyoto as the eldest son of an architect-builder, Kumakura's studies were interrupted by the advent of the Second World War. He began working as a ceramist after his return to Kyoto in 1945, initially under the tutelage of Tomimoto Kenkichi (1886–1963). Although the concern with functional ceramics he developed at this time remained with him to the end of his life, the future direction of his career was determined by his encounter with members of the Modern Art Association in the early 1950s. Already by 1956, when he held a joint exhibition with Fujimoto Yoshimichi (see above, PLATE 17), he was being hailed as one of Japan's 'most eminent figures in avant-garde ceramic art'.[79]

PLATE 34 *Opposite 'Returning to Earth.'* Stoneware. 1990. *diameter 48cm (18¾in)* *Koie Ryōji (b.1938)*

Kumakura's involvement with the Modern Art Association continued until 1959, when he decided to concentrate on his activities as a member of the *Sōdeisha*, which he had joined two years earlier. This has been interpreted as a reflection of his growing commitment to working with and through the medium of clay and of his personal uneasiness with the highly cerebral abstraction to which most of the sculptors belonging to the Modern Art Association subscribed. For the next twenty-five years Kumakura made his involvement with the *Sōdeisha* one of the main focuses of a career that also saw his increasing participation in overseas events from the mid-1970s onwards.

'Birth', the work shown here, is one of the last in a series of strongly organic forms through which Kumakura explored the subject of human sexuality and eroticism with a directness and intensity that is the subject of controversy even today. These sculptures from the late 1960s and early 1970s, whose warm brown colours are the result of the use of ash glaze on Shigaraki clay, constitute a transitional stage between the abstract biomorphism of his earlier work and the more detailed figuration that characterized his later oeuvre.[80] Kumakura's death at the still early age of sixty-five deprived Japan of one of its most talented artists. His influence, however, as one of the originators of what critics refer to as the fetishistic tendency continues to make itself felt today.

The final work to be discussed in this chapter is a sculpture by the Tokyo-based artist Nakamura Kinpei (b.1935) (PLATE 36). The random assemblage of natural and man-made elements rendered in gaudily decorated stoneware may be read on one level as a general observation on the visual chaos of contemporary Japan. Like much of Nakamura's recent work, however, it is more specifically a manifestation of concerns that have engaged his attention since the early 1980s and that were spelt out to considerable critical acclaim in his 1988 exhibition 'An Exploration of Japanese Taste'.

Writing of this exhibition, Nakamura has explained how he became fascinated with the way in which the constant reworking of traditional ceramic styles by artists living in an age with different priorities from those obtaining at the time the original works were made, leads to products that cannot fail to degenerate into 'mere kitsch replicas'.[81] This and his assessment that kitsch underlies all forms of Japanese popular culture – and is thus more representative of Japanese taste than the rarefied aesthetics of the *wabi*-style tea ceremony, for example – prompted him to start exploring the nature of kitsch through his own work.

Nakamura's sculptures are rich in parody and humour. The way in which the rocks and branches on this and similar pieces are actually replicas in clay is a sceptical comment on the artifice underlying the 'naturalness' of effect that is so often the goal of Japan's more elevated cultural pursuits. These 'natural' elements, symbolic of the austerity of Zen aesthetics, have then been cloaked in the garish colours of the Kabuki theatre and combined with scraps of industrial debris in a teasing questioning of established artistic hierarchies. His propensity towards the colourful and flamboyant, though not a consistent feature of his work until the 1980s, is the combined result of his upbringing in Kanazawa – a major centre, like Kyoto, of highly refined

PLATE 35 *Above and opposite (detail)* 'Birth.' Stoneware with ash glaze. 1975. *width 53cm (20¾in)*
Kumakura Junkichi (1920-85)

PLATE 36 'Even Stones have Sap.'
Stoneware with coloured glazes.
1991. *width 83.5cm (32¾in); depth 63.5cm
(25in); height 60cm (23½in)*
Nakamura Kinpei (b.1935)

craft traditions – and an exposure to North American ceramics first gained during a year spent in the United States as a Rockefeller Foundation fellow in 1969–70.

Nakamura's position in the world of contemporary Japanese ceramics is an important one for several reasons. He is, first of all, a very versatile artist with a wide range of interests. As well as making sculptural ceramics of the kind shown here, he has been regularly involved in architectural projects, such as the creation of ceramic wall reliefs and other large-scale permanent installations. His long-term membership of the Japan Craft Design Association reflects a similarly deep-felt concern with contemporary utilitarian ceramics. He is also a prolific author who has contributed extensively to current critical debate about ceramics and other aspects of art, craft and design.

These activities have been paralleled since 1976 by Nakamura's work as a teacher of ceramics at Tama University of Arts, the only major arts college in the Tokyo area where sculptural ceramics are taught. A notable feature of his post is that he belongs not to a ceramics or a design department, the usual loci of ceramics teaching in Japanese art colleges, but to the oil-painting department. Ceramics are introduced not as an independent discipline with its own set of principles and priorities, but as one of any number of potential vehicles for the expression of creative ideas. Nakamura's energy and eloquence as a teacher and the freedom of approach to

clay he has been in the position to encourage have played an important role in the recent rise of Tokyo as a leading centre of experimental ceramics.[82]

Tokyo's emergence as a hotbed of new ideas has posed a major challenge to the hegemony hitherto enjoyed by artists based in the Kyoto area. For so long the centre of avant-garde ceramics in Japan, Kyoto is beginning to find itself burdened by the legacy of the *Sōdeisha*'s past. Tradition has been successfully challenged, and the assertion that ceramics is a valid medium for artistic expression is no longer questioned. The need to produce sculptural forms that speak about clay and clayworking is less of an imperative than it once was, even as improvements in technology offer ever greater scope for the exploration of new effects. This is not to suggest that Kyoto's importance as a centre of experimental ceramics has in any way diminished. The plurality of work emerging from the hands of Kyoto's younger generation of makers is indicative of a healthy degree of innovation. At the same time, however, the conceptual incisiveness apparent in the work of Tokyo's leading artists is the manifestation of a new level of maturity in Japanese ceramics. While local pride may have been damaged in the process, from a broader perspective the breaking down of Kyoto's domination over avant-garde ceramics should be seen as one of the more positive developments of the 1980s. Growing dialogue among artists of increasingly heterogeneous backgrounds can only be of benefit to the long-term future of Japan's contemporary ceramics world.

CHAPTER II
WOODWORK, BASKETRY & BAMBOOWORK

A̲S ANYONE WHO HAS VISITED JAPAN WILL KNOW, wood and bamboo provide an essential and welcome balance to the starkness of the glass, steel and concrete that increasingly dominate the country's urban and rural landscape. Although the consideration of architectural practices lies beyond the scope of this book, it should be borne in mind that the sensitivity to material and the sophistication of technique seen in the making of the small-scale artefacts discussed below have evolved in the context of a culture in which building in wood and bamboo has been the historical norm. It is also important to note that any assessment of the prevalence of woodworking skills in contemporary Japan needs to take into account the fact that the core structures of higher quality lacquerwares are predominantly made from wood.[1]

The centrality of wood and bamboo in Japanese culture has much to do with the climatic conditions that result from Japan's geographical location along the eastern seaboard of the Asian land mass.[2] Japan's four main islands – Hokkaidō, Honshū, Shikoku and Kyūshū – stretch for some 2000 kilometres (1250 miles) from a latitude of nearly 46 degrees in the north to less than 31 degrees in the south. Combined with the configuration of the mountain ranges that cover large areas of the country and the hot and cold currents that circulate in the surrounding oceans, this latitudinal variation is responsible for conditions ranging from the subarctic to the subtropical. Clearly marked seasonal changes and the abundant rainfall enjoyed by most parts of Japan support a diverse and prolific flora. Bamboo flourishes in many regions and there are numerous varieties of hardwood and softwood tree suitable both for building purposes and for the fashioning of furniture and other domestic items.

Opposite 'Sea' (detail) by Tanabe Chikuunsai II (see plate 46)

WOODWORK

TIMBERS HAVE TRADITIONALLY BEEN CLASSIFIED in Japan according to whether they derive from broad-leafed (*kōyōju*) or coniferous (*shinyōju*) trees, or whether they are hard (*kōboku*) or soft (*namboku*).[3] A separate category, foreign wood (*karaki*), refers to what are mainly hardwoods imported from South and Southeast Asia.

Broad-leafed trees whose timber is used by Japanese woodwork artists include persimmon (*kaki*), evergreen oak (*kashi*), paulownia (*kiri*), camphor (*kusu*), Japanese chestnut (*kuri*), mulberry (*kuwa*), zelkova (*keyaki*), cherry (*sakura*), ash (*shioji*), boxwood (*tsuge*), Japanese horse-chestnut (*tochi*) and Japanese oak (*nara*). Of these paulownia is the lightest and softest, followed by medium-hard camphor, ash and horse-chestnut. The others are all hard to very hard.

Among coniferous trees, Japanese yew (*ichii*), Japanese cedar (*sugi*), Japanese cypress (*hinoki*) and pine (*matsu*) are the most commonly employed. Cedar is light and soft while cypress is lightish and of medium hardness. Yew and pine, particularly the preferred black pine (*kuromatsu*), are heavier and harder. Imported timbers include Chinese quince (*karin*), ebony (*kokutan*), rosewood (*shitan*), Bombay blackwood (*tagayasan*) and sandalwood (*byakudan*).

Woodworking techniques are classified at the broadest level according to whether they are used for the forming of the basic shape, for purposes of decoration or for surface finishing. The main forming techniques are turning (*hikimono*), carving from the block (*kurimono*), joinery (*sashimono*) and bentwood work (*magemono*). Decorative techniques include relief carving and openwork (*horimono*), marquetry (*yosegi*) and inlay (*mokuzōgan*).[4] Materials used in marquetry and inlay include wood, metal, ivory, tortoise-shell and mother-of-pearl. The principal methods of surface finishing are staining, polishing and a process called *fuki-urushi* (wiped-lacquer). This involves the application of multiple coats of clear lacquer that intensify the colours of the wood and increase its durability.

The discussion that follows has been divided according to the three main forming techniques of turning, carving from the block and joinery. Bentwood work has been omitted from consideration because its application is largely limited to the artisanal production of trays, lunch-boxes and other plain utilitarian items and is almost never used by individual artists. Its basic techniques are, however, outlined in the next chapter.[5]

TURNING (*HIKIMONO*)

THE LARGE BOWL by Mizukami Sōei (b.1907) (PLATE 37) is the product of skills handed down at Yamanaka in Ishikawa Prefecture since at least the seventeenth century. Mizukami began his training when he was twelve years old, set up his first workshop in 1946 and has contributed to the Traditional Crafts Exhibition since 1966. It can be seen that he is a master both of sturdily turned forms and of delicate inlay patterning, in this case executed in

brass wire and tortoise-shell. His favoured material is zelkova treated with a wiped-lacquer finish to enhance the grain and to bring out the rich colours of the wood.

The way in which shapes are fashioned on a lathe from solid pieces of wood means that production is restricted to regular, rounded forms whose dimensions cannot exceed the size of the available timber. In addition to the careful selection of materials, individuality is expressed through nuances of curve and through so-called *sujibiki*, the impartation to the wood surface of different configurations of concentric rings and other types of turned patterning. This has been used to good effect on the interior of Mizukami's bowl.[6]

The employment of various means of embellishment on what would otherwise be straightforward turned forms is common to much of the work of artists who contribute to the Traditional Crafts Exhibition. This is in marked contrast to the approach of Arioka Ryōeki (b.1930), a Takamatsu-based artist who makes a positive virtue out of the limitations inherent in the use of the lathe. In the example of his work shown here (PLATE 38) he has used pine selected

PLATE 37 Bowl of turned zelkova with tortoise-shell and wire inlay and wiped-lacquer finish. 1987. *diameter 36cm (14¼in)*
Mizukami Sōei (b.1907)

from the most resinous part of the tree for the lustrous sheen it gives when sanded and polished to produce a plain, solid form with a thick, rounded rim and simple tripod feet. The minimalism of Arioka's work reflects his long-standing involvement with the Japan Craft Design Association and his concern to produce affordable but well-crafted goods that meet the needs of the modern consumer.

CARVING FROM THE BLOCK (*KURIMONO*)

THE SCALLOPED DISH by the Tokyo-based Nakadai Zuishin (b.1912; appointed Living National Treasure in 1984) (PLATE 39) is an example of carving from the block by one of Japan's most eminent woodwork artists. It is made from paulownia, a material whose softness allows for relatively easy carving of the basic shape but poses considerable difficulties at

PLATE 39 Dish of carved paulownia.
1981. *diameter 34.7cm (13¼in)*
Nakadai Zuishin (b.1912)

the finishing stage. Unlike other, harder woods paulownia cannot be sanded or polished and can be finished only by planing and fine chiselling. Here, as in all of his work, Nakadai's skill is reflected in the fashioning of an exactly regular form from a single block of wood and in the smooth rendering of flat and curved surfaces solely by means of carving tools.

The sense of energy that imbues the curved and cusped sides of the dish by Murayama Akira (b.1944) (PLATE 40) is the product of supreme technical abilities combined with the inventiveness of an artistic imagination guided during its formative years by Kuroda Tatsuaki (1904–82; appointed Living National Treasure in 1970). Kuroda, one of Japan's most renowned woodworkers of recent times, was the master of a daunting range of woodworking and lacquerworking skills. He deployed these in the creation of a wide diversity of work inspired in the main by the Korean furniture and other household items with which he initially became familiar through his friendship with Yanagi Sōetsu (1889–1961) and other leaders of the Japanese Folk Craft movement in the late 1920s.[7]

PLATE 40 Dish of carved zelkova with wiped-lacquer finish. 1989. *width 47.2cm (18½in)*
Murayama Akira (b.1944)

Murayama joined the Kuroda workshop in 1966 after completing a degree in wood sculpture at Kyoto City University of Arts. A member of the Japan Crafts Association since 1971, he works in Uji in the southern outskirts of Kyoto. In his preference for strong and dignified forms and in his concern to give voice to the innermost qualities of his materials, he owes much to his teacher's example. At the same time, however, he exerts sensitivities that are his own in his insistence on the importance of wood – both a manifestation of and a metaphor for nature and the organic – in the increasingly mechanized environment of late twentieth-century Japan.[8]

JOINERY (*SASHIMONO*)[9]

PLATE 41 *Opposite* Box of carved and joined horse-chestnut with wiped-lacquer finish. 1990. *width 35.7cm (14in); depth 23.5cm (9¼in); height 21.2cm (8¼in)*
Toki Chihiro (b.1948)

TOKI CHIHIRO (b.1948) is another heir to Kuroda Tatsuaki's powerful style of wood-working. A graduate of Musashino University of Arts, he joined the Kuroda workshop in 1974. Since 1977 he has been based in Suwa where he operates independently of any craft organization. The timber used in the work shown here (PLATE 41) is horse-chestnut taken from near the root of the tree. Panels were sawn from a solid block of wood and, after partial carving of the exterior ribbing, assembled to give maximum continuity to the flow of the grain.

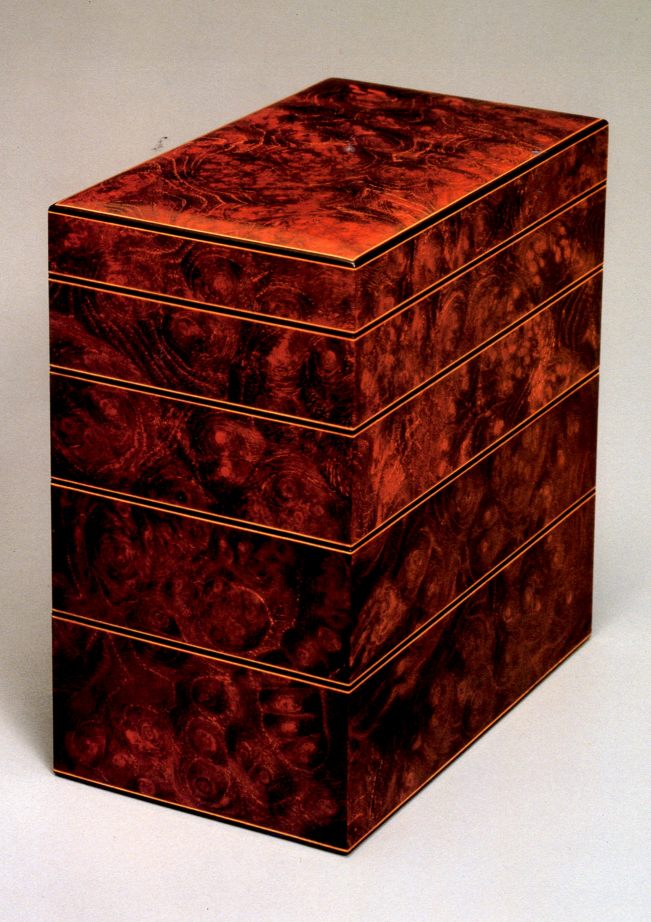

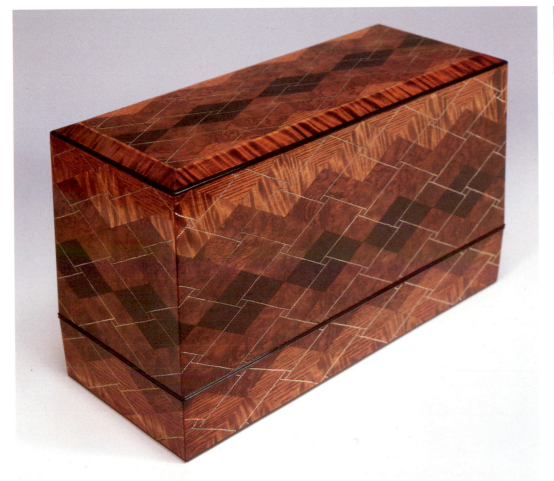

PLATE 43 Box for sutras (Buddhist scriptures) of wood marquetry with wire inlay. 1973. *width 31cm (12¼in); depth 12.4cm (4¾in); height 18.3cm (7¼in)*
Himi Kōdō (1906–75)

The basic construction of the base and lid having been completed, the box was carved into final shape and treated with a wiped-lacquer finish. It is a masterly demonstration of what can be achieved by applying the techniques of carving from the block to an underlying joined form.

The set of stacking boxes executed in mulberry with black persimmon (*kurogaki*) and boxwood trimming by Ōno Shōwasai (b.1912) (PLATE 42) is the manifestation of a more highly wrought aesthetic than that which informs the work of artists from the Kuroda stable. Ōno was born in Okayama Prefecture as the eldest son of an established cabinet-maker. Exposed from an early age to a wide variety of materials and woodworking techniques, he is especially recognized for his restrained use of inlaid edging on sharp and exquisitely balanced forms. Ōno has been a regular contributor to the Traditional Crafts Exhibition since 1967. He was appointed a Living National Treasure in 1984.

Along with Nakadai Zuishin (see above, PLATE 39), Ōno is a worthy successor to the late Himi Kōdō (1906–75; appointed Living National Treasure in 1970). The diamond lattice design on Himi's sutra box (PLATE 43) makes direct reference to examples of early woodwork preserved in the eighth-century Shōsōin Imperial Repository in Nara.[10] The Shōsōin treasures have been a major source of inspiration for Japanese woodworkers and makers working in other disciplines since the time of the surveys carried out in 1878–80 and again in 1893–1905.[11] Himi's own

PLATE 42 *Opposite* Set of stacking boxes of mulberry with black persimmon and boxwood trimming. 1985. *width 9.1cm (3½in); depth 14.8cm (5¾in); height 16.2cm (6¼in)*
Ōno Shōwasai (b.1912)

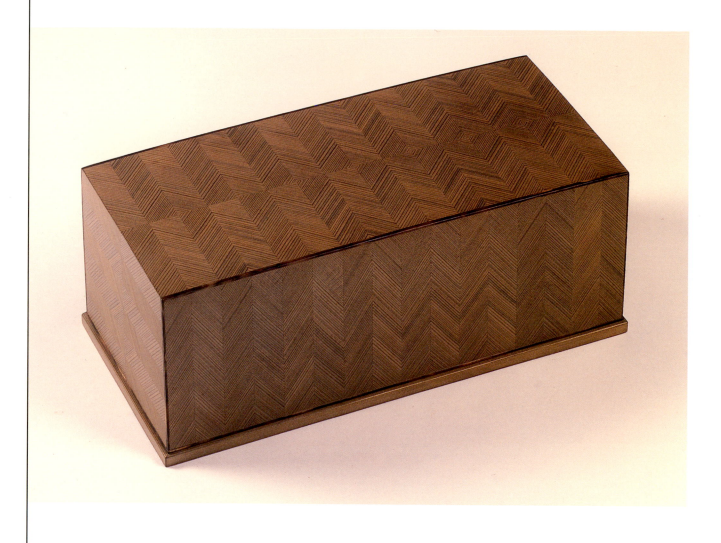

PLATE 44 Box of marquetry in 'ancient'
cryptomeria with hardwood trimming.
1987. *width 32.5cm (12¾in); depth 15.8cm
(6¼in); height 13.3cm (5¼in)*
Nakagawa Kiyotsugu (b.1942)

interests developed in the immediate postwar years under the direction of Matsuda Gonroku (1896–1986), a fellow artist from Kanazawa specializing in lacquerwork.[12] Many of the submissions Himi made to the Traditional Crafts Exhibition from the late 1950s onwards reflect the fruits of his research into early woodworking techniques. The work shown here was the outcome of a survey of the Shōsōin treasures in which he participated in 1972–3.

The precision of execution and careful balance of form characteristic of Himi's oeuvre is also seen in the work of Nakagawa Kiyotsugu (b.1942). On the piece shown here (PLATE 44) the lid is slightly arched to counteract the visual effect of the marquetry design, and the hardwood trimming has been omitted from the shorter of the upper edges to emphasize the flow of the pattern along the box's length. Nakagawa works in Kyoto and has been a regular contributor to the Traditional Crafts Exhibition since 1972. He is well known for his use of 'ancient' cryptomeria (*jindai sugi*) – a material whose grey colour results from the timber having been submerged in water or buried in the earth over an extended period – in the creation of sophisticated geometric designs based on the natural end-grain patterning of the wood. Inspired by the effects found on traditional wooden basins and buckets, Nakagawa's work is intriguing for the way in which forms of extreme elegance and refinement are rendered through the application of techniques originating in the craft of the cooper.

Basketry and Bamboowork

THE VOCABULARY OF BASKETRY AND BAMBOOWORK IS, like that of woodwork, a complex and extensive one. While there are baskets woven from materials other than bamboo and there are bamboo products fashioned by methods other than weaving, the ready availability of bamboo in most parts of Japan and the flexibility afforded by basketry techniques have ensured a traditional prevalence of woven bamboo items over others. The abundance of bamboo is reflected in the fact that about half of the twelve hundred or more varieties of bamboo and bamboo grass known worldwide have been identified in Japan.[13] Those most frequently used in basketry and bamboowork include common Japanese bamboo (*madake*; *Phyllostachys bambusoides*), black bamboo (*hachiku*; *Phyllostachys nigra*) and thick-stemmed bamboo (*mōsōchiku*; *Phyllostachys pubescens*). In terms of flexibility Japanese basket-makers employ everything from extremely intricate and regular weaves to a free, unstructured approach that permits almost limitless variation.[14]

Once it has been felled bamboo undergoes a number of processes to prepare it for use. These include drying, bleaching and splitting into strips. Drying is carried out by natural means or in a kiln. Bleaching, which also hardens the bamboo and prevents insect infestation, is carried out by heating over a charcoal fire or by boiling in water. Caustic soda is added when a more powerful whitening effect is required. Splitting the bamboo into weavable strips is a lengthy business involving much repetitive manual labour, relieved only to some extent by the use of machinery. A basic distinction is drawn between the preparation of strips by splitting the bamboo in parallel with the outer surface (*hirawari* or *itawari*) and that by splitting it at right angles (*masawari*). The latter is used when very fine strips are required, the nodes and shiny outer layer of the bamboo usually being removed before the splitting proceeds. The former is used when the intention is to exploit the natural surface qualities of the bamboo.

The discussion that follows begins by examining the work of four artists who make woven baskets from bamboo prepared in the ways outlined above. An example of work fashioned from bamboo without weaving is then described. The chapter concludes with an examination of three baskets by an experimental basket-maker who operates within the context of international, in particular North American, trends in contemporary basket-making.

Traditional Basket-making

THE CONTINUING VITALITY OF TRADITIONAL BASKET-MAKING in late twentieth-century Japan owes much to the activities of the formidable Iizuka Rōkansai (1890–1958) during the years either side of the Second World War. In conjunction with his vigorous pursuit of new techniques and freely sculptural forms, Rōkansai was responsible for introducing into the world of basket-making the concepts of *shin-gyō-sō* (formal–semi-formal–informal). Originally

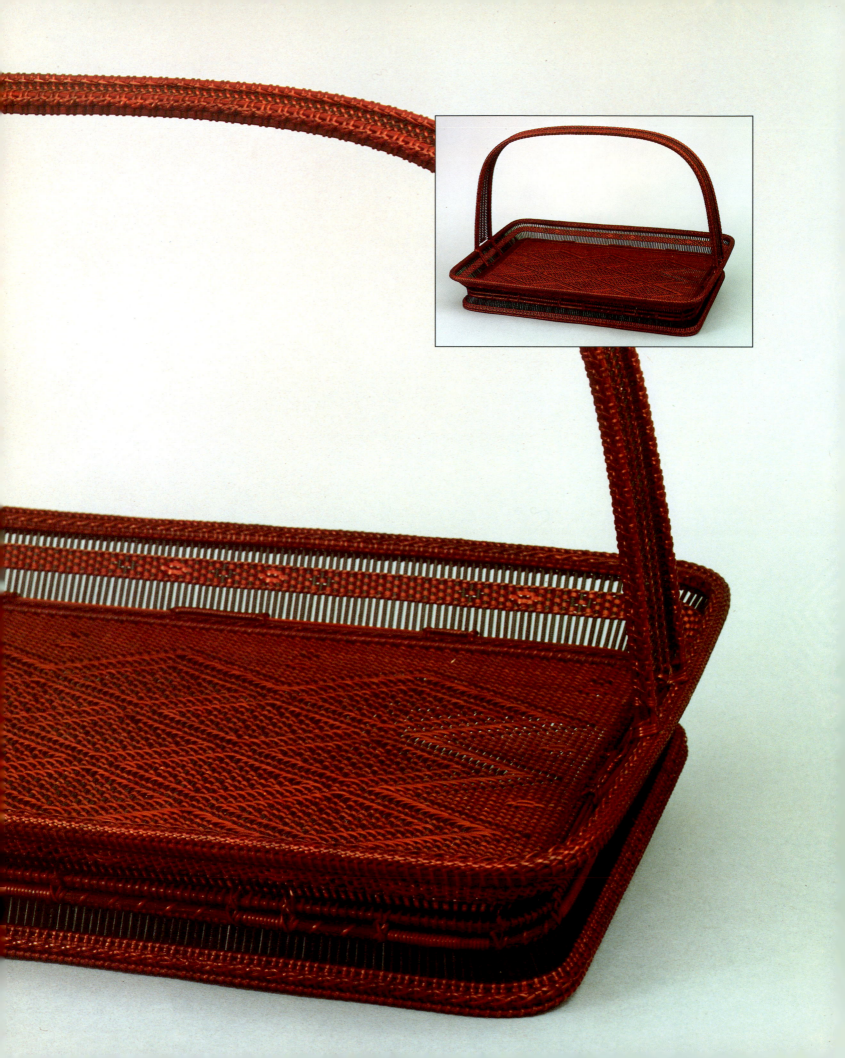

devised in China as a means of describing different styles of calligraphy, this system has come to be used in Japan as a philosophical and aesthetic framework for the practice of numerous other activities, such as the tea ceremony, flower-arranging and garden design.

Writing in 1937, Rōkansai explains that formal implies regularity of form and precision of weave so exquisite that at first glance you might not think a work is made of bamboo at all, the natural qualities of the material being totally denied in the pursuit of refinement and artifice. Semi-formal suggests a certain loosening of form and weave within the bounds of an essentially regular approach. Informal, on the other hand, means the breaking of the rules governing formal and semi-formal and the purposeful exploration of irregular weave and asymmetrical form. Writing again in 1939, he states that informal is the most difficult of the three, for in permitting complete freedom of expression its demands on the basket-maker are the greatest.[15]

The perception of what constitutes formal as opposed to informal is based to a considerable extent on differences in style between baskets used in steeped tea (sencha) drinking and the tea ceremony.[16] Formality is equated with the highly wrought Chinese styles of basket traditionally preferred in the context of steeped tea drinking and informality with the more rustic styles of basket usually associated with the tea ceremony. The prevalence of steeped tea drinking in the nineteenth and early twentieth centuries and the fact that its requirements for basketry items were particularly extensive meant that, up to the time of Rōkansai's efforts to expand the boundaries of his art, the majority of works produced by leading basket-makers were in formal Chinese styles.[17]

The handled tray by Rōkansai's son Iizuka Shōkansai (b.1919) (PLATE 45) is a representative example of basket-making in formal (shin) style. Shōkansai, who lives in Gunma Prefecture to the northwest of Tokyo, originally intended to become a painter. When his elder brother died prematurely, however, it fell to him to carry on the family tradition of basket-making. The training he received from his father equipped him to become a regular contributor to the Nitten exhibition from the late 1940s onwards. He won several Nitten prizes before transferring his allegiance to the Traditional Crafts Exhibition in 1974, shifting away from the execution in basketry of essentially two-dimensional graphic works to the making of flower vases, trays, boxes and other vessel forms. Shōkansai was appointed a Living National Treasure in 1982.

The basket by Tanabe Chikuunsai II (b.1910) (PLATE 46) is a striking example of work in informal (sō) style. While a pattern to the weave can be discerned, there is an overriding sense of spontaneity and freedom quite different from the aesthetic that informs Shōkansai's tray. The feeling of immediacy is further heightened by the use of susudake, knotty strips of smoke-blackened bamboo taken from the ceiling of an old farmhouse. Chikuunsai II works in Osaka where he studied with his father Chikuunsai I (1877–1937). As well as being a contributor to the Nitten exhibition, he has also been closely involved in the activities of Nitten-related groups such as the Association of Modern Artist Craftsmen (Nihon Gendai Kōgei Bijutsu Kyōkai) and the New Craft Artists Federation (Nihon Shinkōgei Bijutsuka Renmei). In his continuing pursuit of reorientation within the Nitten network he differs from those, like Shōkansai, who abandoned it in favour of the Japan Crafts Association and the Traditional Crafts Exhibition.

PLATE 45 Opposite Woven bamboo tray with handle. 1973. width 37cm (14¼in)
Iizuka Shōkansai (b.1919)

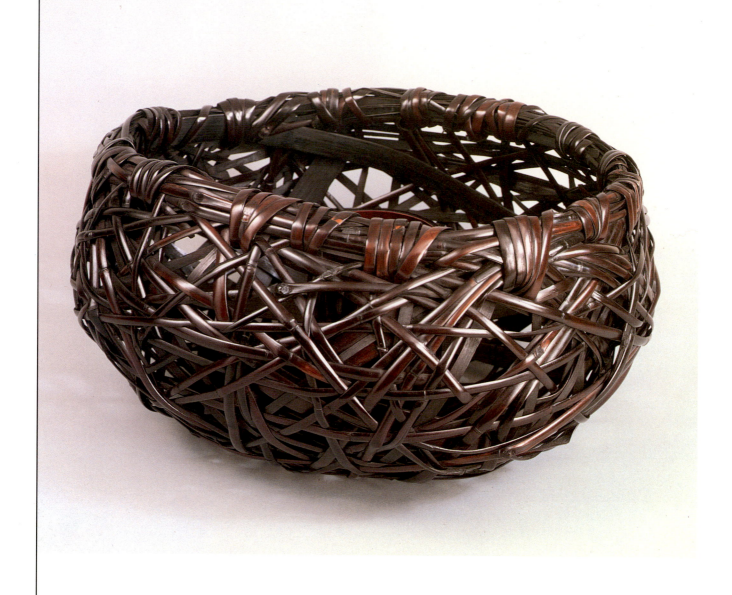

PLATE 46 *Above* 'Sea.' Woven bamboo basket. 1973. *diameter 43cm (17in)*. See also page 80.
Tanabe Chikuunsai II (b.1910)

PLATE 47 *Opposite* 'Mountain Ridge.' Woven bamboo basket. 1982. *height 23cm (9in)*
Abe Motoshi (b.1942)

In contrast to both the formality and the informality of the two works discussed so far, the softly textured surface and the regular but expansive form of the basket by Abe Motoshi (b.1942) (PLATE 47) recommend it as an example of work in the intermediary semi-formal (*gyō*) style. Abe was born in Ōita Prefecture and studied with Shōno Shōunsai (see below, PLATE 49) before taking over his family's basket-making business in 1963. He has been a regular contributor to the Traditional Crafts Exhibition since 1976. In addition to its generous proportions, the beauty of Abe's basket lies in the way in which the swirling pattern has been achieved by the weaving together of openly spaced vertical strips with bundles of horizontal strips, which emerge from a dense but only partially discernible inner layer.

The generation of a sense of mass and volume through the use of a multi-layered structure has been achieved particularly effectively on the basket by Hayakawa Shōkosai V (b.1932) (PLATE 48). It can be seen how the lighter outer strips have been cut away in a large undulating pattern to

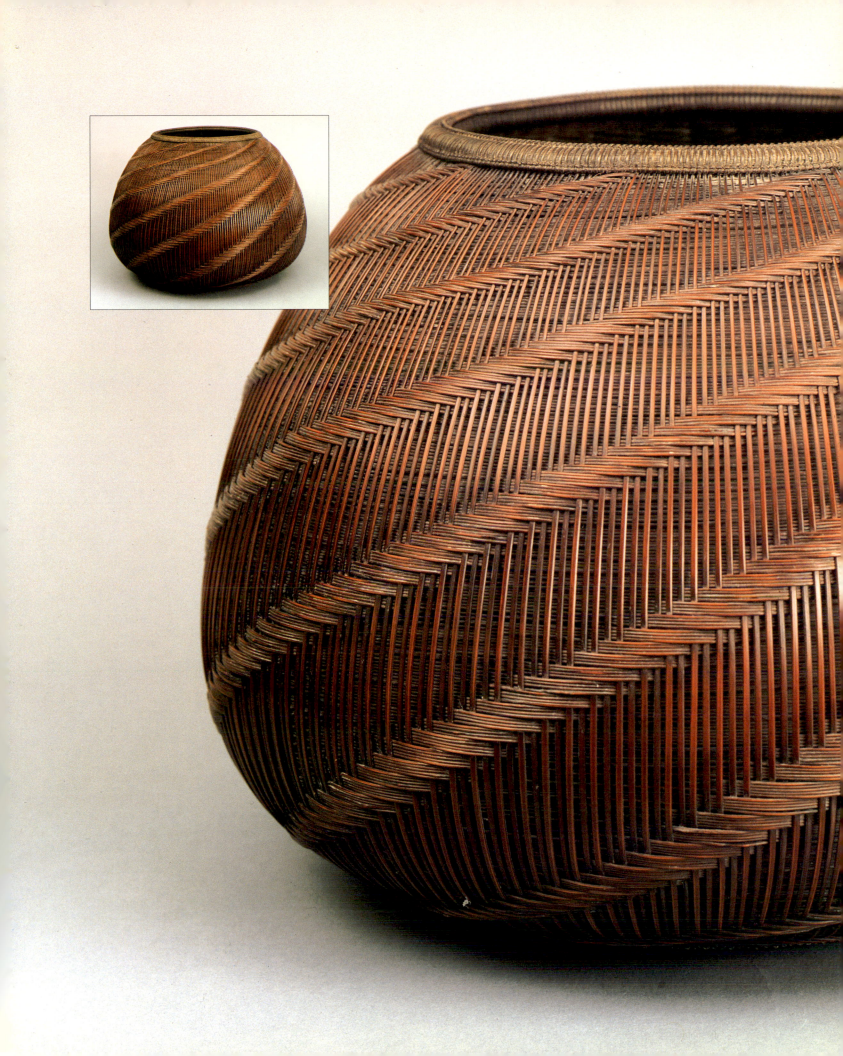

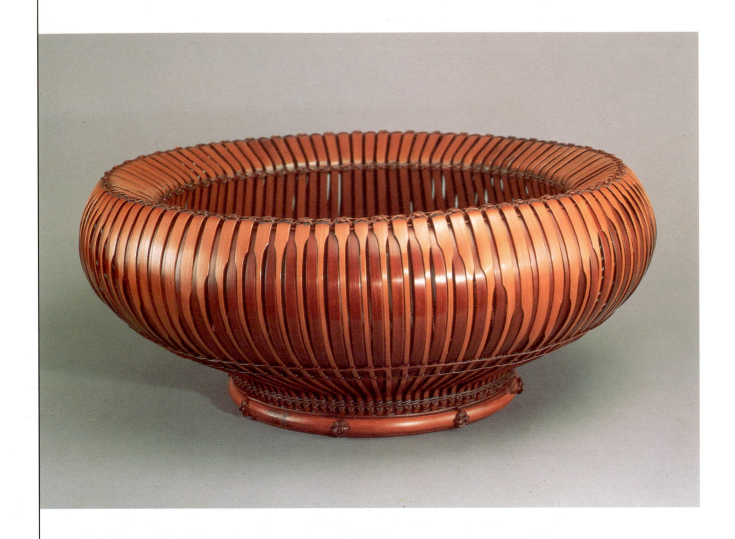

reveal an inner layer of more darkly stained bamboo. Shōkosai V is the present head of an Osaka-based family of basket-makers whose founder, Shōkosai I (1815–97), was one of the best known practitioners of his time. He trained with his father, Shōkosai IV (1902–75), from the age of nineteen and has contributed to the Traditional Crafts Exhibition since 1968. The example of his work shown here is interesting as evidence that although Rōkansai's system of formal–semi-formal–informal is a useful way of conceptualizing the range of approaches that can be taken to basket-making, it is possible to use rigorously formal structures to explore the innate materiality of bamboo in a manner characteristic of baskets in more informal styles.

BAMBOOWORK

THE VASE WITH THE TALL LOOP HANDLE by the basket-maker Shōno Shōunsai (1904–74; appointed Living National Treasure in 1967) (PLATE 49) is an example of work in bamboo that has not depended on woven techniques for its making. Its minimalism has much in common with the products of makers belonging to the Japan Craft Design Association, a number of whom work in the basket-making area in Ōita Prefecture where Shōunsai lived and

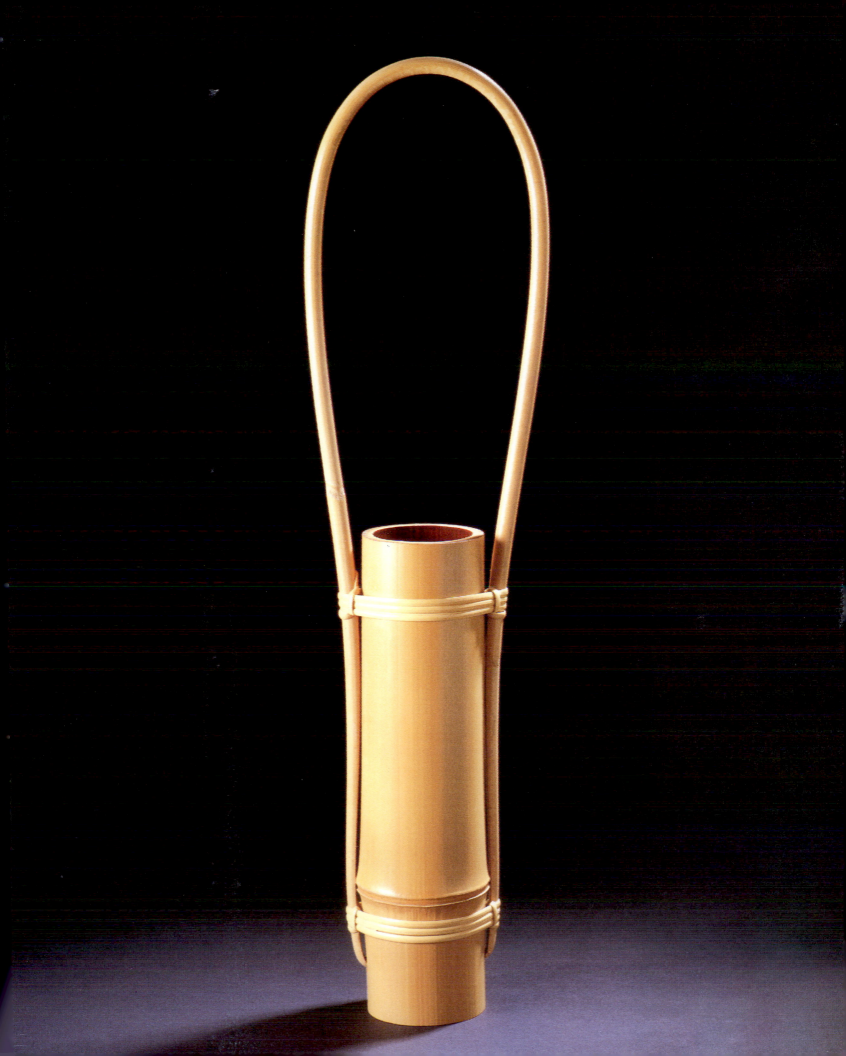

taught. Although Shōunsai was never directly involved in the Japan Craft Design Association, exhibiting at the *Nitten* exhibition and from the mid-1960s at the Traditional Crafts Exhibition, he had an underlying interest in the functionality as well as the expressive possibilities of basketry and bamboowork. This revealed itself in the increasingly simple but powerful forms that he produced during his later years.

Although the making of non-woven bamboo items remains a largely artisanal activity, there is a long-established tradition in the tea ceremony of individuals fashioning their own tea scoops and flower vases out of bamboo. The relative simplicity of the processes involved makes bambooworking an ideal focus for the untrained amateur, and the bamboo utensils made by former tea devotees are valued as a direct reflection of their taste and disposition. Seen in this light, Shōunsai's vase may be interpreted as an especially charged manifestation of his artistic personality.

NEW DIRECTIONS IN BASKET-MAKING

THE FINAL PLATES IN THIS CHAPTER show three baskets by Sekijima Hisako (b.1944) (PLATES 50A–C). One of Japan's most adventurous contemporary basket-makers, Sekijima occupies a position far removed from that of the established basket-making fraternity. The inclusion of her work in a recently published survey of Japanese fibre art is indicative of the regard in which she is held for the conceptual approach that she takes to the use of non-loom weaving techniques.[18] Sekijima's interest in basketry initially developed in the period after she graduated from university as a student of English literature. It was further kindled by the exposure to American Indian and other non-Japanese basket-making traditions she received while living in New York during the late 1970s. More importantly she was inspired by the writings of Ed Rossbach and Carol Hart to become involved in the contemporary basketry movement that had been gaining momentum in the United States since the late 1960s. Her attendance at a workshop run by John McQueen in 1978 marked the turning point in her career. Writing about what was for her a seminal work made the following year, she states:

> *I found that the basket [of interlaced akebia] I created successfully represented my definition of basketry and my preference for using materials naturally. Not only had I departed from designing modifications of conventional techniques, but I had also found a new dimension of expressive potential in basketry and its materials. Instead of building a woven wall out of tangible material, I gave equal value to the interior space and the spaces in the textile structure. Natural materials became more than a physical medium with which to visualize my idea. As soon as I stopped forcing materials into a predesigned form and let natural materials transform themselves, I found the inherent properties were more effectively revealed. Thus I turned all 'restrictions' derived from*

PLATE 50A *Opposite* Basket of cypress shavings and lengths of split root. 1991. *height 20cm (7¾in)*
Sekijima Hisako (b.1944)

PLATE 50B Willow basket. 1991. *heights 31cm (12¼in) and 23.5cm (9¼in)*
Sekijima Hisako (b.1944)

material and method into a means of conceptualizing baskets. Now I try to match the form that the properties of the material suggest with the form that results from my conceptualizing.[19]

The three works shown here demonstrate some of the different ways in which Sekijima pursues her exploration of the relationship between materials and techniques and of the concept of the basket as both structure and space. The basket in PLATE 50A is an archetypal example of structure being determined by the materials at hand. It consists of layer upon layer of extremely thin cypress shavings wound around a roughly plaited internal form made from split lengths of cypress root. These were left long enough so that they could be pulled around and secured on the outside, thus binding the walls into a solid whole. The nature of the materials used means that, although the basket has only a small interior volume and very thick walls, it weighs surprisingly little when picked up.

With the basket in PLATE 50C it was more a case of a suitable material being selected to realize a preconceived structure and then allowing the details of the final form to be determined by the nature of the chosen material. The small step woven into the base allows what would otherwise be an upright rectangular form to sit at an angle. The direction of the weave is such

PLATE 50C Basket of cypress bark.
1991. *height 25.5cm (10in)*
Sekijima Hisako (b.1944)

that it appears square-on when the basket is placed correctly. The rhomboid mouth runs slantwise across the upper panel. The position of its lower further corner corresponds to the midpoint of the two-stranded cable that runs around the middle of the basket and cuts across the bottom of the upper panel. With this as a starting point, the disposition of the mouth is determined by the way in which the strips of bark are folded back on themselves to form the rim.

The basket in PLATE 50B left plays on the juxtaposition, to use the artist's words, between 'the interior space and the spaces in the textile structure'. It was originally made as a single entity fully enclosing the space within it. At this stage it would have appeared as an almost solid form whose randomly plaited, multi-layered walls both concealed and hinted at the existence of an inner void. This was then subjected to the rather dramatic action of being cut in half. By doing this Sekijima not only revealed the full extent of the hitherto hidden interior. She also set up an excited dialogue between two disparate but associated elements where only a mute singularity had existed before.

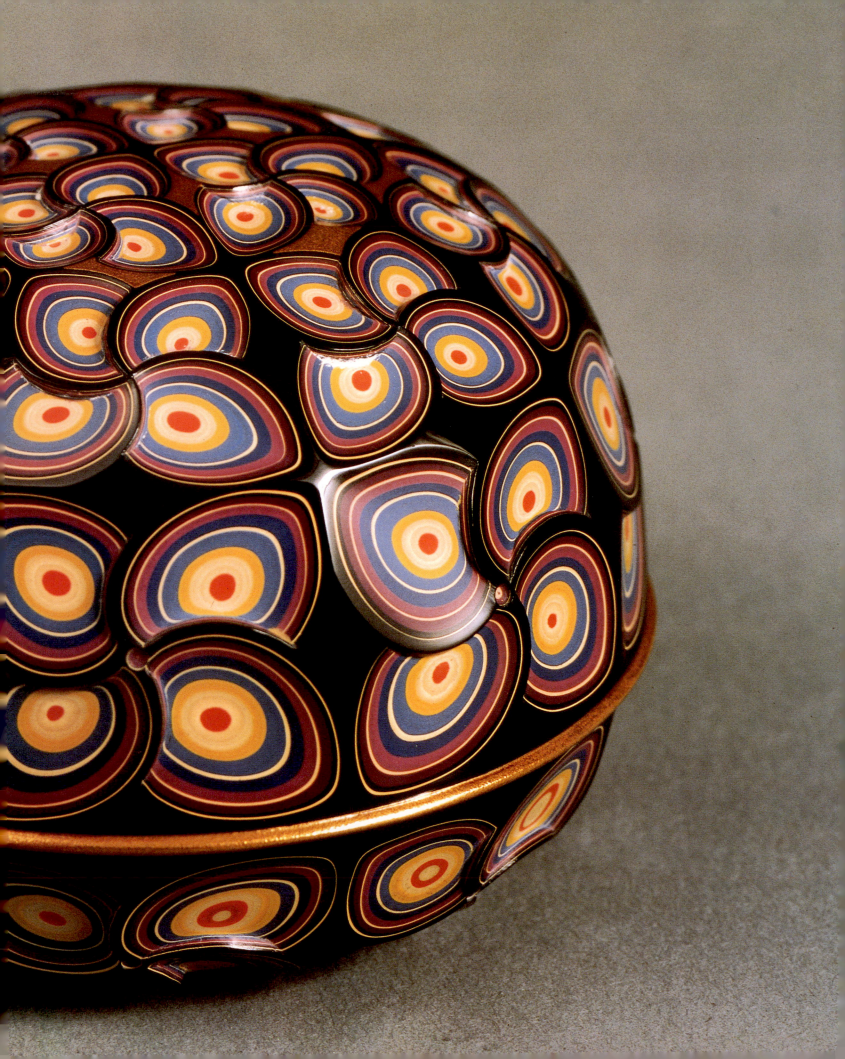



CHAPTER III

LACQUERWORK



AMONG THE DIFFERENT DISCIPLINES COVERED IN THIS BOOK, lacquerwork is the only one without a ready parallel in contemporary western craft practice. The great vogue for Japanese lacquer imported into Europe during the seventeenth and eighteenth centuries encouraged western furniture-makers to imitate lacquer techniques using alternative materials. This practice, known as 'japanning', is limited nowadays to the work of restorers and conservators. Following the opening of Japanese ports to western nations in the mid-nineteenth century, Japanese goods became widely available and extremely fashionable in Europe and America. Among the numerous products available, lacquerware was especially sought after. As in earlier centuries, however, the difficulty of the techniques and the unavailability of the necessary raw materials precluded the adoption of lacquerworking by western practitioners. The achievements of Eileen Gray and Jean Dunand, who used traditional techniques learnt from Japanese lacquerers working in London and Paris in the early part of this century, were exceptional. Their interests are currently pursued by a small number of contemporary makers belonging to the French L'Association Lac.[1]

Given this situation, the supra-national exchange of ideas that has been so important in prompting new developments in areas such as ceramics, fibre art, jewellery and studio glass has not been possible for lacquer artists. However, contrary to the view held by some critics that lacquerwork is intractably conservative in nature, the examples discussed in this chapter show that there is a healthy degree of experimentation in the field, with some artists, especially those of the younger generation, using lacquer techniques in the creation of non-vessel forms and large sculptural installations.

Lacquer is obtained in the form of sap extracted from trees of the *Rhus* species. The best quality lacquer is obtained from *Rhus verniciflua*, the variety traditionally grown in Japan. Raw

Opposite Incense box (detail) by Otomaru Kōdō (see plate 55)

lacquer is thickened by exposure to strong sunlight and impurities are removed by sieving. The water content may be further reduced by heating. The lacquer at this stage is a viscous, browny-black liquid, which is ready for the addition of vegetable or mineral colourants. Plain or coloured, lacquer can be kept almost indefinitely as long as it is not exposed to air. Its transformation into a hard, durable substance is caused by the action of oxygen and high humidity at a temperature of 25–30°C (77–86°F). Hardening is usually carried out in a large wooden cabinet known as a *furo* (literally 'bath'), inside which the appropriate atmospheric and dust-free conditions can be maintained. Lacquer has to be applied extremely thinly to prevent the outer surface hardening over a still-liquid inner layer. High quality products may have a dozen or more coats of lacquer, each of which has to be hardened and polished smooth before the next one can be applied.[2]

Lacquer is used on a large variety of organic and inorganic materials. Wood is the most common, but paper, cloth, leather, bamboo, metal, ceramic and even modern synthetic materials such as acrylic are used. Lacquer is a very versatile and durable material. It does, however, make great demands on those who work with it, both in terms of time and skill.

The production of lacquerware has traditionally been carried out by separate groups of specialist craftsmen working in one of numerous centres established during, or in some cases prior to, the Edo period (1615–1868).[3] As the majority of items are made from wood, the first step is usually the preparation of the core by a joiner, wood-turner or bentwood worker. This is passed to the lacquerer, who is responsible for preparing the plain lacquer ground on which the third craftsman, the lacquer decorator, executes the surface design. The high degree of skill required and the fact that the decoration is usually the most prominent feature of the finished item mean that the lacquer decorator tends to enjoy the highest status within the lacquer-working community. Modern taste for plain, undecorated surfaces has led, however, to a re-evaluation of the position of the plain lacquerer, and it has always been recognized that no amount of dexterity on the part of the lacquer decorator will conceal a flawed ground.

The nature of the relationship between the different groups of craftsmen depends on the size of the enterprise involved. In large commercial concerns such as those found in Wajima, one of Japan's most important lacquerwork centres, there is usually an overseeing owner-manager who co-ordinates production without being directly involved in the making process itself. The plain lacquerers are usually employed directly. The preparation of the core and the lacquer decoration may also be carried out by direct employees, but they are normally subcontracted out to specialist workshops. In smaller businesses subcontracting out of all the activities is standard.

With individual artists, such as those whose work is discussed in this chapter, the situation is more variable. Artists specializing in decorated lacquerware who work in or near one of the large regional manufacturing centres usually provide specifications to specialist artisans who make the core and execute the plain lacquering. This enables the artist to concentrate on the decoration. She or he may, nevertheless, carry out some or all of the plain lacquering or delegate it to an apprentice. The tendency to undertake the plain lacquering as well as the lacquer

PLATE 51 'Bean Field.' Hexagonal box of lacquered wood with *maki-e* (sprinkled picture), mother-of-pearl and metal foil decoration. 1978. *width 24.5cm (9½in); depth 28.3cm (11¼in); height 7.3cm (2¾in)*
Taguchi Yoshikuni (b.1923)

decoration is more marked in the case of artists who work on their own in areas that do not have a particular orientation towards lacquerware manufacturing.

Decorative lacquerwork may be created either by building designs on to the plain lacquered surface or by carving into it. In the case of the latter, the incised areas may be filled with materials such as gold and coloured lacquer. In decorative lacquerwork the underlying form is of interest largely as a vehicle for the exploration of pictorial designs, but in plain lacquerwork primary emphasis is placed on the harmonizing of shape, colour and texture.[4] The sections that follow will discuss these varying approaches to lacquer-making and will also examine the work of a number of artists who are engaged in the search for new possibilities in the use of lacquer as a creative medium.

LACQUERWORK WITH BUILT-UP DECORATION

THE HEXAGONAL BOX by Taguchi Yoshikuni (b.1923) (PLATE 51) was used for many years by the artist as a demonstration piece to show his students at Tokyo University of Arts the different techniques of *maki-e* (sprinkled picture) lacquer decoration.[5] The term *maki-e*

PLATE 52 Cosmetic box of lacquered wood with *maki-e* (sprinkled picture) and mother-of-pearl decoration. 1955. *width 29cm (11½in); depth 22.6cm (8¾in); height 16.6cm (6½in)*
Matsuda Gonroku (1896-1986)

covers a large number of techniques involving the application of metal dusts on to a still wet lacquer surface. It is often used in combination with the inlaying of various materials such as mother-of-pearl. The extraordinary range of pictorial effects that can be achieved by these techniques has ensured that *maki-e* decorated items have for many centuries been the most highly prized of Japanese lacquerwares.

Taguchi's work is remarkable for the way in which he transforms workaday images from the locality north of Tokyo where he lives into elegant and hauntingly beautiful designs. In this case the theme is of beans growing on protective straw matting, a late evening setting being suggested by the reversal of the usual arrangement of contrasting coloured motifs against a black ground. The straw matting and the veins of the leaves are executed by means of *hiramaki-e* (flat sprinkled picture) techniques. These involve applying lacquer to a plain lacquer ground, sprinkling it with different grades and tones of gold and silver powder, leaving it to dry, and then covering it with layers of transparent lacquer. In this instance Taguchi has scratched away the metal powder to render the grid of the straw matting and the striated patterning on the leaves. For the tips and edges of certain of the leaves he has used flakes of gold, silver and mother-of-pearl, applied piece by piece rather than by sprinkling. He has also used *togidashi-e* (polished out picture) techniques in the delineation of the stems and the leaves. *Togidashi-e* is similar to *hiramaki-e* except that

black rather than clear lacquer is used to obliterate the decoration temporarily. The black lacquer is then polished away so that the decoration emerges from below. Through careful control of the polishing, the underlying pattern has been rendered with different degrees of clarity and intensity, adding softness to an otherwise starkly contrasting design. The depiction of the flowers and the beans has been achieved by a combination of *hiramaki-e* using pulverized green lacquer and the inlaying of large pieces of mother-of-pearl and strips of cut-out gold sheet (*hyōmon*). In using the technique of *hyōmon* inlay, Taguchi makes reference to eighth-century lacquerwares preserved in the Shōsōin Imperial Repository in Nara.

Taguchi was made a Living National Treasure in 1989, the year before he retired from teaching at Tokyo University of Arts, making him the third appointee active in the field of *maki-e*. His two counterparts are Ōba Shōgyo (b.1916) and Terai Naoji (b.1912), both Kanazawa-based artists, who received their titles in 1982 and 1985 respectively. All three of these artists studied and trained at some time in their careers with the towering giant of modern Japanese lacquer history, Matsuda Gonroku (1896–1986).

The core of Matsuda's box (PLATE 52) is made of cypress wood, the surfaces of which were charred and carbonized prior to being impregnated with lacquer. Linen and lacquer were then applied to produce an extremely stable base. Various *maki-e* techniques and mother-of-pearl inlay were used in the box's decoration. Diagonal lines divide the box into four areas. The longer sides are decorated with oak branches, the shorter with Chinese black pine. The latter is depicted in a combination of coloured *maki-e* and gold *takamaki-e* (raised sprinkled picture) against a *nashiji* (pear skin) ground. In *takamaki-e* lacquer is mixed with powdered charcoal or clay so that it can be built up in relief before metal dusts are applied. *Nashiji* involves the suspension of irregularly shaped flakes of gold in clear lacquer.

In view of the length of Matsuda's career and the influence he has had on subsequent generations of lacquer artists, both traditionalists and those with more experimental interests, it is worth recounting his career in some detail.[6] He was born in Kanazawa and began studying lacquer-making at the age of seven. By the time he graduated from the Ishikawa Prefectural Industrial School (*Ishikawa Kenritsu Kōgyō Kōkō*) in 1914, he was master of the elaborate style of *maki-e* decoration that had evolved in the Kanazawa area during the Edo period (1615–1868). He then studied under Rokkaku Shisui (1867–1950) and Shirayama Shōsai (1853–1923) at Tokyo University of Arts, from which he graduated in 1919. He also studied western and traditional Japanese styles of painting, and became acquainted with Masuda Don'o (1848–1938), a powerful business magnate and devotee of the tea ceremony who owned a major collection of tea utensils and other works of art.[7]

Matsuda's appreciation for classical art and his understanding of traditional lacquer technology were further deepened by his involvement during the early 1920s in a project to restore a group of Eastern Han period (AD 25–220) Chinese lacquer items excavated from the Lelang commandery in Korea. He also developed expertise in the use of traditional lacquer techniques in commercial applications during a brief period of employment with a company

specializing in export lacquerware, and in 1928 he designed and executed in lacquer parts of the interiors of two Japanese passenger ships. The year before he had been appointed Assistant Professor of Lacquer at Tokyo University of Arts. He became Professor in 1943 and continued to teach until his retirement in 1963.

In the postwar period he was involved in a survey of the lacquerware in the Shōsōin Imperial Repository in Nara and in the restoration of various important shrines and temples. He was appointed a Living National Treasure in 1955 and played a central role in the setting up and running of the Traditional Crafts Exhibition. Matsuda was also involved in the establishment of the Kagawa Prefectural Lacquer Research Institute (*Kagawa-ken Shitsugei Kenkyūjo*) in Takamatsu and the Ishikawa Prefectural Wajima Lacquer Technology Research and Training Institute (*Ishikawa Kenritsu Wajima Shitsugei Gijutsu Kenshūjo*), founded in 1954 and 1967 respectively.

Matsuda's efforts have been rewarded by the continuing vitality of contemporary Japanese lacquer-making as seen in events such as the Traditional Crafts Exhibition. That he and three of his former students should have been appointed Living National Treasures for their skills in *maki-e* is both a measure of Matsuda's talent as a practitioner and teacher and an affirmation of the centrality of *maki-e* among Japanese lacquer-making traditions.

While the achievements of Matsuda and his successors have been remarkable, it could be said that their influence has been disproportionately large and has had a proscriptive effect on the activities of younger artists. This is reflected in the composition of the membership of the Lacquer Section of the Japan Crafts Association and in the fact that many young *maki-e* artists seem to find it difficult to progress beyond the reworking of their teachers' styles.

The box by Miyoshi Kagari (b.1954) (PLATE 53) is an example of the work of a young artist operating within the Japan Crafts Association who has managed, unlike many of her peers, to develop a strikingly individual mode of expression. It is one of a series of recent works based on night views of Shinjuku in Tokyo as seen from the top of one of the skyscrapers for which the area is famous. Miyoshi started studying lacquer-making in 1975 while still at university. Her teacher was Sasaki Ei (1934–84), a former student of Matsuda Gonroku and a specialist in the use of mother-of-pearl. Miyoshi has exhibited at the Traditional Crafts Exhibition since 1984. Her work is interesting both for the inventiveness of its designs and for its imaginative use of mother-of-pearl. The extraordinary range of colours seen on this box results from the use of many different varieties and thicknesses of shell in combination with numerous colours of metal foil backing.

The use of mother-of-pearl is also central to the work of Sekino Kōhei (b.1943) (PLATE 54), a graduate of Tama University of Arts who lives, like Miyoshi, in Kanagawa Prefecture. The interior of this striking set of stacking boxes is finished in black lacquer. The exterior is covered in an irregular arrangement of perfectly fitting pieces of Japanese abalone shell. The supreme quality of Sekino's craftsmanship may be seen in the gently curving contours of the lid, which has been carved from a solid block of wood. Sekino studied for thirteen years under the late Kuroda

PLATE 53 *Opposite* 'Le Soir.' Box of lacquered wood with mother-of-pearl decoration. 1988. *width 17.5cm (6¾in); depth 12cm (4¾in); height 26.7cm (10½in)* **Miyoshi Kagari (b.1954)**

PLATE 54 Set of stacking boxes of lacquered wood with mother-of-pearl decoration. 1993. *width 33.2cm (13in); depth 21.2cm (8¼in); height 21.7cm (8½in)*
Sekino Kōhei (b.1943)

PLATE 55 *Opposite* Incense box of polychrome carved lacquer on a wooden core. 1970. *height 5.9cm (2¼in).* See also page 102.
Otomaru Kōdō (b.1898)

Tatsuaki (1904–82).[8] Like his teacher, Sekino finds inspiration in the wood and lacquer crafts of Korea, particularly those of the Chosŏn period (1392–1910). In this respect he differs from Taguchi, Matsuda and Miyoshi, whose work is based on Japanese lacquerworking precedents.

LACQUERWORK WITH CARVED DECORATION

THE INCENSE BOX by Otomaru Kōdō (b.1898) (PLATE 55) is a masterful rendering of a hydrangea in bloom executed in carved lacquer (*chōshitsu*).[9] Otomaru was born in Takamatsu and began his career as an apprentice to a woodcarver. His interest in lacquer-making developed in his late teens and he soon became a leading figure in the local craft community. In 1952 he moved his workshop to Tokyo, where he has continued to teach his formidable skills to his sons and other members of the family as well as to a succession of apprentices, mainly from the Takamatsu area. He was appointed a Living National Treasure in 1955.

In contrast to the techniques of *maki-e*, whereby designs are built up by the repeated application of lacquer and decorative elements, carved lacquer involves the cutting away of a pre-prepared lacquer base with a variety of tools. The base may consist of up to several hundred

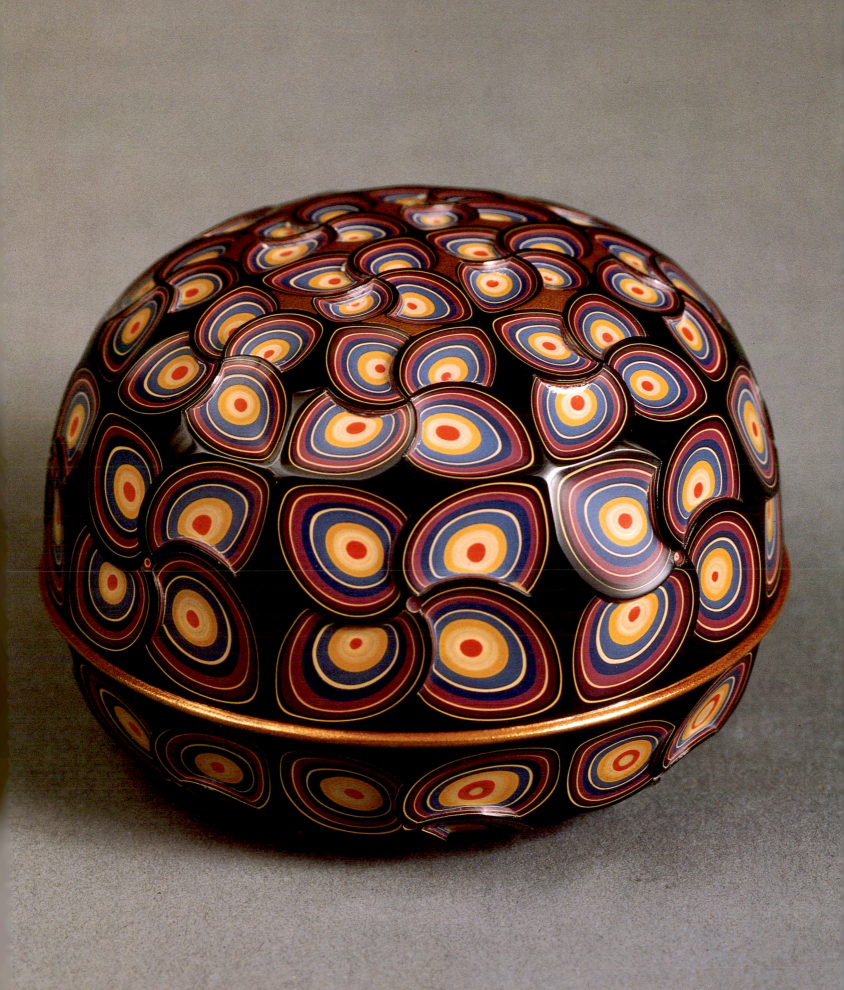

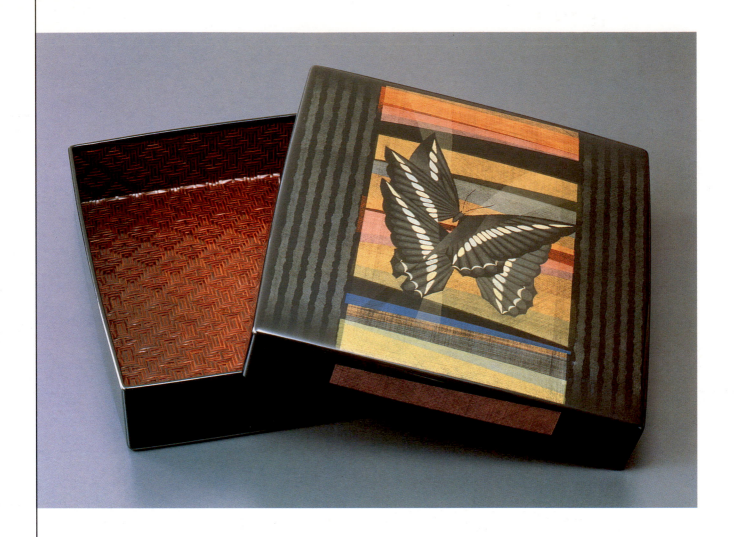

PLATE 56 'Butterfly.' Letter box of lac-
quered basketry with *kinma* (incised
and colour-filled) lacquer decoration.
1986. *width 26.5cm (10½in); depth 28cm
(11in); height 6.5cm (2½in)*
Ōta Hitoshi (b.1931)

layers, either single-coloured (usually red, black or yellow) or multicoloured, in which case the
order of their application has to be planned in accordance with the intended design. The
techniques of carved lacquer originated in China. They were used with particular sophistication
from the Yuan period (1279–1368) onwards and were introduced to Japan during the
Muromachi period (1336–1573). The development of modern pigments permits carved lacquer
artists to use a far broader range of colours than before. Otomaru has taken full advantage of
recent advances in technology and has extended the boundaries of carved lacquer through the
exploration of a startling new range of colour combinations. Although he and his followers are
prone to indulge in the overt prettiness seen on much contemporary Japanese lacquerwork, the
design of this particular piece is refreshingly simple and direct.

The technique of *kinma* (incised and colour-filled) lacquer decoration used by Ōta Hitoshi
(b.1931) (PLATE 56) also originated in China. Like carved lacquer, *kinma* is particularly associated
with the Takamatsu area, where Ōta now lives and works. Its introduction to Takamatsu is
accredited to Tamakaji Zōkoku (1805–69), who is said to have been inspired by lacquerwares
using this technique imported from Burma and Thailand. This explains the use of woven
bamboo cores characteristic of modern Japanese *kinma* production. *Kinma* lacquer decoration
involves the incising of a pattern into a plain lacquered ground. Coloured lacquer is then applied

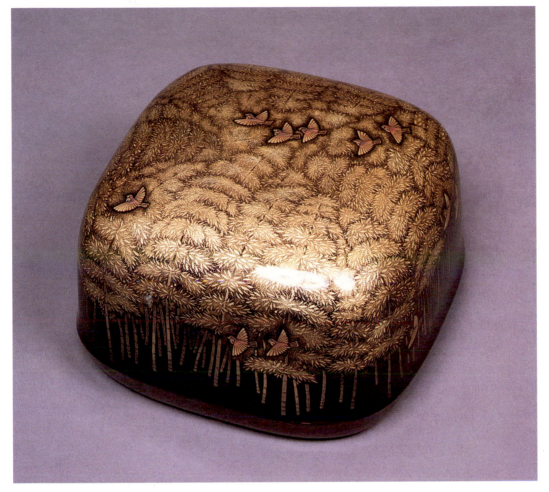

PLATE 57 'Bamboo Grove.' Box of lacquered wood with polychrome *chinkin* (incised and gold-filled) lacquer decoration. 1992. *width 25cm (9¾in); depth 25cm (9¾in); height 15cm (6in)*
Mae Fumio (b.1940)

over the whole area of the decoration and is polished down when dry so that it remains only in the incisions.

Having begun his career as a student of woodwork, Ōta became an apprentice to Isoi Joshin (1883–1964; appointed Living National Treasure in 1956), a leading exponent of *kinma* lacquer decoration. Ōta moved to Takamatsu in 1961 and has taught both at the Kagawa Prefectural Lacquer Research Institute (*Kagawa-ken Shitsugei Kenkyūjo*) and at Kagawa University. He has become an important figure in his field and is widely recognized for his execution of colourful designs on elegant and superbly crafted basketry forms. Ōta has been a regular contributor to the Traditional Crafts Exhibition since 1965. He was appointed a Living National Treasure in 1994.

Closely related to *kinma* and also originating in China is the technique of *chinkin* (incised and gold-filled) lacquer decoration as used by the Wajima-based Mae Fumio (b.1940) (PLATE 57). Mae studied at Kanazawa College of Arts and has contributed to the Traditional Crafts Exhibition since 1968. He is the son of the late Mae Taihō (1890–1977; appointed Living National treasure in 1955), a major figure in the recent history of Wajima responsible for the revival of *chinkin* techniques. *Chinkin* resembles *kinma* in the way in which a usually very intricate pattern is incised into a plain lacquered ground. Rather than coloured lacquers being used, however, a coat of clear lacquer is applied and then wiped away while it is still wet so that it

remains only in the incisions. This acts as an adhesive for the gold powder or gold foil that is then forced into the incisions. The decoration is fixed with a further coating of clear lacquer before being polished down so that any excess gold is removed. Although *chinkin* (literally 'sunken gold') implies the use of gold, other materials such as pulverized coloured lacquer may be employed. This can be seen in the detailing of the birds on the work shown here. The box is a masterful example of how *chinkin* lacquer techniques allow the rendering of sharply defined patterns of extreme intricacy and elegance.

Plain Lacquering

THE SET OF STACKING BOXES by Komori Kunie (b.1945) (PLATE 58) is an example of the work of a Wajima-based artist who has broken away from the traditional local mould to find a more personal means of expression. The edges of the lid and the trims of the three compartments are lacquered black. The basketry panels, which are fixed to wooden substructures, are lacquered by the so-called *tamenuri* technique. This involves covering a lower coating of red lacquer, in this case pigmented with iron oxide (*bengara*), with clear lacquer. Considerable care has been exercised in applying a sufficient number of layers of clear lacquer to achieve the appropriate sense of depth and translucency without obliterating the texture of the woven bamboo.

Komori departs from the practice of the division of labour that is characteristic of lacquer-making in Wajima. He undertakes every aspect of the design and execution of his work, starting with the felling of the bamboo and its preparation into weavable strips. His work, now reaching maturity, is a manifestation of a formidable diversity of skills which he continues to refine with single-minded dedication. He began his lacquer-making career in 1965, studying *chinkin* lacquer decoration at the Ishikawa Prefectural Wajima Lacquer Research and Training Institute (*Ishikawa Kenritsu Wajima Shitsugei Gijutsu Kenshūjo*) between 1968 and 1971. He has since gone on to study a wide range of woodworking, basket-making and lacquering techniques. Komori has exhibited at the Traditional Crafts Exhibition since 1977.

One of Komori's most important mentors was Akaji Yūsai (1906–84). Akaji was born in Kanazawa, where he studied lacquer-making from the age of sixteen. He moved to Tokyo in 1928 and two years later set up his own business. He ran this until 1946 when he joined a trading company, for which he worked until 1953. It was during this period that he conducted the research that was to lead him to the development of a distinctively personal idiom that combined superlative skills in plain lacquering with the making of highly wrought hoop-built (*magewa*) forms such as can be seen in the example illustrated here (PLATE 59).

Magewa, which is a technique pioneered by Akaji, is an extension of bentwood work (*magemono*). Instead of taking a thin, wide board of wood and bending it into shape, strips of wood of relatively even cross-section are bent into a series of concentric hoops of slightly differing diameters and are then assembled, one on top of the other, to build up the vessel form.

PLATE 58 *Opposite* Set of stacking boxes, wood and basketry core, with black and *tamenuri* lacquer finish. 1992. *width 26.1cm (10¼in); depth 19cm (7½in); height 18.5cm (7¼in)*
Komori Kunie (b.1945)

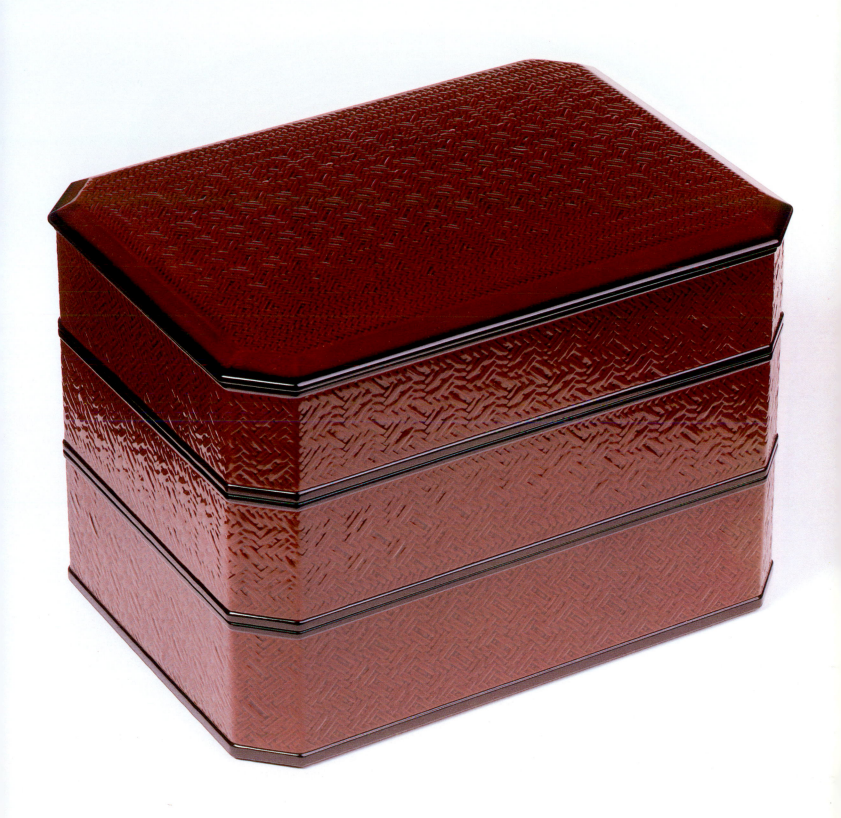

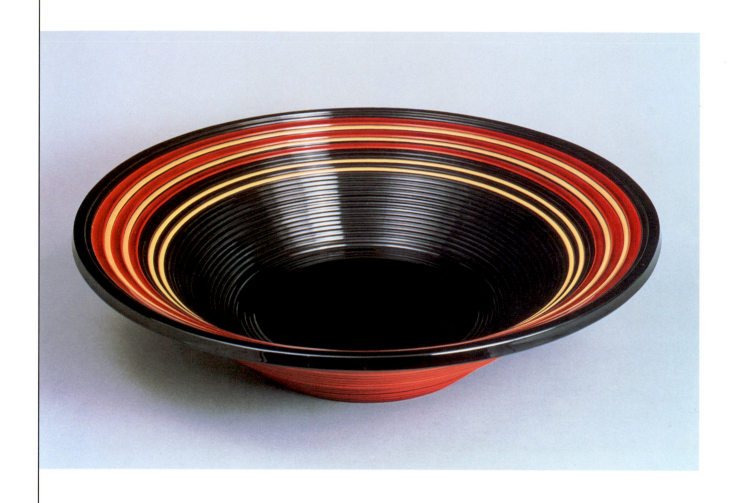

PLATE 59 Bowl, hoop-built core, with
red, yellow and black lacquer finish.
1961. *diameter 42.1cm (16½in)*
Akaji Yūsai (1906-84)

The hoops are prepared so that they expand and contract in the same direction, making for a final shape with a characteristically stepped profile that is virtually free from warping. They may be circular, as in the case of the bowl illustrated here, or faceted. The sharpness of definition between the strongly contrasting black, red and yellow banding was achieved by lacquering the hoops individually before joining them together. This elaborate and highly sophisticated technique was first used by Akaji in 1960 and was ultimately to earn him the title of Living National Treasure in 1974.

The exploration of new shapes that was such a fundamental aspect of Akaji's endeavour is a central concern of Masumura Kiichirō (b.1941), who uses dry lacquer (*kanshitsu*) as his main forming technique (PLATE 60). The dry lacquer technique involves the application of successive layers of fabric impregnated with wet lacquer to a previously prepared mould. This dries to give a lightweight but very strong core, which is removed from the mould and then subjected to the standard processes of lacquering. The profile of the core is determined by that of the mould, which, being made from wood, clay or plaster, can be freely shaped and modelled. Dry lacquer allows almost unlimited experimentation in the creation of new forms and is much more flexible in this respect than standard woodworking or basket-making techniques.

Masumura's primary interests lie in the researching of historical lacquer-making practices. He is a graduate of Tokyo University of Arts, where he has taught since 1986. The work shown here is a classic example of dry lacquer work of the most challenging kind. The mould for the

PLATE 60 Bowl, dry lacquer core, with red lacquer finish. 1991. *diameter 37.2cm (14½in)*
Masumura Kiichirō (b.1941)

core was made from plaster prepared by semi-mechanical means up to the point of being a basic curved conical shape with flat, faceted sides. The facets were then individually carved to provide the rounded contours seen on the finished work. The rigorous care with which this carving was carried out is especially apparent in the regularity of the pattern marking the transition from the flat bottom of the inside to the everted side walls.

The adoption of dry lacquer techniques by substantial numbers of contemporary Japanese lacquer artists reflects recent enthusiasm for sensitively designed shapes that are enhanced by and show off the subtlety of high quality plain lacquering. While an appreciation of simple forms and plain monochromes has long been part of the Japanese aesthetic, there is no doubt that modernist tendencies in Japan have also been a significant factor.

The large bowl (PLATE 61) is an exemplary piece of dry lacquer work in a minimalist vein by Ōnishi Nagatoshi (b.1933), presently Professor of Lacquer at Tokyo University of Arts, from which he himself graduated in 1959. As a student he developed an interest in *negoro* wares, a traditional style of lacquerwork much appreciated for the way in which the underlying black lacquer shows through the upper layer of red when worn. The bold forms, plain colours and utilitarian nature of *negoro* wares have inspired Ōnishi throughout a complex career, which has seen his involvement in a number of different craft organizations. His most long-standing affiliation has been with the Lacquer Craft Association (*Urushi Craft-tai*), an organization founded in 1963 to promote lacquerware functionally and aesthetically in tune with

contemporary styles of living. These interests also led to his involvement with the Japan Craft Design Association between 1968 and 1991.

Ōnishi is prominent among his peers in taking a keen interest in contemporary developments in lacquer-making in countries other than Japan. His initiatives in this area, which began with a research trip to Southeast Asia in 1982, have led to him becoming chairman and founding member of the World Lacquer Culture Council (*Sekai Urushi Bunka Kaigi*).

NEW DIRECTIONS IN LACQUER-MAKING

WITH THE EXCEPTION OF ŌNISHI, all the makers discussed so far work in traditionalist veins. There is, however, a substantial number of artists who employ lacquer techniques in the exploration of more experimental styles. Among the major focuses for these artists are the exhibitions held by the *Nitten* group and its related organizations – the Association of Modern Artist Craftsmen (*Gendai Kōgei Bijutsuka Kyōkai*) and the New Craft Artist Federation (*Nihon Shinkōgei Bijutsuka Renmei*).

One important artist who has been a regular contributor to the *Nitten* exhibition since 1954 is the Kyoto-based Suzuki Masaya (b.1932).[10] While the base of the work shown here (PLATE 62) is constructed and lacquered in the standard manner, its lid is made of carved and polished acrylic. The inside of the base is decorated with diagonal bands of orange and grey oil-based paint. Blue and green paint have been applied to the flat, uncut areas of the acrylic and then covered in black lacquer. The combination of the carving and the high refractive index of the acrylic results in the wildly swirling pattern of colours contained within the confines of the subdued black and red cube.

Suzuki's introduction of acrylic into the world of lacquer-making dates from the end of the 1960s, a time when he was actively seeking new materials that would allow him greater freedom to explore sculptural approaches to forming and surface patterning. Suzuki, who studied in Kyoto and then at Tokyo University of Arts, was born into a family of Kyoto lacquer-makers and started his training when he was twelve years old. His father, who had been a follower of trends in European design and had incorporated Constructivist elements into his work in the 1930s, influenced his development of avant-garde interests.

In addition to employing a wide range of both conventional and modern materials for his work, Suzuki also uses a variety of different formats. He makes everything from small-scale items, like the box shown here, to large pieces of furniture. Like the majority of his *Nitten*-associated colleagues, however, much of his major exhibition work has been in the form of lacquered graphic screens and panels or the occasional piece of abstract sculpture.

The potential offered by the use of two-dimensional formats is realized with particular success by Takahashi Setsurō (b.1914), a leading figure in the world of contemporary Japanese lacquer-making (PLATE 63). A graduate of Tokyo University of Arts, he has played a central role in the

PLATE 61 *Above and opposite (detail)* 'Earth.' Bowl, dry lacquer core, with red lacquer finish. 1986. *width 38cm (15in)*
Ōnishi Nagatoshi (b.1933)

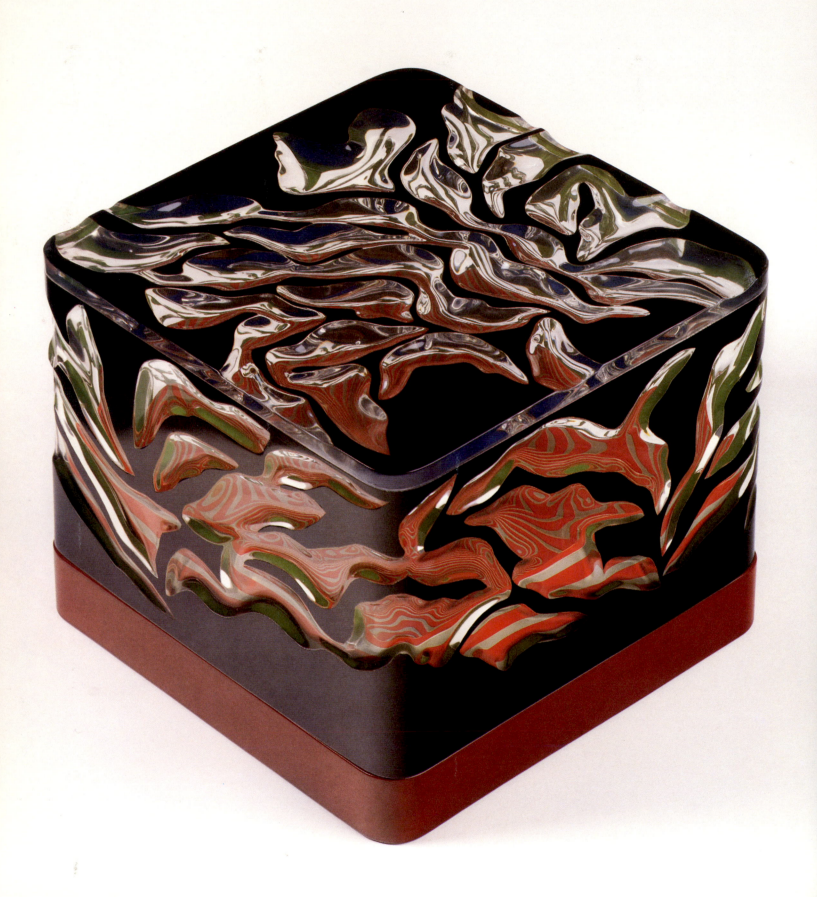

PLATE 63 'The Genesis of a Constel-
lation.' Two-panel screen (mobile
mural) of lacquered wood with poly-
chrome *chinkin* (incised and gold-
filled) lacquer decoration. 1975. *height
1.73m (5ft 8in)*
Takahashi Setsurō (b.1914)

activities of both the *Nitten* group and the Association of Modern Artist Craftsmen (*Gendai Kōgei Bijutsuka Kyōkai*). He was Professor of Lacquer at his *alma mater* between 1976 and 1982 and is well known for the almost fantastical nature of his imagery. On the screen shown here he has used *chinkin* (incised and gold-filled) lacquer decoration techniques involving gold, platinum and small amounts of red and green lacquer in the creation of a romantic and sublimely ethereal design.

For many years Kado Isaburō (b.1940) was another artist who specialized in the use of *chinkin* lacquer techniques in graphic formats. In the early 1980s, however, he abandoned this kind of work and cut his ties with the *Nitten*-related New Craft Artist Federation (*Nihon Shinkōgei Bijutsuka Renmei*). Kado, a native of Wajima, found the inspiration for the very different style of his new work in the large, roughly lacquered food bowls that used to be made for local consumption in the nearby village of Yanagida.[11] The approach to the making of the tray shown here (PLATE 64) is an unusual one. It has less in common with standard lacquer-making practices than with the work of potters who exploit the chance effects of firing and for whom the visible

PLATE 62 *Opposite* 'Sprouting Box.'
Lacquered and painted wood and
carved acrylic. c.1978. *width 26cm
(10¼in); depth 26cm (10¼in); height 21.5cm
(8½in)*
Suzuki Masaya (b.1932)

PLATE 64 Tray of lacquered wood dec-
orated with strips of lacquer-soaked
hemp cloth. 1991. *width 84.9cm (33½in)*
Kado Isaburō (b.1940)

evidence of their engagement with their materials is a key aspect of the finished product. The tray is one of a recent series in which Kado soaked torn-up strips of old hemp cloth in clear lacquer and applied them in a variety of bold patterns, in this case by throwing them on to the lacquered wooden core in a mood of Abstract Expressionist abandon. The strips of black lacquered fabric that protect the rim and strengthen the joints between the base and the walls of the tray have been left intentionally visible, further increasing the overall sense of spontaneity.

The final work illustrated in this chapter is by Kurimoto Natsuki (b.1961), a young Kyoto-based artist who, in the late 1980s, established an important reputation for strongly coloured, mixed media works based around large-scale dry lacquer (*kanshitsu*) forms.[12] The piece shown here (PLATE 65), which dates from immediately after this phase in his career, was also made by the dry lacquer technique, the inner core being made of polystyrene. He has used metal powders, pulverized and coloured lacquers and mother-of-pearl to create a bold and unusual design. The title of the work, 'A Priest's Crown', is indicative of Kurimoto's interest in ritual and religion. Kurimoto studied at Kyoto City University of Arts, to which he has recently returned as a member of the teaching staff. The desire to explore new and exciting approaches that he will undoubtedly inspire in his students augurs well for the future of contemporary Japanese lacquer-making.

PLATE 65 *Opposite* 'A Priest's Crown.'
Polystyrene and dry lacquer core with
polychrome lacquer decoration. 1991.
height 41cm (16¼in)
Kurimoto Natsuki (b.1961)

DYEING, WEAVING & FIBRE ART

A RECENT OVERVIEW OF INTERNATIONAL TRENDS in textile design stated that 'in terms of attitude, technology and tradition Japan is the closest thing on this planet to a textile paradise'.[1] The current strength of the Japanese textiles industry, it was argued, is the product of decades of investment in sophisticated textile technology within a culture that pays continuing respect to veteran kimono makers. Minagawa Makiko's designs for Issey Miyake and the interior fabrics of Arai Jun'ichi, Sudo Reiko and other designers associated with the Nuno Corporation are evidence of the extraordinary results that can ensue when sensitivities based on a deep knowledge of traditional textiles are harnessed to the application of advanced technology.

That textile design and textile art are coming to be viewed as parts of a larger totality is reflected in the inclusion of fabrics by textile designers in major exhibitions of studio textiles and, even more significantly, in the organization of the Kyoto International Textile Competition.[2] The borderlines between hitherto separate disciplines have started to blur, the emergence of individuals whose activities straddle more than one area being a feature of modern Japan in the same way as it is of Europe and North America. Dyers, weavers and fibre artists such as those whose work is discussed in this chapter operate in a context whereby their interests and imperatives and those of textile designers bear on one another in an increasingly complex manner.

DYEING AND WEAVING

JAPAN'S POSITION AS A MAJOR CENTRE for contemporary studio textiles owes much to the richness of its dyeing and weaving traditions. Some of these have continued unbroken from the time of their inception to the present day. Others are known of through surviving textile

Opposite 'Green Waves', kimono (detail) by Moriguchi Kunihiko (see plate 74)

fragments and artefacts. In the same way as artists working in ceramics and other media have revived various historical traditions, Japanese dyers and weavers have been actively engaged in the recreation and exploration of former styles and techniques.[3] Interest in indigenous traditions has been reinforced by increased access to information about the textiles of other cultures. These have also served as sources of inspiration in their own right, leading to a general broadening of Japan's studio textile repertory.

The nine works discussed below have been chosen to illustrate some of the more important techniques in use today and to provide a sense of the mastery of design of Japan's leading dyers and weavers. The discussion has been divided according to whether designs have been achieved by weaving, stencilling or freehand patterning. The term weaving is used in the sense of the Japanese word *sakizome* (pre-dyeing), a general category for textiles produced by the weaving of pre-dyed yarns. *Sakizome* is the antithesis of *atozome* (post-dyeing), which refers to textiles produced by the dyeing of pre-woven fabrics. Stencilling and freehand patterning are both types of *atozome*.

TEXTILES WITH WOVEN PATTERNING

THE PALE BLUE GAUZE-WEAVE (*ra*) kimono (PLATE 66) by the Kyoto-based Kitamura Takeshi (b.1935) is a fine example of the skills of one of Japan's most accomplished weavers.[4] A member of the Japan Crafts Association since 1968, Kitamura gained the solid technical grounding on which his artistry is based as a young apprentice weaver in Kyoto's Nishijin district. The production of gauze-weave fabric is a highly complex process, involving the use of a special loom that allows the repeated twisting together of adjacent warp threads during the course of weaving. The way in which the warp threads are fixed into position on the weft makes it possible to create stable, open-structured textiles with regular overall patterning.

Figured gauze-weave fabrics were made in China by at least the Warring States period (475–221 BC). The technology was subsequently introduced to Japan, where numerous seventh- and eighth-century examples have survived in early collections such as at the Shōsōin Imperial Repository in Nara.[5] We have already seen how important a source of inspiration the treasures in the Shōsōin have been for woodworkers and lacquer artists working in traditional modes. While this has also been true of textile artists, the problems of developing appropriate technical procedures, particularly where patterned weave textiles are concerned, have been very much greater than in other media. Few makers have had the patience or depth of experience needed to reproduce early weaving techniques, let alone to make them the starting point for new work.

If Kitamura's exquisitely woven fabrics evoke a sense of the grandeur of court and temple ritual of the Nara period (710–94), the *tsumugi* textiles of Shimura Fukumi (b.1924) speak of traditions of much humbler origins (PLATE 67).[6] *Tsumugi* is a general term for the sturdy plain-weave cloth that peasants throughout Japan used to weave for personal use from silk obtained

PLATE 66 *Opposite* Gauze-weave silk kimono. 1981.
Kitamura Takeshi (b.1935)

from wild cocoons or from the spoiled leftovers of cultivated silk production.[7] Designs were executed in the form of stripes, checks or *kasuri* (ikat; see below, PLATE 68) and the cloth had a distinctively nubbled texture resulting from irregularities in the hand-spun floss silk yarns. Indigo blue was the predominant colour.

Shimura tends to use smooth reeled silk for her warps and rough *tsumugi* silk for her wefts. This gives the fabric more gloss than it would have if *tsumugi* yarns were used for both warp and weft.[8] Indigo, which she obtains from specialist suppliers, is a key colour, but she also uses an extensive range of dyes obtained from plants grown on a plot of land near her workshop in the northwestern outskirts of Kyoto. The kimono illustrated here is woven from yarns dyed in different shades of indigo blue, eulalia (*Miscanthus sinensis*) yellow, onion skin brown and indigo-over-eulalia green.[9] It is a good example of how Shimura succeeds in preserving the essentially rustic characteristics of the *tsumugi* tradition while making it the vehicle for the exploration of her highly evolved sense of colour and tone.

The title of the kimono comes from the *Tales of Ise*, a tenth-century *utamonogatari* (tale of poems) based on poems by and legends about Ariwara no Narihira (825–80). Narihira was a great romantic figure of the early Heian period (794–1185) court, and the *Tales of Ise* is one of the best known works of classical Japanese literature. As such they were focal subjects for Edo period (1615–1868) artists and designers of the Rinpa school.[10] The title 'Ise' refers to the fact that the colour scheme of the kimono was inspired by the strong, rich pigments characteristic of Rinpa school painting.

The imagery and titles of Shimura's textiles reflect a long-standing interest in classical Japanese literature that predates her relatively late debut as a textile artist. She began to learn weaving in her early thirties under the guidance of her mother and was encouraged to submit an example of her work to the 1957 Traditional Crafts Exhibition by the woodworker Kuroda Tatsuaki (1904–82).[11] A series of prizes won over the next four years established her reputation as one of Japan's leading textile artists, a position she has maintained ever since. Shimura was made a Living National Treasure in 1990.

Munehiro Rikizō (1914–89), the maker of the *kasuri* (ikat) kimono (PLATE 68), was similarly responsible for taking a long-established textile tradition and adding a strongly personal dimension to it.[12] The term *kasuri* refers to textiles woven from yarns that are partially tied or clamped before being dyed. These yarns may be used in the warp, in the weft or in both. Once the loom has been set up, weaving proceeds according to a predetermined plan so that the sections of the yarn reserved from the dye form a pattern in the finished fabric.[13] *Kasuri* textiles became popular in Japan in the late sixteenth and early seventeenth centuries when they began to be imported from the Ryūkyū islands, a major centre of *kasuri* weaving since the fourteenth century. Domestic production started in the seventeenth century and became widespread during the second half of the eighteenth century.

Munehiro's career as a textile artist began relatively late in life. Further to various initiatives he had been involved in before the Second World War to improve living standards in the

PLATE 67 *Opposite* 'Ise.' Plain-weave *tsumugi* (hand-spun floss) silk kimono. 1988.
Shimura Fukumi (b.1924)

PLATE 68 Plain-weave *tsumugi* (hand-spun floss) silk kimono with *kasuri* (ikat) patterning. 1989.
Munehiro Rikizō (1914–89)

mountainous areas around his native town of Gujō Hachiman, he hit on the idea of establishing a textiles industry based on *tsumugi* weaving skills surviving among local households.[14] This was in 1947. The introduction of various technical improvements was followed by the founding of a dedicated research and training centre in 1953. During the late 1950s and early 1960s he staged a series of one-man exhibitions through which he tried to increase public awareness of *tsumugi* textiles and to promote a market for them. The incorporation of *kasuri* into his work at this time was motivated at a personal level by the possibilities it offered him for developing new designs. For the Gujō textiles industry it was a means of making its products more sophisticated and increasing its market penetration.

Munehiro's ambitions as an individual artist led to his involvement with the Traditional Crafts Exhibition from 1965 onwards. The kimono shown here dates from the last year of his life. In a manner typical of his best work, the freshness and immediacy of its geometric pattern executed in shades of madder red (*akane*) belie the exacting process by which it was made. Munehiro's

PLATE 69 'Flight.' Crepe silk kimono with *katazome* (stencil-dyed) patterning. 1990.
Matsubara Yoshichi (b.1937)

profound understanding of traditional textile techniques and his unique sense of design attracted many students to his workshop. As in the case of Shimura Fukumi there is a whole generation of younger artists who have been inspired by his example. He was made a Living National Treasure in 1982.

TEXTILES WITH STENCILLED PATTERNING[15]

THE KIMONO BY THE TOKYO-BASED Matsubara Yoshichi (b.1937) (PLATE 69) is a prime example of contemporary indigo-dyeing using the *katazome* (stencil-dyeing) process, one of the best known traditional methods of dyeing pre-woven fabrics (*atozome*).[16] The basic techniques of *katazome* were established by the end of the sixteenth century and are thought to have remained essentially unchanged to the present day. The stencils used to apply

the designs are made of up to four sheets of Japanese paper laminated and made durable with the juice of unripe persimmons. Resist paste, made from a mixture of rice flour and rice bran, is applied through the stencil on to the fabric. The stencil is peeled away, and the resist paste is allowed to dry. A sizing liquid, usually an extract made by soaking ground soyabeans in water (*gojiru*), is then brushed on. Once this has dried the fabric is dyed, the colour not penetrating the paste-covered areas. This is followed by fixing and the washing off of the water-soluble resist paste to reveal the pattern.

As the tenth son of Matsubara Sadakichi (1893–1955; appointed Living National Treasure in 1955), Matsubara is heir to a particularly complicated form of *katazome* traditionally used in the production of cotton summer robes (*yukata*) with indigo-dyed pictorial patterning set against a white ground. Known as *chūgata* (middle-size patterned) dyeing, this entails the careful registering of resist-paste on both sides of the fabric and in some cases the use of multiple stencils.

Matsubara's contribution to the art of *katazome* lies in his development of a process whereby the resist paste is washed off and reapplied between each of numerous dippings in the indigo vat, either with the stencil being moved by a small but regular amount each time, or with stencils of the same pattern but of increasingly diminishing size being employed. It can be seen from the kimono illustrated here, which was made by the latter method using a set of some thirty stencils, how this gives a gradated effect with the blue growing in intensity from a central area of white. Time-consuming though the process is, it allows the creation of boldly contemporary designs while showing off the traditionally appreciated qualities of indigo dyeing to their best advantage. Matsubara first used this multiple dipping technique in 1965, two years after he started contributing to the Traditional Crafts Exhibition.

The striking design on the cotton kimono by Serizawa Keisuke (1895–1984) (PLATE 70) was also achieved by the use of stencils. The term *kataezome* (stencil-picture-dyeing), which is used to describe calligraphically or pictorially expressive work of this kind, was officially adopted as a new textile category when Serizawa was appointed a Living National Treasure in 1956. Technically speaking there is no difference between *kataezome* and other forms of *katazome*. The distinction is made on the basis of the perception that the *kataezome* artist's involvement in all stages of the making process leads to the creation of more highly individualistic works than is possible under the system of division of labour traditionally associated with *katazome*.

Born in Shizuoka Prefecture but subsequently a long-time resident of Tokyo, Serizawa initially trained as a graphic designer. His nascent interest in textiles was encouraged by his meeting with Yanagi Sōetsu (1889–1961) in 1926. This marked the beginning of a lifelong involvement with the Japanese Folk Craft movement. The future of his career was determined by his encounter with a group of Okinawan *bingata* textiles at a regional products promotion exhibition in 1928. The term *bingata* refers to a particular kind of polychrome stencil-dyed fabric historically associated with the Ryūkyū court and characterized by vibrant colours resulting from the use of intensely hued mineral pigments.[17] The Ryūkyū islands were annexed in 1879 and incorporated

PLATE 70 *Opposite* Plain-weave cotton kimono with *kataezome* (stencil-picture-dyed) patterning. 1961. *Serizawa Keisuke (1895-1984)*

into Japan as Okinawa Prefecture. With the fall of the Ryūkyū court there was no longer any official requirement for *bingata* textiles. A number of workshops managed to survive, however, under the patronage of the wealthy few who could afford to buy their products, and the tradition survived into the twentieth century.

Serizawa's enthusiasm for *bingata* dyeing led him to travel to Okinawa in the late 1930s. Armed with the techniques he learned during this visit and the skills he had already gained as a designer and textile artist, he spent the remainder of his extensive career producing a remarkable diversity of stencil-dyed work in a multiplicity of formats including cushion covers, hangings, screens, calendars and book illustrations as well as kimono. Along with Tomimoto Kenkichi (1886–1963) in ceramics, Matsuda Gonroku (1896–1986) in lacquerware and Kuroda Tatsuaki (1904–82) in woodwork, Serizawa's influence as one of modern Japan's greatest craftsmen-designers has been widespread and enduring. The kimono shown here, its *i-ro-ha* (*hiragana* syllabary) design being the ultimate symbol of the Japaneseness of Japanese culture, is one of the best known works from his exceptional oeuvre.

It has been seen how the designs on the kimono by Matsubara and Serizawa were created by the application of resist paste through stencils and the subsequent dyeing of the unprotected areas of the fabric. This is the way stencils are most often used in Japan. It should be noted, however, that since the advent of chemical dyes in the late nineteenth century it has also been possible to apply dyes directly through stencils. One way of doing this is to mix the dye with the resist paste. This method has been used by the Tokyo-based Komiya family in the making of *komon* (small-size patterned) textiles subsequent to experiments carried out by Komiya Kōsuke (1882–1961; appointed Living National Treasure in 1955) in the early years of this century.

The six-panel screen by the Kyoto-based Fukumoto Shigeki (b.1946) (PLATE 71) is the product of a related but different set of techniques involving stencilling with masking tape and wax resist dyeing (*rōketsuzome*). It is an archetypal example of how Fukumoto employs luminously radiant colour schemes on fabrics that are, to use his words, 'almost too gentle' to bear his severely articulated compositions.[18] The use of a special brush technique in the repeated application of fibre-reactive dyes gives the tonal grading that lies at the heart of his work. At the same time the flexibility of wax resist dyeing allows him to produce the delicately subtle textures revealed by close examination of his surfaces.

Fukumoto's career as a textile artist began after he had completed his studies in western-style painting at Kyoto City University of Arts in 1970. He started showing at the *Nitten* in 1976 and held his first one-man show in 1983. He has taught at Osaka University of Arts since 1989. His choice of wax resist dyeing as a creative medium has been a pragmatic one, based on his desire for a means of expressing particular aesthetic concerns. Fukumoto points to three main characteristics of wax resist dyeing that distinguish it from other techniques.[19] The first is the great range of effects afforded by the use of different waxes and tools. The second is the unique flavour of the crackled and semi-resisted effects that can be achieved through the manipulation of certain waxes. The third is the unlimited potential for overdyeing that it offers.

PLATE 71 *Opposite* 'Box and Vessel' series. Six-panel screen of satin-weave cotton with stencilled wax resist dyed patterning. 1988. *height 1.90m (6ft 3in)* *Fukumoto Shigeki (b.1946)*

It should be noted that although the seventh- and eighth-century wax resist dyed textile fragments preserved in the Shōsōin Imperial Repository have been of much interest to Fukumoto, they have not been a direct source of inspiration in the way that they might have been for an artist affiliated with the Japan Crafts Association.[20] His eschewing of the kimono in favour of screens and panels – a parallel, for example, to the use of two-dimensional formats by lacquer artists in search of alternatives to traditional vessel and container forms – is typical of Japanese makers who are intent on asserting themselves at the leading edge of contemporary textile art.

TEXTILES WITH FREEHAND PATTERNING

THE SWEEPING DESIGN OF SOFTLY RENDERED FLOWERS, leaves and dragonflies set against a latticed background seen on the kimono by Furusawa Machiko (b.1933) (PLATE 72) was achieved through the combined use of *shibori* (shaped-resist-dyeing) techniques and hand-painting.[21] Furusawa was born and educated in Tokyo. During the 1950s, after an initial period when she thought she might become a painter, her growing interest in textiles led her into what has become a continuing involvement with the Japanese Folk Craft movement. Since 1971, when she married the head priest of a temple in Ōita Prefecture, she has lived in Kyūshū.

The delightful lyricism of Furusawa's work is firmly rooted in the wide range of skills she has amassed over the years. The process by which the kimono shown here was created was a long and complicated one. It began with the overall design being drawn on to the temporarily made up kimono with a pale blue tracing liquid (*aobana*) derived from the *tsuyukusa* plant (*Commelina communis*). The kimono was then disassembled to allow work to be carried out on the individual panels of cloth. The areas to be left white or coloured other than green were protected by being stitched around and gathered up, wrapped in plastic film and tightly bound with thread. The fabric was dyed with a yellow dye derived from the *kariyasu* plant (*Arthraxon hispidus*) and, after an intervening period to allow the yellow to stabilize, with indigo blue.

When the blue-over-yellow dyeing of the background was completed, the binding and stitching were undone and work progressed to the treatment of the leaves and dragonflies. The outlines and leaf-veins that were to be left white were protected by a further round of stitching and gathering. Blue pigment was applied by brush to colour the leaves with stitch-resisted veins. The areas around the dragonflies and the remaining leaves were protected by being wrapped in plastic film and bound. This was followed by the repeated dipping of the individual sections of the fabric in a brown dye derived from the bark of the *yamamomo* tree (*Myrica rubra*). The binding and stitching having been undone, Chinese ink (*sumi*) dissolved in soyabean extract (*gojiru*) was used to paint in the flower petals and the veins of the brown leaves and to accentuate other parts of the design. Steam was used to straighten the fabric and to soften the *shibori* marks before the kimono was assembled into its final form.

PLATE 72 *Opposite* Figured plain-weave silk kimono with *shibori* (shaped-resist-dyed) patterning and hand-painting. 1992.
Furusawa Machiko (b.1933)

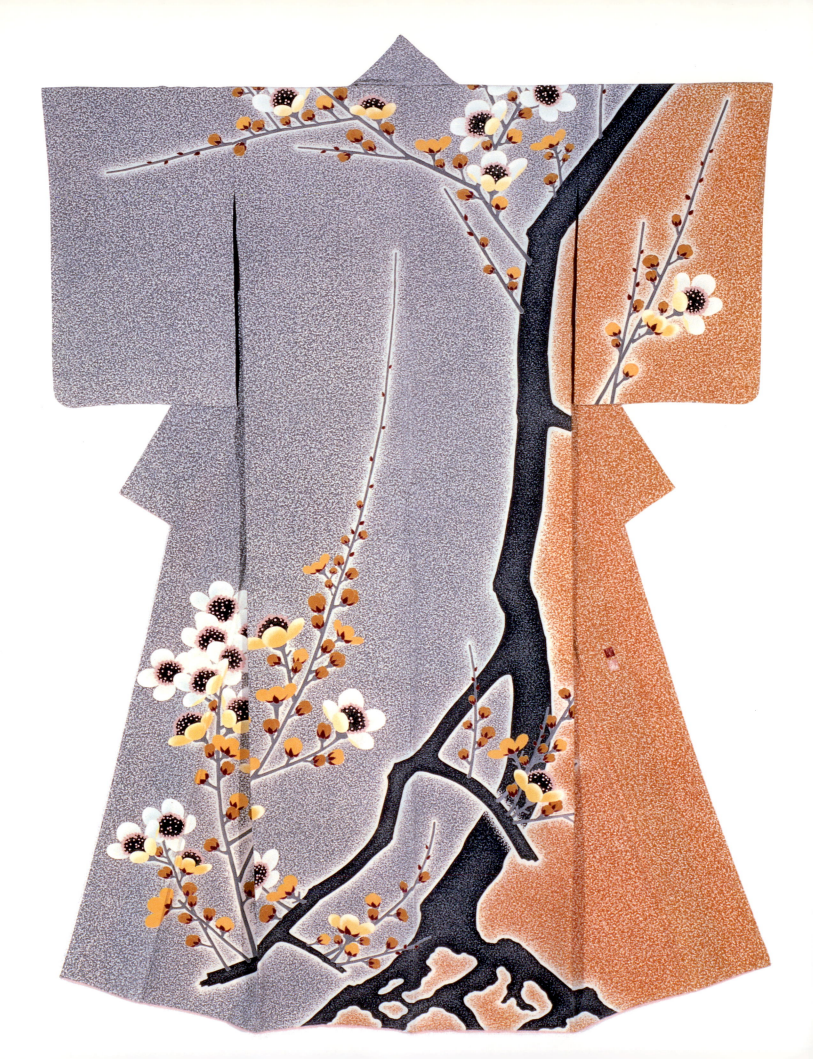

The inspiration for much of Furusawa's work comes from what is known as *tsujigahana*, a distinctively Japanese textile form that was highly popular between the fourteenth and early seventeenth centuries.[22] The majority of examples that survive today date from the latter part of the Momoyama period (1573–1615) and are characterized by richly coloured designs made up of soft-edged *shibori*-dyed motifs highlighted with delicate ink painting. It is evident from the example shown here that Furusawa's interest lies not so much in recreating the *tsujigahana* style but in capturing its spirit of spontaneity rendered through sensitive and accomplished craftsmanship.

The contrast between the designs on the kimono by the Kyoto-based Moriguchi Kakō (b.1909) (PLATE 73) and his son Moriguchi Kunihiko (b.1941) (PLATE 74) says much about the diversity of interests informing the work of contemporary Japanese *yūzen* artists.[23] Kakō's classicizing designs, executed in an expansive painterly style, are based directly on the sketches of nature that he regularly goes out to draw. The titles of Kunihiko's highly innovative and equally arresting kimono reflect a similarly deep-rooted concern with the natural world. His designs are arrived at not through direct observation of nature, however, but through a process of abstraction which involves taking a single stylized motif and subjecting it to a series of mathematically determined transformations. On the work shown here it can be seen how the number of waves in each square decreases as one moves from bottom to top and from left to right. This is combined with tonal grading, from dark green at the bottom to mid-green at the top. An important feature of both artists' work is the way in which they create designs that are effective not only when the kimono is displayed but, more importantly, when it is worn.[24]

The techniques of *yūzen*-dyeing are said to have been developed by the Kyoto fan painter Miyazaki Yūzen in the late seventeenth and early eighteenth centuries as a way of transferring his popular painted designs onto fabric.[25] While mechanized means of achieving the effects of *yūzen*-dyeing have been in use since the late nineteenth century, the Moriguchis have been rigorous in adhering to traditional procedures.[26] With the kimono temporarily assembled the design is drawn onto the white silk fabric with pale blue tracing liquid (*aobana*). The kimono is then unpicked, and the individual panels of cloth are stretched onto bamboo frames. Resist rice paste is painstakingly squeezed through a fine-nozzled applicator along the lines of the drawing. The areas inside the resisted outlines are sized with soya bean extract (*gojiru*) before dyes and pigments are brushed on to build up the pictorial motifs. The colours are fixed by steaming.

When the background is to be dyed the coloured motifs are covered over with resist paste. Sizing liquid followed by one or more background colours are brushed on. Once the dyeing has been completed the panels of cloth are removed from their bamboo frames so that the resist paste can be brushed off in running water. They are then steamed and straightened in readiness for being made up into the finished kimono.

An additional technique unique to the Moriguchis is the sprinkling on of small particles of rice resist paste prior to and between applications of the background colours. The mottling that results from this so-called *makinori* (sprinkled rice paste) technique can be gradated by varying

PLATE 74 *Above* 'Green Waves.' Plain-weave *tsumugi* (hand-spun floss) silk kimono with *yūzen*-dyed patterning. 1973. See also page 124.
Moriguchi Kunihiko (b.1941)

PLATE 73 *Opposite* 'Brilliance.' Crepe silk kimono with *yūzen*-dyed patterning. 1989.
Moriguchi Kakō (b.1909)

the density of application of the resist particles. It can be seen on the example of Kakō's work illustrated here how the increasing of the resist effect towards the edge of the background throws the pictorial motifs into particularly dramatic relief.

Kakō's pioneering of the *makinori* technique dates back to the period immediately after he became a fully qualified *yūzen* master in 1939. This marked the beginning of an impressive career, which saw his establishment of an independent workshop in 1949 and, from the mid-1950s, his close involvement with the Japan Crafts Association. He was appointed a Living National Treasure in 1967. It was in this year that Kunihiko joined his father's workshop after studying Japanese-style painting at Kyoto City University of Arts and then spending three years at the École Nationale Supérieure des Arts Décoratifs in Paris. Kunihiko's decision to become a *yūzen* artist represented a boost to the traditional textiles world no less significant than the appearance of figures such as Shimura Fukumi and Munehiro Rikizō (see above, PLATES 67 and 68) a generation earlier. The strength of his commitment to make the *yūzen* tradition relevant to the late twentieth century is reflected in his view that he would prefer that the kimono should die out altogether than see it enslaved to the past or to purely commercial considerations.[27]

FIBRE ART

THE ORIGINS OF FIBRE ART are usually placed in the late 1950s and early 1960s, when handweavers in the United States and tapestry-makers in eastern Europe began to adapt the techniques used in the making of two-dimensional works to the production of relief forms and three-dimensional structures. Moving away from the concerns of commercial production, artists began to reassess the nature of fibre and the techniques used in its manipulation. The study of historical textiles and the products of pre-industrialized societies led to the discovery of a wealth of alternative forms and processes that could be used as the starting point for contemporary experimentation. The search for new materials resulted in the incorporation into the textile art repertory both of natural unprocessed fibres and of modern industrial products such as metal wire, plastic tubing and celluloid.[28]

Although American artists may have led the fibre art movement since its early days – the seminal exhibition 'Woven Forms' organized by the American Craft Council in 1963 stimulating much interest when it travelled to Europe[29] – it was in Switzerland that the first international showcase for experimental textiles was established. The International Centre of Ancient and Modern Tapestry was set up in Lausanne in 1961 with the primary aim of organizing regular exhibitions of contemporary textiles. First held in 1962 and biennially since 1965, the Lausanne International Tapestry Biennial has played a major role in promoting the work of fibre artists from all over the world. Other large global events in the contemporary textile field include Poland's International Textile Triennial, which was first held in Lodz in 1972, and Japan's Kyoto International Textile Competition. Starting in 1987, this has been held biennially since 1990. As

PLATE 75 'Furniture for the D.H. Company's Single Men's Dormitory.' Dyed and woven cotton. 1976. *width 4m (13ft 1in); depth 3m (9ft 10in); height 60cm (23½in)*
Onagi Yōichi (b.1931)

well as asserting Japan's pivotal position in the world of contemporary textiles, an important aspect of the Kyoto competition is the way in which it actively promotes intercourse between textile artists and textile designers.

The emergence of Japan as an important force in the world of fibre art owes much to the pioneering efforts of Takagi Toshiko (1924–87).[30] Like her husband Yagi Kazuo, one of the founders of the avant-garde ceramics group the *Sōdeisha*,[31] she was alert to developments in contemporary art in the United States and elsewhere. She began producing three-dimensional textile structures at the end of the 1950s. A teacher at Kyoto City University of Arts from 1962 onwards, she trained many of the artists who have since made Kyoto the centre of Japan's fibre art movement.

The creative strengths of Japan's fibre artists were given national recognition through the inclusion of their work in the 'New Textile Artists' exhibition held at the Kyoto National Museum of Modern Art in 1971. This was also the venue for two major international exhibitions that brought the work of overseas artists to Japan – 'Fiber Works – Europe and Japan' held in 1976 and 'Fiber Works – Americas and Japan' held the following year. The impetus behind the staging of these two seminal exhibitions came from the international acclaim Japan had received in 1973 when six of its leading fibre artists were chosen to participate in the 6th Lausanne International Tapestry Biennial.[32]

The Kyoto-based Onagi Yōichi (b.1931) was one of the artists represented at Lausanne in 1973. The sexual connotations of the piece he showed on that occasion, 'The Naked Bride', are seen in many of his works from the early to mid-1970s. The example illustrated here (PLATE 75) consists of two enormous pairs of brightly coloured legs made from dyed and woven cotton. The humorous title alludes to the system common in Japan whereby large companies provide simple

PLATE 76 'M-25.' Plywood, steel and cotton thread. 1979. *width 1.2m (47in); depth 80cm (31½in); height 2m (6ft 7in)*
Kobayashi Masakazu (b.1944)

PLATE 77 *Opposite* ' "Frame Cloth" A,B.' Cut, piled and sewn cotton cloth. 1982. *two pieces, each width 96cm (37¾in); depth 14cm (5½in); height 1.84m (6ft)*
Yoshimura Masao (b.1946)

accommodation for their unmarried male employees. Since the late 1970s Onagi has moved away from this figurative style of work to explore more abstract interests revolving around the way in which woven forms can be made to resist or succumb to the forces of gravity.

A concern with the effects of gravity is also seen in the work of Kobayashi Masakazu (b.1944). An important Kyoto-based artist who graduated from Kyoto City University of Arts in 1966, he was also represented at Lausanne in 1973. The work shown here (PLATE 76) consists of an upright plywood panel and a bundle of threads, which hang as a natural parabola. An uncanny tension is created by the way in which the threads appear to support the vertical panel. This illusionary quality is dependent on the use of a hidden steel armature from which the threads are hung. Kobayashi's long-standing interest in the nature of thread has more recently manifested itself in a series of works in which threads are stretched rather than hung.[33]

If Kobayashi explores the behaviour of thread, Yoshimura Masao (b.1946) is primarily interested in the nature of cloth (PLATE 77). A graduate of Kyoto City University of Arts and now based in Osaka, he teaches at Seian Women's University, a private university in Kyoto which has been another important focus of fibre art activities. As the artist himself has stated, cloth is a material that is very familiar to all of us and that has generally been created to fulfil practical needs.[34] Yoshimura has reinvented the meaning of cloth by removing this functional aspect and

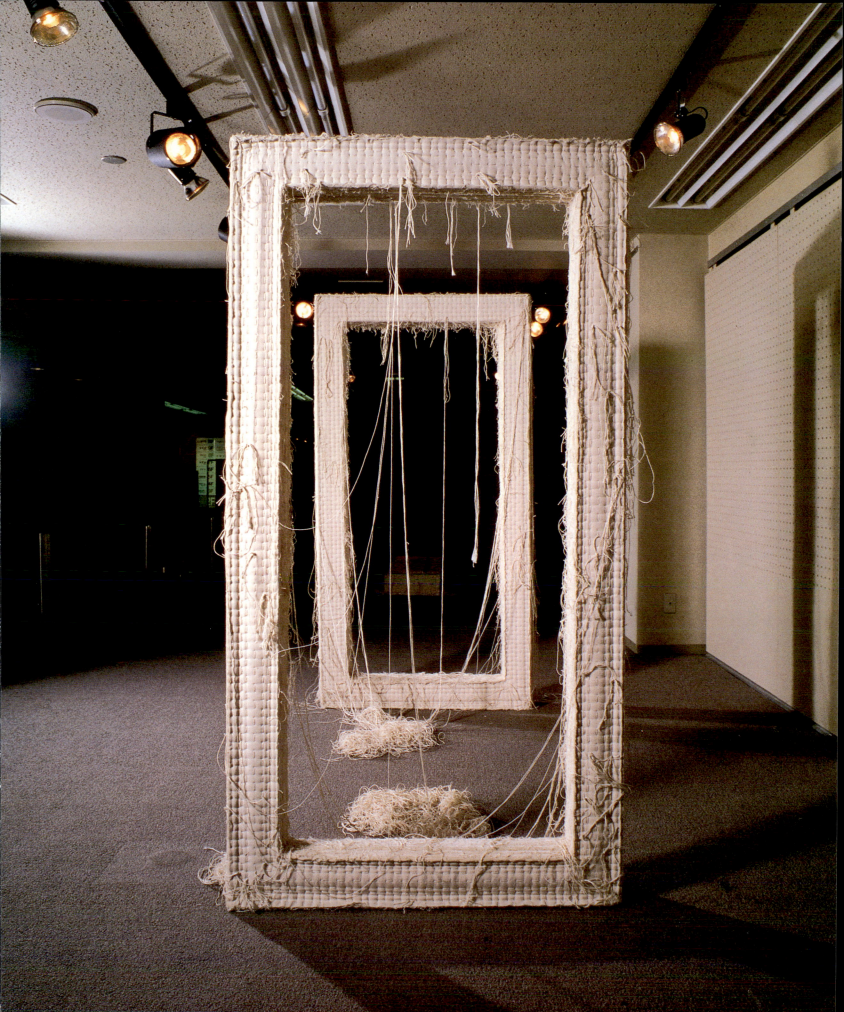

PLATE 79 'Falling Water.' Dyed sisal
hemp and resin. 1990. *width 3.1m (10ft
2in); depth 47cm (18½in); height 1.64m (5ft
5in)*
Cha Kea-Nam (b.1953)

PLATE 78 *Above* 'Blowing in the Wind.'
Stainless steel wire. 1988. *width 20cm
(7¾in); depth 20cm (7¾in); height 20cm
(7¾in). See also page 185.*
Kumai Kyōko (b.1943)

by questioning its essential nature. Since the late 1970s he has produced several series of works that approach cloth from a variety of different angles. This example comes from a series in which architectural forms are made up of compacted layers of fabric whose construction is hinted at by the loosening and fraying of the material.

The use of alternative materials, which is a feature of fibre art the world over, can be seen in the dramatic creations of Kumai Kyōko (b.1943), who weaves thin threads of stainless steel wire to produce works that explore and evoke the qualities of wind, air and light.[35] Kumai graduated from Tokyo University of Arts in 1966 and at present teaches in Niigata Prefecture in northern central Japan. She is one of the many women artists who, following the example of Takagi Toshiko, have produced some of the most exciting and challenging fibre works of recent years. Kumai's interests are wide ranging. As well as producing large sculptural works, she is also involved in the making of objects of a more functional nature, including screens, hangings and articles of clothing.

The work shown here (PLATE 78) is a small-scale piece which encapsulates in miniature the poetic mood of her larger works. The interest in miniature fibre works that is now widespread in Japan was initially inspired by the series of international exhibitions of miniature textiles staged in London between 1973 and 1980. Kumai's work is particularly effective for the way in which she takes a mass-produced and inorganic material such as stainless steel and transforms it into richly expressive and organic compositions.

PLATE 80 'Wave Space II.' Dyed, woven and sewn sisal hemp and ramie. 1989. *width 4.8m (15ft 9in); depth 1.5m (4ft 11in); height 2.2m (7ft 3in)* *Kubota Shigeo (b.1947)*

Another leading woman fibre artist is Cha Kea-Nam (b.1953) (PLATE 79).[36] Korean by birth, Cha came to Japan after completing a first degree in Korea. She has studied both at Kyoto City University of Arts and at the Kawashima Textile School in Kyoto. Based near Kyoto in Kusatsu, Cha's achievement lies in her ability to create solid structures entirely out of raw fibrous materials. She uses sisal hemp, which she dyes and binds into thin sheets with resin. These sheets are stacked, either horizontally or vertically, to produce large-scale abstract compositions. The challenge she has so successfully met has been to use a technique similar to paper-making combined with a method of lamination to transform one-dimensional raw fibres into free-standing three-dimensional forms. Cha's pioneeering of this technology dates from the mid-1980s. Having used bright colours in her early pieces, she now works predominantly in black, the power of which is amplified by the intensity of the secondary colours she uses, in this case a burning red. This helps to articulate the overall form as well as to create the imagery of falling water.

Kubota Shigeo (b.1947) is another artist whose work revolves around the use of sisal hemp.[37] Whereas Cha employs a technique similar to paper-making, Kubota weaves dyed sisal hemp warps with uncoloured ramie wefts to produce strips and panels of gradated colour. On the work shown here (PLATE 80), woven panels are stitched together to form the rear section. The open-meshed structure in front is made up of vertical elements consisting of hollow triangular tubes and horizontal folded bands. These have been sewn together to form a loose, web-like

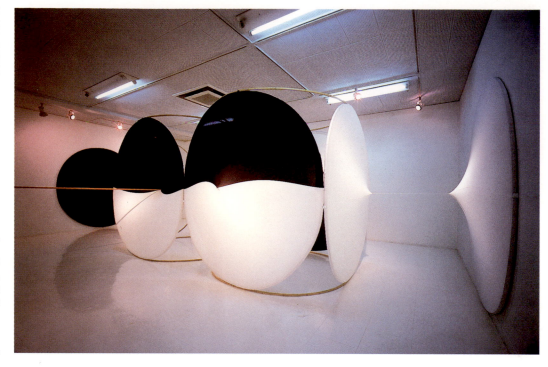

PLATE 81 *Right and opposite (detail)*
'Soft Walls I.' Black and white cloth,
thread, wood and bamboo. 1991. *width
7.5m (24ft 7in); depth 5.3m (17ft 5in); height
2.1m (6ft 11in)*
Shōji Satoru (b.1939)

composition whose undulating quality is evocative of the movement of the ocean. The imagery is enhanced by the use of strong marine-like colours. The two sections are mounted on an aluminium framework to form a large ellipse, which adds to the overall sense of movement. Kubota graduated from Kyoto City University of Arts in 1973. He lives to the southwest of Kyoto and teaches at Seian Women's University. As well as producing exhibition pieces such as the example shown here, he is often commissioned to make works for hotels, offices and public buildings.

The sensitivity to architectural space that is required of Kubota in the creation of works to decorate interiors is the starting point for the more conceptual interests of Shōji Satoru (b.1939) (PLATE 81).[38] Shōji is a graduate of Kyoto City University of Arts, where he studied sculpture. He now lives and works in Nagoya and teaches in the architecture departments of both Meijō and Mie Universities. With such academic credentials he is generally considered a 'fine artist'. The centrality of textiles to his work, however, has seen his involvement in many fibre art events both in Japan and abroad.

Shōji's creativity lies in his ability to develop compositions that relate closely to the spacial parameters of specific sites. His compositions are remarkable for their purity, elegance and inventiveness, much of his work seeking to give visual form to the forces of gravity through the use of sheets of coloured fabric tensioned in various ways by wood, bamboo and cord. The work shown here is primarily concerned with horizontal forces. Stretched circles of fabric are pulled and pushed in opposite directions in order to secure the structure in place in the centre of the room, and the sense of tension is enhanced by the stark contrast between the black and white of the fabric panels. Although it is a dynamic interaction of forces that keeps the structure in a state of unsteady equilibrium, the overall effect of the composition is one of great calm.

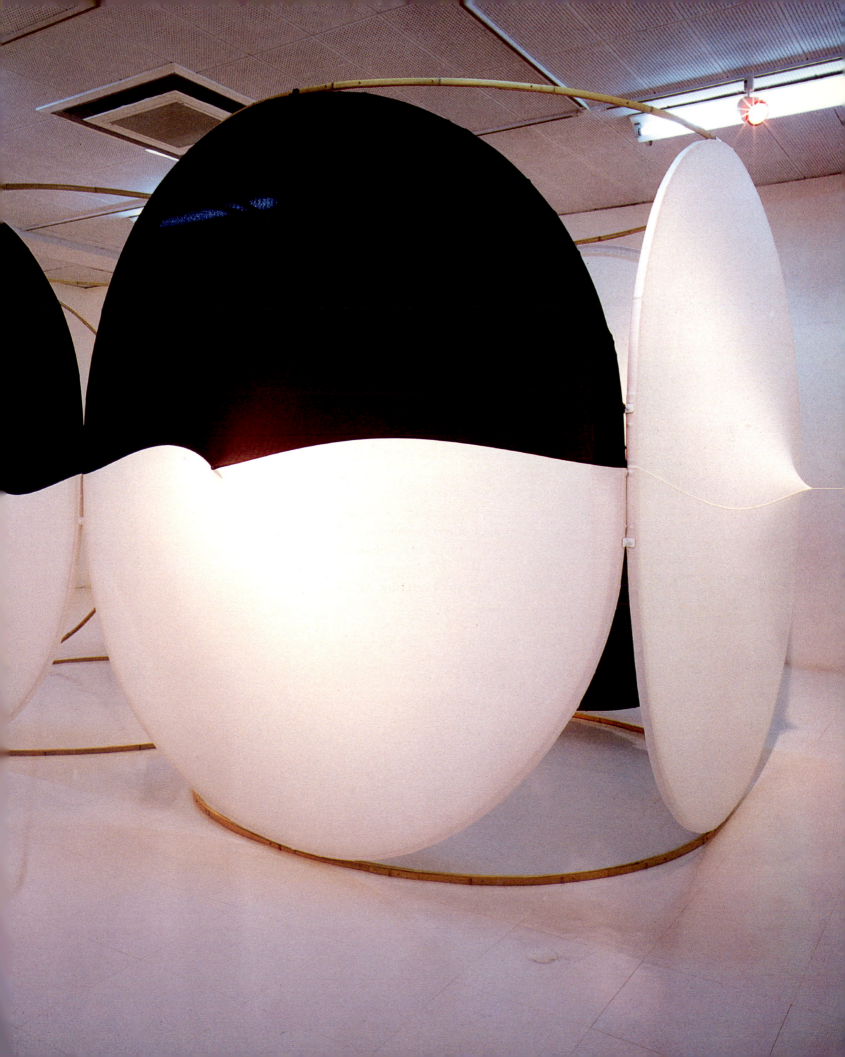

CHAPTER V
METALWORK & JEWELLERY

IN THE SECOND HALF OF THE NINETEENTH CENTURY, following the ending of Japan's long period of isolation from the rest of the world, Japanese goods were exported abroad in ever-increasing quantities. One of the main ways by which Japan promoted its trade interests was through participation in international exhibitions in Europe and the United States. It was the praise received by the Japanese for their display at the 1873 Vienna World Exhibition in particular that prompted the leaders of the Meiji period (1868–1912) government to take positive steps to encourage the manufacture of craft items for export to the West. Ceramics and textiles, for which there was extensive domestic as well as overseas demand, were already being modernized under the guidance of foreign advisors and through the introduction of new technology. Other crafts such as metalwork and lacquerwork were in a more precarious situation, however, because of the collapse of the systems of patronage under which they had flourished prior to the upheavals that brought the Edo period (1615–1868) to a close. It was primarily in order to encourage and exploit these more specialist practices that organizations such as the *Kiritsu Kōshō Kaisha* (Company for the Establishment of Industry and Commerce) were set up. Through their employment of skilled bronze-casters and other craftsmen, the *Kiritsu Kōshō Kaisha* and its counterparts were responsible for producing many of the elaborate and often large-scale pieces of metalwork that figured so prominently in the Japanese displays at international exhibitions during the late nineteenth century, and which are now widely distributed across private and institutional collections in the West.

If the Meiji government's economic policy helped to encourage the development of metalworking and other specialist skills, anxiety among educationalists and those interested in Japan's cultural heritage about the potential demise of traditional craft practices under the changed circumstances of the new era led to further measures being taken. When the Tokyo

Opposite 'First Quarter Moon' (detail) by Seki Genji (see plate 84)

School of Arts (now Tokyo University of Arts) opened in 1889 it had departments of painting, sculpture and crafts, the last of which offered courses in metalwork and lacquerwork.

Under the initial directorship of Okakura Kakuzō (1862–1913) the atmosphere at the Tokyo School of Arts was essentially pro-traditional and anti-western. Following Okakura's forced resignation in 1898, however, a broader based approach was adopted. Where only Japanese-style painting (*nihonga*) had been taught, for example, western-style painting (*yōga*) was included in the curriculum. It is notable that many of the young artists who rebelled against the perceived conservatism of the crafts section of the *Teiten* exhibition (the prewar equivalent of the *Nitten* exhibition) during the late 1920s and 1930s were metalworkers who had trained at the Tokyo School of Arts. If ceramists have been at the forefront of anti-traditionalist tendencies in the postwar era, the angry young men of Japan's studio craft movement during its early years were to a large extent metalworkers.[1]

A little over a hundred years on from the founding of Tokyo University of Arts, metalwork and lacquerwork are now taught in parallel with more recently instituted courses in ceramics and textiles. Following the formula established at the end of the nineteenth century the teaching of metalwork is officially divided into three separate disciplines – casting (*chūkin*), hammering (*tankin*) and chasing (*chōkin*). Given the institution's long-standing pre-eminence as a training ground for metalworkers, this system of categorization has been highly influential in setting the parameters within which successive generations of makers have operated. This has been true of metalworkers working in traditional modes as well as those with more avant-garde interests.

It is on the basis of the strong sense prevailing among metalworkers of all persuasions that they belong to a particular technical discipline that the discussion that follows has been divided into sections on casting, hammering and chasing. This is supplemented by a fourth section that looks at the work of two artists who have been closely involved in the Japan Craft Design Association and also at the work of one of Japan's most adventurous contemporary jewellery makers.

CASTING (*CHŪKIN*)

DESPITE THE DIVERSITY OF ALTERNATIVES offered by modern technology, Japanese studio metalworkers continue to prefer the time-honoured method of casting in moulds made from a mixture of clay and silica sand. The Japanese term for such moulds is *manegata*, *mane* meaning 'pure earth' and *gata* meaning 'mould'.[2] While it is possible to cast simple shapes such as coins and mirrors into raw moulds, anything more complicated requires that the moulds be hardened by firing to a temperature of about 800°C (1470°F). A distinction is made according to whether the inner and outer moulds are fired separately (*sōgata*), the traditional method used in the making of temple bells and cast iron kettles, or together (*yakigata*). Distinctions are also made according to whether the moulds are taken from original models or are created through the use of rotating profile templates cut from wood or sheet metal. Original

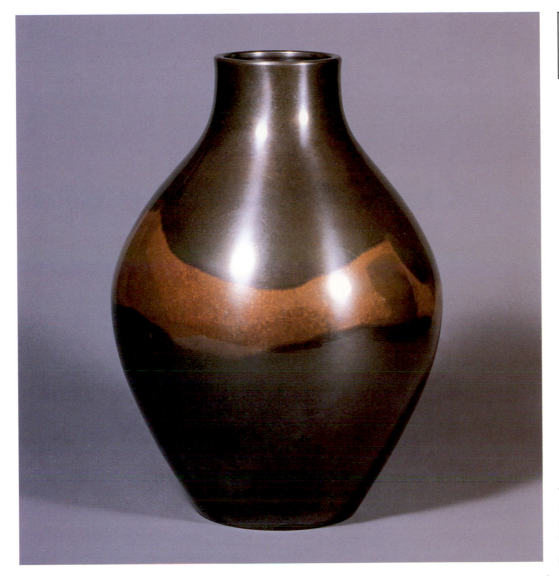

models may be made either from wax, which is melted away once the casting mixture compacted around it has dried, or from more permanent materials such as plaster. When a permanent original is involved it has to be removed before the mould can be used for casting.

The vase by Hannya Tamotsu (b.1941) (PLATE 82) is a classic example of *sōgata*-type *manegata* casting in moulds made through the use of rotating sheet metal templates. Hannya lives and works in the important metalworking centre of Takaoka where he initially trained at the long-established Toyama Prefectural Takaoka Crafts High School (*Toyama Kenritsu Takaoka Kōgei Kōkō*). His understanding of traditional casting techniques was deepened through the guidance in bell-making he received between 1982 and 1985 from Katori Masahiko (1899–1988; appointed Living National Treasure in 1977). A regular contributor to the Traditional Crafts Exhibition since 1977, Hannya specializes in casting with dual alloys. In the case of the vase shown here the darker alloy consists of 80 per cent copper, 10 per cent zinc, 5 per cent lead, 4 per cent silver and 1 per cent gold. The lighter brass type alloy consists of 70 per cent copper, 25

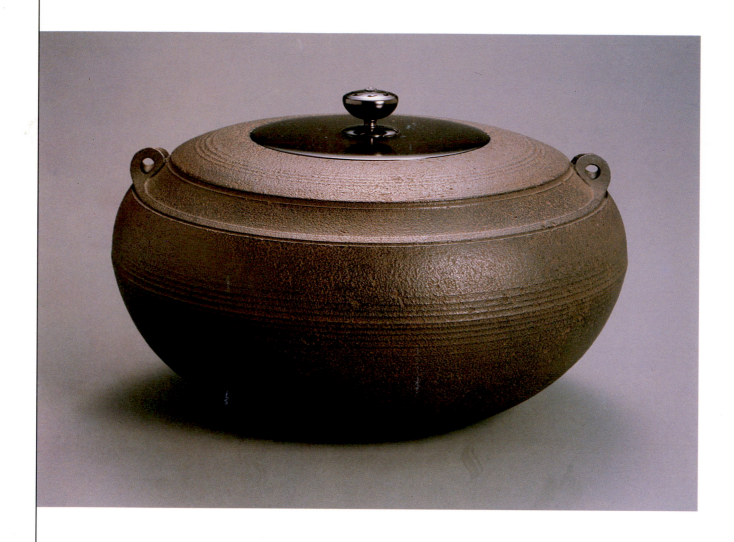

PLATE 83 Cast iron kettle. 1991. *diameter 27cm (10½in)*
Kakutani Seiichi (b.1939)

per cent zinc and 5 per cent lead. Patination was carried out by the traditional method of heating in a solution of blue vitriol (copper sulphate) and verdigris (copper acetate).

The basic procedures for making the moulds for cast iron kettles, such as the example by the Osaka-based Kakutani Seiichi (b.1939) shown here (PLATE 83), are similar to those used by Hannya and his fellow bronze-casters. The main differences are that the two halves of the outer mould are made by dividing the shape horizontally rather than vertically and that the dividing line between the upper and lower halves is usually left visible.

Kakutani studied metalwork and design before joining the workshop of his father, Kakutani Ikkei (b.1904; appointed Living National Treasure in 1978) in 1960. He has contributed to the Traditional Crafts Exhibition since 1965. The work shown here is a good example of how a modern minimalist aesthetic can be successfully incorporated into the making of a traditional metalwork form that has been closely associated with the practice of drinking whipped tea (*matcha*) – the type of tea drunk in the tea ceremony – since its introduction from China during the Kamakura period (1185–1336). As with teabowls and other tea ceremony utensils the general shape and basic attributes of cast iron kettles have long been dictated by the role they play in the tea room. The artistry of the maker is expressed through nuances of form, surface texturing, the application of decorative motifs and the design of the lugs.

The most notable aspect of Kakutani's kettle is the high degree of integration between the lugs and the overall form that he has succeeded in engineering. It can be seen how the lugs fit neatly into the width of the recessed band running around the shoulder of the kettle. They have been designed, furthermore, so that they appear to form a continuum with the lower step of the recessed band. Another important feature is the way in which the striations around the waist have been applied both above and below the central dividing line. Normal practice is for decorative patterning to be applied only to the upper part of a kettle.

The work of Seki Genji (b.1939) (PLATE 84) demonstrates how the traditional techniques of lost-wax casting can be employed to very dramatic ends in the creation of large-scale abstract forms.[3] Seki graduated from Tokyo University of Arts in 1963. After a period working for a printing company, his career as an artist began in earnest in 1970 when he started showing at the *Nitten* exhibition and the *Nitten*-related Association of Modern Artist Craftsmen's (*Gendai Kōgei Bijutsuka Kyōkai*) annual exhibition. He now teaches at Kanazawa College of Arts.

The original shape from which the outer mould was taken was constructed from sheets of modelling wax 5mm (about ¼in) thick and made from a mixture of beeswax, pine resin and paraffin wax.[4] The use of this medium has allowed Seki to produce a sculpture in which severity of form is modulated by warmth and depth of surface detail. The combination of cupronickel

PLATE 84 'First Quarter Moon.' Dual alloy lost-wax casting. 1985. *width 95.5cm (37½in).* See also page 148. *Seki Genji (b.1939)*

PLATE 85 'Hall of the Thousand-handed Avalokitesvara.' Lost-wax cast stainless steel. 1970. *width 50cm (19½in); depth 30cm (11¾in); height 30cm (11¾in)*
Miyata Kōhei (b.1926)

PLATE 86 *Opposite* 'Bashful King and his Queen.' Cast brass. 1968. *height 74cm (29in)*
Hara Masaki (b.1935)

and brass in the creation of an effect comparable to that found on Hannya Tamotsu's vase (see above, Plate 82) further intensifies the poetry of the work. The quadrant 'moon' is set off by the dark swirling patterning of the sculpture's sides, the colours and texture of which were accentuated by localized heating over a charcoal fire.

The work by Miyata Kōhei (b.1926) (PLATE 85) is an example of the extremely free approach to sculptural modelling that lost-wax casting permits. Miyata, who graduated from Tokyo University of Arts in 1949 and is also known for his work as a jeweller, comes from an established family of metalworkers based on the island of Sado. His career began precociously with the acceptance of his submission to the 1946 *Nitten* exhibition when he was still a student. He continues to be closely involved in the activities of the *Nitten* and its related Association of Modern Artist Craftsmen (*Gendai Kōgei Bijutsuka Kyōkai*).

Whereas the large scale and planar structure of Seki's sculpture necessitated the preparation of an inner as well as an outer mould, only a single mould was required for Miyata's representation of a temple building collapsing around a figure of the goddess of mercy. There is some irony in his use of a process historically associated with the making of Buddhist figurines and ritual paraphernalia in what can be read as a bitter reflection on the decline of Buddhism in late twentieth-century Japan.

The last example of cast metalwork to be discussed here is a work by Hara Masaki (b.1935) (PLATE 86). Hara graduated from Tokyo University of Arts in 1958, since when he has been a regular contributor to the *Nitten* exhibition. He has also been involved in the activities of the

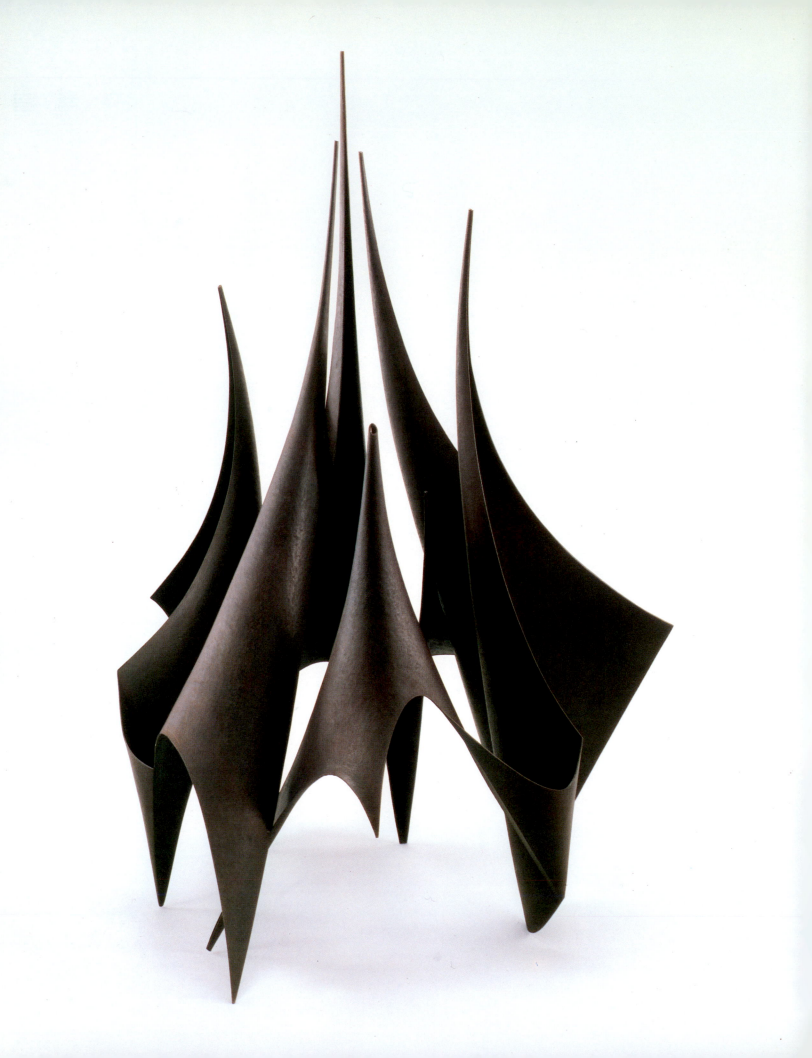

Nitten-related Association of Modern Artist Craftsmen (*Gendai Kōgei Bijutsuka Kyōkai*) and New Craft Artists Federation (*Nihon Shinkōgei Bijutsuka Renmei*). In 1982 he returned to teach at Tokyo University of Arts where he is now Professor of Metalwork (Casting).

In contrast to Miyata, for whom richness of texture and complexity of modelling are central concerns, Hara seeks to render his often anthropomorphic forms with the minimum of detail. The moulds in which the work shown here was cast were taken from a plaster original, which was itself cast from moulds taken from an initial clay model. While the general shape of the finished sculpture was determined by that of the clay model, the mirror-like smoothness of its surfaces was the result of work carried out on the plaster original and finalized through grinding and polishing of the cast brass form. It is evident that modelling in clay is merely an expedient for Hara and that his primary interest lies in the transposition into metal of qualities that can be achieved only through working with plaster.

HAMMERING (*TANKIN*)

THE UNTIMELY DEATH OF Ochi Kenzō (1929–81) at the peak of his career dealt a severe blow to the Japanese metalworking community.[5] Born in Ehime Prefecture, Ochi graduated from Tokyo University of Arts in 1953. His submission to the *Nitten* exhibition was accepted the following year, marking the beginning of a life-long involvement in the activities of the *Nitten* and its related organizations. Ochi returned to Tokyo University of Arts as a part-time teaching assistant in 1959. He joined the full-time staff in 1965 and became Professor of Metalwork (Hammering) in 1976.

As the work illustrated here (PLATE 87) reveals, Ochi had a remarkable ability to use hammers and anvils to forge iron into shapes of awesome sophistication and refinement.[6] The essential characteristics of his work – sharpness of profile contrasted with subtle surface tooling, elongation of form, and rhythmic interplay between inwardly and outwardly curved surfaces – were largely established in the context of the vases and other functional objects he made during the late 1950s and early 1960s. His works from the second half of the 1960s, the period to which the example shown here belongs, were both more monumental and more overtly sculptural. His fascination with the vessel form never left him, however, and he returned to it in the mid-1970s. Whether he was working in vessel or non-vessel formats, Ochi's shapes made consistent reference to the natural world. Here the imagery is of a flock of birds gathering together with outstretched necks.

It is evident from the titles and decorative schemes she uses that nature is also central to the work of Ōsumi Yukie (b.1945), the Tokyo-based maker of the hammered silver bottle (PLATE 88). Ōsumi studied history of art at Tokyo University of Arts, from which she graduated in 1969, before starting to train as a metalworker. Her teachers included Sekiya Shirō (b.1907; appointed Living National Treasure in 1977) and Kashima Ikkoku (b.1898; appointed Living National

PLATE 87 *Opposite* 'Gathering.' Hammered iron. 1968. *height 1.01m (39¾in)*
Ochi Kenzō (1929-81)

PLATE 88 'Heat Haze.' Hammered
silver bottle with *nunomezōgan* (textile
imprint inlay) decoration. 1992. *height
31.5cm (12¼in)*
Ōsumi Yukie (b.1945)

Treasure in 1979), from whom she learnt the techniques both of hammering and of chasing. She
has been a regular contributor to the Traditional Crafts Exhibition since 1976.

Ōsumi's work is characterized by gracefully proportioned forms and generously flowing
surface patterning executed in *nunomezōgan* (textile imprint inlay). This involves hammering
metal leaf or wire into a fine, mesh-like grid incised into the surface of the metal ground. On the
example shown here, Ōsumi has used lead and gold in the rendering of an abstract pattern that
swirls around in the opposite direction to the spiral faceting of the bottle. This gives stability to the
overall composition while providing colour and a sense of energy and drama. After the inlaying
had been completed, the bottle was pickled black and then polished so that just enough of the
patina remained to show off the intricate texture of the hammered surface. The bright, un-
patinated bands that border the areas of lead inlay are the natural outcome of the manner in which
the presence of lead prevents the blackening of the silver in the pickling bath. The exploitation of
this effect is a distinctive feature of Ōsumi's increasingly mature metalworking style.

PLATE 89 Lidded jar of hammered silver with chased decoration and gilding. 1988. *height 13.5cm (5¼in)*
Masuda Mitsuo (b.1909)

CHASING (CHŌKIN)

WHILE THE USE OF *nunomezōgan*-type chased decoration is central to Ōsumi's oeuvre, the faceting found on the majority of her forms and the emphasis she places on the hammered tooling of her surfaces make it appropriate to classify her works in the first instance as examples of hammering. In contrast to this the exquisite forms of Masuda Mitsuo (b.1909) (PLATE 89), which are hammered by specialist craftsmen according to his specification, are primarily vehicles for the sensitively chased pictorial patterning in which he specializes.[7] Masuda, who lives just outside Tokyo in Saitama Prefecture, studied at Tokyo University of Arts during the early 1930s. This was followed by a period when he became acquainted with, and received extensive guidance from, Yanagi Sōetsu (1889–1961) and Tomimoto Kenkichi (1886–1963). His long-standing friendship with Tomimoto both before and after the Second World War led him to make many of the metalwork fittings for Tomimoto's

THE EMERGENCE OF GLASS-MAKING as a major new focus of artistic activity has been one of the most exciting developments in the Japanese crafts world in recent years. Several hundred makers, many of them still in their twenties and thirties, participate in an increasingly busy calendar of exhibitions and competitive events. Following the establishment of Japan's first glass-making course at Tama University of Arts in 1975, there has been a steady growth in the number of educational institutions offering specialist training. This has given rise to a change in demography such that while designers from the glass industry used to dominate the field, independent artists with their own workshops are now in the ascendant.[1] Technical skills are highly developed and the range of interests explored is broad. If in international terms the Japanese studio glass movement is still in its youth – 'the epoch of fascinating chaos' was the phrase used to summarize the current situation in a catalogue to an exhibition of contemporary Japanese glass that recently travelled to Europe[2] – the structures now in place are such that an ever more dynamic and productive future is guaranteed.

The term studio glass is often used in the specific sense of glass produced by artists who operate in small workshops and are personally involved in every stage of the designing and making process. The technical breakthroughs that have allowed individuals to work independently of glass-making factories were made during the early 1960s in the United States. These included the development of small-scale glass-melting furnaces and annealing (cooling) ovens together with glass materials that could be melted at relatively low temperatures. The first workshop using these new technologies to be set up in Japan was built in 1969 by Itō Makoto (b.1940) and Funaki Shizuho (b.1935). While the number of independent artists has been steadily increasing, the role played by designers in the glass industry continues to be an important and significant one. In order to embrace the full range of developments in the field of

Opposite 'BS-O' (detail) by Takahashi Yoshihiko (see plate 99)

PLATE 96 *Above* 'Composition no. 148.' Cast, cut, polished and glued glass. 1990. *width 29cm (11½in); depth 7cm (2¾in); height 40cm (15¾in). See also page 176.*
Takeuchi Denji (b.1934)

PLATE 95 *Opposite* 'Candlelight.' Blown, cast, hot-worked and glued glass. 1988. *height 59cm (23¼in)*
Yokoyama Naoto (b.1937)

He has since been involved in a large number of domestic and international events. Along with Iwata Hisatoshi, he played a major role in the establishment of the Japan Glass Artcrafts Association in 1972.

Although, as we have seen, the major attraction of working in glass has been its freedom from traditional cultural precedents, Fujita's work is interesting for the way in which it finds inspiration in classical Japanese art. The imagery and title of this box (PLATE 94), one of a series that he began in 1973, make direct reference to a painted screen by Ogata Kōrin (1658–1716), a leading artist of the Rinpa school.[8] The two halves of the box were made by blowing molten glass into metal moulds. The rich surface decoration was achieved by the application of small pieces of red and white glass in combination with silver and gold leaf. Mattness and texture were provided by masking out the areas covered in metal leaf with wax resist before dipping in an acid bath.

In contrast to Fujita's work, which is classicizing in nature, the sculpture by the Tokyo-based Yokoyama Naoto (b.1937) is highly contemporary in feeling (PLATE 95). Yokoyama studied metalwork at Tokyo University of Arts, from which he graduated in 1962. His knowledge of glass was gained through his experience at the Jōetsu Crystal Glass Company in Gunma Prefecture, for which he worked until 1975 before becoming an independent glass designer. The work he has produced since the early 1980s marks a radical departure from the minimalist mode in which he worked earlier in his career. His humorous style, which makes increasingly extravagant use of coloured glass, draws its ultimate inspiration from recent trends in Italian design.

Each component of the work shown here consists of separate pieces of glass which have been fused together as part of a coordinated process involving several glass technicians working in harmony. Yokoyama hires the staff and workshop facilities of his former employer, the Jōetsu Crystal Glass Company, for the actual making of his work. He acts as designer and producer, overseeing and orchestrating the making process without being directly involved himself. Yokoyama works in cycles, alternating between designing and working up full-sized colour drawings and concentrated bouts in the workshop.

Takeuchi Denji (b.1934) is a well-established Tokyo-based artist who has continued to pursue his personal artistic concerns from within the framework of a large glass-making organization, the Sasaki Glass Company, which he joined in 1958 immediately after graduating from university. The work shown here (PLATE 96) is one of a series that he began in the late 1970s. This series is characterized by the use of individual components made of cast, cut and polished glass, clear or tinted, which are assembled with glue to form the final geometric composition. Takeuchi is particularly interested in the effects of light reflected against and refracted through glass. Through the manipulation of these effects he is able to create compositions that have a presence greater than the sum of their physical elements.

Being a relatively new discipline and therefore less subject to the male-dominated hierarchies that operate in more established areas of the crafts world, glass-making has attracted a large number of women practitioners. One of the most highly regarded of these is the Kyoto-based Ikuta Niyoko (b.1953). She uses thin sheets of plate glass to build up large and dynamic

PLATE 99 'BS-O.' Blown, cut, fumed and glued glass with brass fittings. 1986. *width 90cm (35½in). See also page 166.*
Takahashi Yoshihiko (b.1958)

Takahashi Yoshihiko (b.1958) is one of the most talented young glass-makers working in Japan today (PLATE 99). He graduated from Tama University of Arts in 1980. He then worked in Germany before establishing his own workshop in Kanagawa Prefecture in 1985. As is the case with many makers of his generation, he works independently of any craft organization, the Japan Glass Artcrafts Association included. In addition to lecturing at the recently established Toyama City Institute of Glass Art, he has been a visiting lecturer in Australia. In this and in his involvement in numerous exhibitions overseas he is both a product of, and a contributor to, the internationalization that is so much an aspect of the contemporary Japanese glass-making scene.

Through his work Takahashi strives to capture the inherent power of glass as released through the process of blowing. The work shown here is from a series marking the beginning of his mature style. Its forceful solidity is combined with a sense of energy and movement. It consists of three parts, which are glued together and bound with brass fittings. The iridescent surface of the central part was achieved by fuming the blown glass form with tin chloride. The two black parts were made by a sophisticated overlay technique by which a very thin layer of coloured glass was deposited on the surface of a clear crystal glass interior. The use of this overlaying technique is one of the hallmarks of Takahashi's work.

PLATE 100 Sculpture, cast glass. 1990. *width 68cm (26¾in); depth 52cm (20½in); height 90cm (35½in)* **Iwata Ruri (b.1951)**

Another artist who has made a major impression on the world of Japanese glass-making since the mid-1980s is the Tokyo-based Iwata Ruri (b.1951).[10] She began working in glass in 1975 at the same as pursuing her studies in metal-casting at Tokyo University of Arts. She has held regular solo exhibitions since 1979. In 1985 she established her own gallery in Tokyo at which to show her own work and that of artists with whom she feels an affinity. In her recent work she has been exploring the essential nature of glass through a series of large-scale compositions consisting of blocks of soda glass cast in solid, minimal forms. The work shown here (PLATE 100) exemplifies this approach at its most potent. Iwata has rejected colour, content and the contrivance of a title and has concentrated instead on the creation of a sculpture which relies on pure form and monumental physicality for its power. The realization of such works would not be possible without the facilities provided by her family's business, the Iwata Glass Company. In exploiting the opportunities offered by factory production methods in the fulfilment of her artistic vision Iwata Ruri is a worthy heir to the pioneering spirit of her grandfather Iwata Toshichi.

Overleaf 'Composition no. 148' by Takeuchi Denji (see plate 96)

41. The vase belongs to the series which Kamoda exhibited in his one-man show in Tokyo in May–June 1969. Tokyo National Museum of Modern Art 1987b, nos. 47–8 and *p. 210*. See also Tochigi Prefectural Museum of Art 1986.

42. Tochigi Prefectural Museum of Art 1986, *p. 13*.

43. Nakanodō 1987b, *p. 31*.

44. Nakanodō 1987b, *pp. 31–2*.

45. Wakayama Prefectural Museum of Modern Art 1990, *pp. 90–95*. See also Tokyo National Museum of Modern Art, 1987a, *pp. 146–9*.

46. See, for example, Takashimaya Department Stores 1990, *pp. 34–9*.

47. Wakayama Prefectural Museum of Modern Art 1990, *pp. 96–101*. See also Tokyo National Museum of Modern Art 1987a, *pp. 150–53*.

48. Kyoto National Museum of Modern Art 1981, Chronology.

49. Quoted in Uchiyama 1981.

50. For an overview of the history of the *Sōdeisha* see Nakanodō 1987a. See also Kimura 1988. For Yagi Kazuo see Baekeland 1993, *pp. 181–3*, Kyoto National Museum of Modern Art 1981, and Salter 1983.

51. Hayashi 1987 is the most detailed source available for the history of the activities of the *Shikōkai*.

52. Discussed and illustrated in Salter 1983. See also Uchiyama 1981.

53. Hayashi 1987 and Wakayama Prefectural Museum of Modern Art 1990, *p. 65*.

54. For Isamu Noguchi see Tokyo National Museum of Modern Art 1987a, *pp. 102–103*. See also Inui 1990, *pp. 100–101*.

55. Wakayama Prefectural Museum of Modern Art 1990, *pp. 61–3*.

56. Newcastle Region Art Gallery 1987, *pp. 26–9, 46–7*.

57. Fukunaga 1987. See also Nakanodō 1993, *p. 64*.

58. For an overview of the history of the Modern Art Association see Kaneko 1987.

59. Inui 1990, *p. 101*. See Wakayama Prefectural Museum of Modern Art 1990 for illustrations of late 1950s and early 1960s works by a number of different artists. See also Shiga Prefectural Contemporary Ceramics Museum 1990, *pp. 148–55*.

60. Suzuki 1993, *p. 16*.

61. This and the other major ceramics exhibitions mentioned below are discussed in Nakanodō 1993 and Suzuki 1993.

62. Tokyo National Museum of Modern Art 1987a, *p. 177*. See also Seibu Department Stores (Ōtsu Branch) 1991, *p. 63*. The chronology in the former covers the period 1945–73. The chronology in the latter covers the main events of the 1960s and 1970s, but is especially useful for its coverage of the period 1980–91.

63. Moeran 1982c, *p. 34*.

64. Seibu Department Stores (Ōtsu Branch) 1991, *pp. 63–5*. Some of the more important of these exhibitions are discussed in Nakanodō 1993, *pp. 65–6* and Suzuki 1993, *pp. 18–19*.

65. Shiga Prefectural Contemporary Ceramics Museum 1990.

66. Baekeland 1993, *p. 185*.

67. Wakayama Prefectural Museum of Modern Art 1990, *pp. 42–7*. See also Tokyo National Museum of Modern Art 1987a, *pp. 78–81*.

68. Baekeland 1993, *p. 180*.

69. An exhibition of Katō's works in the collection of Teshigahara Sōfu was held in 1987 to commemorate the sixtieth anniversary of the founding of the Sōgetsu school of flower-arranging.

70. Hayashi 1987.

71. For details about the carbonizing materials and firing methods used by artists working with Black Fire see Salter 1984.

72. Uchiyama 1981.

73. Wakayama Prefectural Museum of Modern Art 1990, *pp. 66–71*. See also Hayashiya 1983, *p. 105, no. 249*.

74. Redman 1989, *pp. 58–9*.

75. Jones 1990, *p. 29*.

76. The variety of materials used by Nishimura is well illustrated in Galerie Pousse 1991.

77. Illustrated in Tokyo National Museum of Modern Art 1987a, *p. 69*.

78. Koie 1990, *p. 75*.

79. Kaneko 1987, *p. 27*.

80. For a chronology of Kumakura's work see Tokyo National Museum of Modern Art 1989.

81. Nakamura 1992, *p. 3*.

82. Jones 1990.

WOODWORK, BASKETRY AND BAMBOOWORK

1. See *pp. 102–23*.

2. For the geography of Japan see Bowring and Kornicki 1993, *pp. 2–39*.

3. Useful glossaries covering the terminology listed here are given in Hokkaidō Asahikawa Museum of Art 1986, *pp. 89–91* and Tokyo National Museum of Modern Art 1987d, *pp. 119–22*.

4. Marquetry (*yosegi*) and inlay (*mokuzōgan*) are sometimes referred to by the more general term *mokuga* (wood picture).

5. See the discussion of the bowl by the lacquerwork artist Akaji Yūsai (1906–84) on *pp. 114–16*.

6. Examples of different kinds of *sujibiki* are illustrated in Shiraishi 1991, *p. 45*.

7. For the work of Kuroda Tatsuaki see Tokyo National Museum of Modern Art 1983a.

8. For an overview of Murayama's work see Murayama 1991.

9. For illustrations of woodworking joints used in Japan see Koizumi 1986, *pp. 186–94* and Shiraishi 1991, *pp. 26–7*.

10. A good example is illustrated in Shiraishi 1991, *p. 53*.

11. Tokyo National Museum of Modern Art 1987d, *p. 20*.

12. For Matsuda Gonroku see *pp. 107–109*.

13. See Satō 1974, *p. 4ff*.

14. For examples of some of the more regular weave structures used by Japanese basket-makers see Tokyo National Museum of Modern Art 1985a, *pp. 110–14* and Shiraishi 1991, *pp. 66–8*.

15. The original passages are quoted in Aoki 1989, *p. 19*.

16. For the tea ceremony and steeped tea drinking see *pp. 26–8, 42–4*.

17. This is discussed in Tokyo National Museum of Modern Art 1985a, *pp. 18–20*.

18. Tsuji 1994, *pp. 96–7*.

19. Sekijima 1986, *p. 8*.

LACQUERWORK

1. For a discussion of lacquer-making in the West see Bourne 1984, chapters 7 (Europe and Russia) and 9 (The Twentieth Century).

2. The explanations of lacquer-making given here and below are based on descriptions in Hutt 1987, *pp. 159–76*, and in the glossary in Tokyo National Museum of Modern Art 1982, *pp. 293–9*. Tokyo National Museum of Modern Art 1982, *pp. 200–35* reproduces samples prepared by various leading lacquerwork artists in the 1950s and early 1960s showing many of the key processes of lacquer-making. A detailed analysis of the chemistry of *Rhus verniciflua* is given in Kumanotami 1985.

3. Itō 1979, *pp. 668–71* gives details of the regional lacquer manufacturing centres which receive official support from the Ministry of International Trade and Industry under the provisions of the 1974 Law for the Promotion of Traditional Craft Industries (*Dentōteki Kōgeihin Sangyō no Shinkō ni kansuru Hōritsu*).

4. For an overview of plain lacquering in modern Japan see Tokyo National Museum of Modern Art 1993.

5. For illustrations of works by Taguchi over the course of his career see Taguchi 1991.

6. Biographic details of Matsuda Gonroku and other leading twentieth-century lacquerwork artists are given in Tokyo National Museum of Modern Art 1982, *pp. 267–91*. For illustrations of works by Matsuda over the course of his career see Tokyo National Museum of Modern Art 1978.

7. For Masuda Don'o see Guth 1993.

8. For Kuroda Tatsuaki see *p. 85*.

9. For illustrations of works by Otomaru over the course of his career see Seibu Department Stores 1988.

10. For illustrations of works by Suzuki over the course of his career see Suzuki 1989.

11. For an overview of Kado's recent work see Kado 1991.

12. For illustrations of works by Kurimoto over the course of his career see Ōtani Memorial Art Museum 1994.

DYEING, WEAVING AND FIBRE ART

1. Colchester 1991, *p. 18*.

2. For the Kyoto International Textile Competition see *pp. 140–41*.

3. For an overview of textiles in traditional styles see Kitamura 1991.

4. For illustrations of Kitamura's most recent achievements see Kitamura 1993.

5. These and other early textiles are discussed in Matsumoto 1984.

6. For illustrations of kimono by Shimura over the course of her career see Tokyo National Museum of Modern Art 1985b, *pp. 76–100* and Gunma Prefectural Museum of Modern Art 1982.

7. Dalby 1993, *p. 156*.

8. Shimura's techniques are described in detail in Tokyo National Museum of Modern Art 1985b, *pp. 113–14*.

9. A detailed description of dyeing with indigo and other vegetable dyes is given in Wada, Rice and Barton 1983, *pp. 275–87*.

10. For the Rinpa school see *pp. 31–2*.

11. For Kuroda Tatsuaki see *p. 85*.

12. For illustrations of kimono by Munehiro over the course of his career see Tokyo National Museum of Modern Art 1985b, *pp. 49–74* and Kanagawa Prefectural Museum of Modern Art 1990.

13. For the techniques of *kasuri* textiles see Tomita 1982. For a historical survey see Dusenbury 1993.

14. Tokyo National Museum of Modern Art 1985b, *p. 17*.

15. For an overview of current trends in stencil-dyeing see Tokyo National Museum of Modern Art 1994.

16. For the history and techniques of *katazome* textiles see Nakano 1982 and Mellott 1993.

17. For the history and techniques of *bingata* textiles see Stinchecum 1993.

18. Fukumoto 1988, *p. 52*.

19. Fukumoto 1988, *p. 54*.

20. For a discussion of early wax resist dyed textiles see Matsumoto 1984, *pp. 207–208*.

21. For the history and techniques of *shibori* textiles see Wada, Rice and Barton 1983.

22. For *tsujigahana* textiles see Wada, Rice and Barton 1983, *pp. 20–27* and Itō 1980.

23. For illustrations of kimono by Moriguchi Kakō over the course of his career see Tokyo National Museum of Modern Art 1985b, *pp. 22–47* and Yomiuri Newspapers 1994, *pp. 16–101*. For Moriguchi Kunihiko see Impey 1991 and Yomiuri Newspapers 1994, *pp. 104–43*.

24. This is discussed in Best 1991, *p. 20*.

25. For Miyazaki Yūzen and the early history of *yūzen*-dyeing see Maruyama 1988.

26. Moriguchi Kakō's techniques are described in detail in Tokyo National Museum of Modern Art 1985b, *pp. 111–12*.

27. Best 1991, *p. 20*.

28. Kester 1989 and Kester 1994.

29. Colchester 1991, *p. 137*.

30. For an overview of Takagi's achievements see Yagi 1989.

31. For Yagi Kazuo and the *Sōdeisha* see *pp. 61–2*.

32. While the Kyoto National Museum of Modern Art was the venue for these various fibre art exhibitions during the 1970s, many of the most important exhibitions since the beginning of the 1980s have been held at the Gunma Prefectural Museum of Modern Art. See Gunma Prefectural Museum of Modern Art 1980, 1983 and 1991. For a more recent exhibition see Fukushima Prefectural Museum of Art 1993. A detailed chronology of events in the fibre art world, both in Japan and internationally, is given in Tsuji 1994, *pp. 201–12*.

33. See, for example, the work by Kobayashi published in Brennand-Wood 1991.

34. Artist's statement in Brennand-Wood 1991.

35. For illustrations of works by Kumai over the course of her career see Kumai 1991.

36. For illustrations of works by Cha over the course of her career see Cha 1992.

37. For illustrations of recent works by Kubota see Kubota 1990.

38. For illustrations of works by Shōji over the course of his career see Sakura Gallery 1989.

METALWORK AND JEWELLERY

1. For a discussion of anti-traditionalist tendencies during the 1920s and 1930s see Tokyo National Museum of Modern Art 1983b.

2. An outline of *manegata* casting techniques is given in Ōtaki 1991, *pp. 40–45*. For a more exhaustive step-by-step guide see Katori 1983.

3. For further examples of Seki's work see Tokyo National Museum of Modern Art 1987a, *pp. 84–5*. This catalogue also includes entries on the three other sculptural metalworkers discussed in this chapter: Miyata Kōhei (*pp. 128–31*); Hara Masaki (*pp. 108–11*); and Ochi Kenzō (*pp. 52–5*). A useful discussion of sculptural metalwork is given in Suzuki 1975, *pp. 62–70*.

4. Details of the kind of modelling wax used by Japanese metalworkers are given in Katori 1983, *pp. 140–43*.

5. For illustrations of works by Ochi over the course of his career see Tokyo National Museum of Modern Art 1987c.

6. An outline of hammering techniques is given in Ōtaki 1991, *pp. 52–5*.

7. An outline of chasing techniques is given in Ōtaki 1991, *pp. 46–51*.

8. For a representative selection of Hiramatsu's work see Tokyo University of Arts 1993.

GLASS

1. This is discussed in Takeda 1993.

2. Dusseldorf Kunstmuseum 1993.

3. A useful summary of the history of glass-making in Japan up to the postwar period is given in Mizuta 1993. See also Tsuchiya 1987.

4. For Iwata Toshichi and Kagami Kōzō see Hokkaidō Museum of Modern Art 1986, *pp. 77–83* and *pp. 84–8*.

5. For Iwata Hisatoshi see Hokkaidō Museum of Modern Art 1986, *pp. 106–109*.

6. This is discussed in Ricke 1993, *p. 37*.

7. For Fujita Kyōhei see Hokkaidō Museum of Modern Art 1986, *pp. 101–105*.

8. For the Rinpa school see *pp. 31–2*.

9. For illustrations of works by Masuda over the course of his career see Masuda 1987.

10. For illustrations of works by Iwata see Gallery Ghibli 1989 and Gallery Ghibli 1991.

BIBLIOGRAPHY

○ *Japanese including English translation or summary*
● *Japanese only*

● **ADACHI 1981**
Adachi Kenji, 'Gendai Kōgei Bijutsuka Kyōkai 20-Shūnen Kinenten o Shuku-shite' (In Celebration of the 20th Anniversary Exhibition of the Association of Modern Artist Craftsmen), *p. 1 in 20-Nen no Ayumi: Gendai Kōgei Bijutsuka Kyōkai, 1981* (20 Years: The Association of Modern Artist Craftsmen, 1981) (exhibition catalogue), Tokyo; Association of Modern Artist Craftsmen, 1981

○ **AKANUMA 1976**
Akanuma Taka, *Raku Daidai (Raku Ware), Nihon Tōji Zenshū vol. 21 (A Pageant of Japanese Ceramics)*, Tokyo; Chūō Kōronsha, 1976

● **AOKI 1989**
Aoki Hiroshi, 'Iizuka Rōkansai to sono Kindaisei' (Iizuka Rōkansai and his Modernity), *pp. 14–22 in Iizuka Rōkansai-ten (Iizuka Rōkansai: Master of Modern Bamboo Crafts)* (exhibition catalogue), Utsunomiya; Tochigi Prefectural Museum of Art, 1989

ASAHI NEWSPAPERS 1991
Asahi Ceramic Art Exhibition – Sydney: Asahi Tōgeiten '90 (exhibition catalogue), Nagoya; Asahi Newspapers Nagoya Head Office, 1991

BAEKELAND 1993
Frederick Baekeland *et al., Modern Japanese Ceramics in American Collections* (exhibition catalogue), New York; Japan Society, 1993

BECKER 1986
Johanna Becker, O.S.B., *Karatsu Ware: A Tradition of Diversity*, Tokyo, New York and San Francisco; Kōdansha International, 1986

BEST 1991
Susan-Marie Best, 'The Yūzen Kimono of Moriguchi Kunihiko', *Eastern Art Report*, vol. III no. 2, July/August 1991, *pp. 18–20*

BOURNE 1984
Jonathan Bourne *et al., Lacquer: An International History and Collector's Guide*, Marlborough, UK; The Crowood Press, 1984

BOWRING AND KORNICKI 1993
Richard Bowring and Peter Kornicki (eds.), *The Cambridge Encyclopedia of Japan*, Cambridge; Cambridge University Press, 1993

BRENNAND-WOOD 1991
Michael Brennand-Wood *et al., Restless Shadows: Japanese Fibreworks* (exhibition catalogue), London; Goldsmiths' Gallery, 1991

BRITTON 1991
Alison Britton, 'Craft: Sustaining Alternatives', *pp. 9–15 in Margetts 1991*

○ **CHA 1992**
Cha Kea-Nam *et al., CHA, Kea-Nam*, Ōtsu; Cha Kea-Nam, 1992

COLCHESTER 1991
Chloe Colchester, *The New Textiles*, New York; Rizzoli, 1991

CORT 1979
Louise Cort, *Shigaraki, Potters' Valley*, Tokyo, New York and San Francisco; Kōdansha International, 1979

CORT 1992
Louise Cort, *Japanese Collections in the Freer Gallery of Art: Seto and Mino Ceramics*, Washington, D.C.; Smithsonian Institution, 1992

DALBY 1993
Liza Dalby, *Kimono: Fashioning Culture*, New Haven and London; Yale University Press, 1993

DUSENBURY 1993
Mary Dusenbury, 'Kasuri', *pp. 57–74 in Rathbun 1993*

DUSSELDORF KUNSTMUSEUM 1993
Helmut Ricke (ed.), *Neues Glas in Japan: New Glass in Japan* (exhibition catalogue), Dusseldorf; Kunstmuseum Dusseldorf, 1993

EARLE 1986
Joe Earle *et al., Japanese Art and Design*, London; Victoria & Albert Museum, 1986

● **ENOMOTO 1989**
Enomoto Tōru *et al.* (eds.), *Gendai no Nihon Tōgei* (Contemporary Japanese Ceramics), 10 vols., Kyoto; Tankōsha, 1989

FAULKNER AND IMPEY 1981
Rupert Faulkner and Oliver Impey, *Shino and Oribe Kiln Sites: A Loan Exhibition of Mino Shards from Toki City* (exhibition catalogue), London; Robert G. Sawers Publishing in association with the Ashmolean Museum, Oxford, 1981

○ **FUKUMOTO 1988**
Fukumoto Shigeki, *Fukumoto Shigeki Senshoku Sakuhinshū (Shigeki Fukumoto: Rōketsuzome – Collected Works 1981–1988)*, Tokyo; Yōbisha, 1988

FUKUNAGA 1987
Fukunaga Shigeki, 'A Brief Genealogy of the Avant-Garde and Unaffiliated Independent Ceramicists . . .', *pp. 19–24 in Newcastle Region Art Gallery 1987*

● **FUKUSHIMA PREFECTURAL MUSEUM OF ART 1993**
Fiber Art: Ito to Nuno no Kanōsei (Fibre Art: The Potentiality of Thread and Cloth) (exhibition catalogue), Fukushima; Fukushima Prefectural Museum of Modern Art, 1993

○ **GALERIE POUSSE 1991**
Ichikawa Fumie (ed.), *Nishimura Yōhei Sakuhinshū 1975–1990 (Youhei Nishimura 1975–1990)*, Tokyo; Galerie Pousse, 1991

● **GALLERY GHIBLI 1989**
Iwata Ruri Sakuhinshū 1986–1989 (Iwata Rury Glass Works 1986–1989), Gallery Ghibli Series no. 1, Tokyo; Gallery Ghibli, 1989

○ **GALLERY GHIBLI 1991**
Iwata Ruri Sakuhinshū 1986–1991 (Iwata Rury Glass Works 1986–1991), Gallery Ghibli Series no. 2 – Craft, Tokyo; Gallery Ghibli, 1991

GRAHAM 1985
Patricia J. Graham, 'Sencha (Steeped Tea) and its Contribution to the Spread of Chinese Literati Culture in Edo Period Japan', *Oriental Art*, vol. XXXI no. 2, Summer 1985, *pp. 186–95*

● **GUNMA PREFECTURAL MUSEUM OF MODERN ART 1980**
Some to Ori: Gendai no Dōkō (Dyeing and Weaving: Contemporary Trends) (exhibition catalogue), Takasaki; Gunma Prefectural Museum of Modern Art, 1980

● **GUNMA PREFECTURAL MUSEUM OF MODERN ART 1982**
Shimura Fukumi-ten (Shimura Fukumi Exhibition) (exhibition catalogue), Takasaki; Gunma Prefectural Museum of Modern Art, 1982

● **GUNMA PREFECTURAL MUSEUM OF MODERN ART 1983**
Fiber Work-ten: Ori no Zōkei to sono Tenkai (Fibre Work Exhibition: Woven Forms and their Development) (exhibition catalogue), Takasaki; Gunma Prefectural Museum of Modern Art, 1983

● **GUNMA PREFECTURAL MUSEUM OF MODERN ART 1991**
Some to Ori: Gendai no Dōkō II (Dyeing and Weaving: Contemporary Trends II) (exhibition catalogue), Takasaki; Gunma Prefectural Museum of Modern Art, 1991

GUTH 1993
Christine M. E. Guth, *Art, Tea, Industry: Masuda Takeshi and the Mitsui Circle*, Princeton; Princeton University Press, 1993

HAGA 1989
Haga Kōshirō, 'The Wabi Aesthetic through the Ages', pp. 195–230 in Paul Varley and Kumakura Isao (eds.), *Tea in Japan: Essays on the History of Chanoyu*, Honolulu; University of Hawaii Press, 1989

HARADA 1983
Harada Hiroshi et al., *Living National Treasures of Japan* (exhibition catalogue), Boston; Boston Museum of Fine Arts, 1983

● **HARADA 1990**
Harada Yoshiko, 'Seikatsu Bunka Ronkō III: Bijutsu to Kōgei' ('A Study on Culture and Life – III: Fine Arts and Handicrafts'), *Hiroshima Jogakuin Daigaku Ronshū*, 1992

○ **HASEBE 1981**
Hasebe Mitsuhiko, 'Ishiguro Munemaro no Tōgei' ('The Ceramic Art of Munemaro Ishiguro'), n.p. in Tokyo National Museum of Modern Art (ed.), *Ishiguro Munemaro Ten: Tōgei no Kokoro to Waza* (Ishiguro Munemaro Exhibition: The Creative Spirit of His Ceramic Art) (exhibition catalogue), Tokyo; Mainichi Newspapers, 1981

● **HASEBE 1991**
Hasebe Mitsuhiko, *Tōgei: Dentō Kōgei* (Traditional Ceramic Art), *Nihon no Bijutsu no. 306* (Japanese Arts series), Tokyo; Shibundō, 1991

● **HAYASHI 1987**
Hayashi Yasuo: Shiryō Nenpu (Hayashi Yasuo: Chronology and Related Materials), Kyoto; Hayashi Yasuo, 1987

○ **HAYASHIYA 1976**
Hayashiya Seizō, *Chōjirō* (Chōjirō Ware), *Nihon Tōji Zenshū vol. 20* (A Pageant of Japanese Ceramics), Tokyo; Chūō Kōronsha, 1976

○ **HAYASHIYA 1978**
Hayashiya Seizō, *Hagi, Agano, Takatori, Nihon Tōji Zenshū vol. 18* (A Pageant of Japanese Ceramics), Tokyo; Chūō Kōronsha, 1978

HAYASHIYA 1983
Hayashiya Seizō et al., *Japanese Ceramics Today: Masterworks from the Kikuchi Collection* (exhibition catalogue), Tokyo; Hakuhōdō, 1983

● **HOKKAIDŌ ASAHIKAWA MUSEUM OF ART 1986**
Ki no Bi: Dentō no Nihon (The Beauty of Wood: Tradition in Japan) (exhibition catalogue), Asahikawa; Hokkaidō Asahikawa Museum of Art, 1986

● **HOKKAIDŌ MUSEUM OF MODERN ART 1986**
Nihon no Garasu Zōkei: Shōwa (Japanese Glass in the Shōwa Period) (exhibition catalogue), Tokyo; Asahi Newspapers, 1986

HUTT 1987
Julia Hutt, *Understanding Far Eastern Art*, Oxford; Phaidon Press, 1987

● **IMAIZUMI 1975–7**
Imaizumi Atsuo et al. (eds.), *Gendai no Tōgei* (Contemporary Ceramics), 17 vols., Tokyo; Kōdansha, 1975–7

IMPEY 1991
Oliver Impey, *The Yūzen Kimono of Moriguchi Kunihiko* (exhibition catalogue), Oxford; Ashmolean Museum, 1991

○ **INUI 1990**
Inui Yoshiaki, ' "Primitivism" in the Contemporary Ceramics Regard for "Earth" [sic]', pp. 96–104 in *Shiga Prefectural Contemporary Ceramics Museum 1990*

ISHIMURA 1988
Ishimura Hayao et al., *Robes of Elegance: Japanese Kimonos of the 16th–20th Centuries* (exhibition catalogue), Raleigh; North Carolina Museum of Art, 1988

● **ITŌ 1979**
Itō Seizō, *Nihon no Urushi* (Japanese Lacquer), Tokyo; Tokyo Bunko, 1979

ITŌ 1980
Itō Toshiko, *Tsujigahana-zome* (Tsujigahana Dyeing), Tokyo, New York and San Francisco; Kōdansha International, 1980

● **JAPAN CRAFT DESIGN ASSOCIATION 1986**
Nihon no Craft: Mono, Kurashi, Inochi (Contemporary Craft in Japan), Tokyo; Gakken, 1986

JENYNS 1971
Soame Jenyns, *Japanese Pottery*, London; Faber & Faber, 1971

JONES 1990
Derek Jones, 'Tokyo Clay', *Ceramics Monthly*, vol. 38 no. 9, November 1990, pp. 26–9

○ **KADO 1991**
Kado Isaburō, *Kado Isaburō: Shitsugei* (Kado Isaburō: Urushi Art), *NHK Kōbō Tanbō: Tsukuru vol. 6* (NHK Workshop Visits: Craft Makers), Tokyo; Japan Broadcasting Association, 1991

● **KANAGAWA PREFECTURAL MUSEUM OF MODERN ART 1990**
Munehiro Rikizō no Sekai-ten (The World of Rikizō Munehiro) (exhibition cat.), Kamakura; Kanagawa Prefectural Museum of Modern Art, 1990

○ **KANEKO 1987**
Kaneko Kenji, 'Modern Art Kyōkai no Seikatsu Bijutsu' ('Craft Art of the Modern Art Association'), pp. 18–30 in *Tokyo National Museum of Modern Art 1987a*

● **KATŌ 1972**
Katō Tōkurō, *Genshoku Tōki Daijiten* (Complete Colour Dictionary of Ceramics), Kyoto; Tankōsha, 1972

● **KATORI 1983**
Katori Kazuo, *Bijutsu Imono no Shuhō* (Techniques of Art Metal Casting), Tokyo; Agne, 1983

● **KAWAKITA 1991**
Kawakita Michiaki et al. (eds.), *Kōgei vols. I–III* (Crafts), *Shōwa no Bunka Isan vols. 6–8* (Cultural Heritage of the Shōwa Period), Tokyo; Gyōsei, 1990–91

KERR 1991
Rose Kerr (ed.), *Chinese Art and Design*, London; V&A, 1991

KESTER 1989
Bernard Kester, 'Development of Materials in Fiber Art', n.p. in *The International Textile Competition '89 Kyoto* (exhibition catalogue), Kyoto; International Textile Fair Executive Committee, 1989

KESTER 1994
Bernard Kester, 'Message', p. 4 in *Tsuji 1994*

○ **KIMURA 1981**
Kimura Shigenobu, 'Yagi Kazuo no Yakimono-kan' ('Kazuo Yagi's View of Ceramics'), n.p. in *Kyoto National Museum of Modern Art 1981*

● **KIMURA 1988**
Kimura Shigenobu *et al.*, 'Sōdeisha: 40-Nen no Kiseki' ('Sōdeisha 40th Anniversary'), *Quarterly Honoho Geijutsu*, no. 21, 1988, pp. 83–111

● **KITAMURA 1991**
Kitamura Tetsurō, *Senshoku: Dentō Kōgei* (Traditional Dyeing and Weaving), *Nihon no Bijutsu no. 307* (Japanese Arts series), Tokyo; Shibundō, 1991

○ **KITAMURA 1993**
Gendai ni Ikiru Ori: Kitamura Takeshi (*Traditional Fabric Design & Technique Given Life by an Artist, Takeshi Kitamura*), Kyoto; Kitamura Takeshi, 1993

○ **KOIE 1990**
Koie Ryōji, *Koie Ryōji: Tōgei* (Koie Ryōji: Clay Work), NHK *Kōbō Tanbō: Tsukuru vol. 4* (NHK Workshop Visits: Craft Makers), Tokyo; Japan Broadcasting Association, 1990

KOIZUMI 1986
Koizumi Kazuko, *Traditional Japanese Furniture*, Tokyo, New York and San Francisco; Kōdansha International, 1986

○ **KUBOTA 1990**
Kubota Shigeo, *Tapestry Work, 1983–1990*, Nagaokakyō; Shigeo Kubota Tapestry Studio, 1990

○ **KUMAI 1991**
Kumai Kyōko (ed.), *Kumai Kyōko: Fiber Work no Sekai 1975–1990* (*Kyōko Kumai's Fiber Works 1975–1990*), Ōita; Kumai Kyōko, 1991

KUMANOTAMI 1985
Kumanotami Jū, 'The Chemistry of Oriental Lacquer (*Rhus Verniciflua*), pp. 243–51 in N.S. Bromelle and Perry Smith (eds.), *Urushi: Proceedings of the Urushi Study Group, June 10–27, 1985, Tokyo*, California, Marina del Ray; The Getty Conservation Institute, 1988

● **KURE CITY MUSEUM** 1985
Gendai no Yakimono-ten: Atarashii Zōkei e no Shōtai (Contemporary Ceramics Exhibition: An Invitation to New Ways of Making) (exhibition catalogue), Kure; Kure City Museum and Kure Cultural Promotion Foundation, 1985

● **KURE CITY MUSEUM 1987**
Nihon no Tōgei, Kindai no Kyoshōtachi: 1920–1940 o Chūshin to shite (Masters of Modern Japanese Ceramics, 1920–1940) (exhibition catalogue), Kure; Kure Cultural Promotion Foundation, 1987

○ **KYOTO NATIONAL MUSEUM OF MODERN ART 1981**
Kazuo Yagi-ten (Kazuo Yagi) (exhibition catalogue), Tokyo; Nihon Keizai Newspapers, 1981

○ **KYOTO SHOIN 1992–3**
Toh (The Best Selections of Contemporary Ceramics in Japan), 100 vols., Kyoto; Kyoto Shoin, 1992–3

● **MAINICHI NEWSPAPERS 1991**
Shōwa no Bijutsu vols. 1–6 (*Chronicle of Art* of the Shōwa Period), Tokyo; Mainichi Newspapers, 1991

MARGETTS 1991
Martina Margetts (ed.), *International Crafts*, London; Thames & Hudson, 1991

MARUYAMA 1988
Maruyama Nobuhiko, 'Yūzen Dyeing', pp. 23–30 in *Ishimura 1988*

○ **MASUDA 1987**
Masuda Yoshinori, *Masuda Yoshinori: Garasu Zōkei* (Yoshinori Masuda Glass Work Collection), Tokyo; Kōdansha, 1987

○ **MATSUMOTO 1984**
Matsumoto Kaneo, *Shōsōin-gire to Asuka Tempyō no Senshoku* (*Jōdai-gire: 7th and 8th Century Textiles in Japan from the Shōsō-in and Hōryū-ji*), Kyoto; Shikōsha, 1984

MELLOTT 1993
Richard Mellott, 'Katazome, Tsutsugaki, and Yūzenzome', pp. 51–6 in *Rathbun 1993*

● **MINAMI 1992**
Minami Kunio *et al.*, *Ningen Kohuhō Jiten: Kōgei Gijutsuhen* (Dictionary of Living National Treasures: Craft Techniques), Tokyo; Geisōdo, 1992

MIZUTA 1993
Mizuta Yoriko, 'Historical Development of Modern Glass in Japan', pp. 16–22 in *Dusseldorf Kunstmuseum 1993*

MOERAN 1982a
Brian Moeran, 'A Survey of Modern Japanese Pottery, Part 1: From Craft to Art', *Ceramics Monthly*, vol. 30 no. 8, October 1982, pp. 30–32

MOERAN 1982b
Brian Moeran, 'A Survey of Modern Japanese Pottery, Part 2: In Search of Tradition', *Ceramics Monthly*, vol. 30 no. 9, November 1982, pp. 44–6

MOERAN 1982c
Brian Moeran, 'A Survey of Modern Japanese Pottery, Part 3: Exhibitions', *Ceramics Monthly*, vol. 30 no. 10, December 1982, pp. 32–4

MOERAN 1983
Brian Moeran, 'A Survey of Modern Japanese Pottery, Part 4: The Business of Pottery', *Ceramics Monthly*, vol. 31 no. 1, January 1983, pp. 54–7

MOERAN 1984
Brian Moeran, *Lost Innocence: Folk Craft Potters of Onta, Japan*, Berkeley, Los Angeles and London; University of California Press, 1984

○ **MURAYAMA 1991**
Murayama Akira, *Murayama Akira: Mokkō* (Murayama Akira: Woodwork), NHK *Kōbō Tanbō: Tsukuru vol. 9* (NHK Workshop Visits: Craft Makers), Tokyo; Japan Broadcasting Association, 1991

○ **NAKAMURA 1992**
Nakamura Kinpei, *Nakamura Kinpei 1988–1991*, Toh vol. 15 (The Best Selections of Contemporary Ceramics in Japan), Kyoto; Kyoto Shoin, 1992

NAKANO 1982
Nakano Eisha, *Japanese Stencil-Dyeing: Paste-Resist Techniques*, New York and Tokyo; Weatherhill, 1982

○ NAKANODŌ 1987a
Nakanodō Kazunobu, 'Objet Seisaku e no Michi: *Sōdeisha* o Chūshin to shite' ('The Passage Towards the Creation of Objects [sic] – with the *Sōdeisha* as the Central Theme'), *pp. 31–44* in *Tokyo National Museum of Modern Art 1987a*

○ NAKANODŌ 1987b
Nakanodō Kazunobu, 'Kamoda Shōji no Tōgei' ('The Ceramic Work of Kamoda Shōji'), *pp. 9–37* in *Tokyo National Museum of Modern Art 1987b*

NAKANODŌ 1993
Nakanodō Kazunobu, 'Japanese Public Collections of Modern Ceramics and Their Direction: From a Museum Curator's Viewpoint', *pp. 61–7* in *Baekeland 1993*

NEWCASTLE REGION ART GALLERY 1987
Four Aspects of Contemporary Japanese Ceramics (exhibition catalogue), Newcastle (Australia); Newcastle Region Art Gallery, 1987

● NICHIGAI ASSOCIATES 1990
Gendai Meikō Shokunin Jinmei Jiten (Skilled Craftsmen and Artisans in Japan: A Biographical Dictionary), Tokyo; Nichigai Associates, 1990

○ NISHIDA 1977
Nishida Hiroko, *Kakiemon*, *Nihon Tōji Zenshū vol. 24 (A Pageant of Japanese Ceramics)*, Tokyo; Chūō Kōronsha, 1977

● ŌME MUNICIPAL MUSEUM OF ART 1988
Fujimoto Yoshimichi-ten (Fujimoto Yoshimichi Exhibition) (exhibition catalogue), Tokyo; Ōme Municipal Museum of Art, 1988

ORIENTAL CERAMIC SOCIETY 1990
John Ayers, Oliver Impey, J.V.G. Mallet *et al.*, *Porcelain for Palaces: The Fashion for Japan in Europe, 1650–1750* (exhibition catalogue), London; Oriental Ceramic Society, 1990

● ŌTAKI 1991
Ōtaki Mikio, *Kinkō: Dentō Kōgei* (Traditional Metalwork Crafts), *Nihon no Bijutsu no. 305* (Japanese Arts series), Tokyo; Shibundō, 1991

● ŌTANI MEMORIAL ART MUSEUM 1994
Koshimizu Susumu, Kurimoto Natsuki: Gendai no Zōkei, Katachi to Iro (Koshimizu, Kurimoto: Beyond Sculpture, Form and Colour) (exhibition catalogue), Nishinomiya; Ōtani Memorial Art Museum, 1994

POLLARD 1989
Clare Pollard, *The Influence of Sencha and the Literati Movement on Kyoto Ceramics in the Late Edo Period*, unpublished dissertation for Part II of the Tripos in Oriental Studies: Japanese, Cambridge University, 1989

RATHBUN 1993
William Rathbun (ed.), *Beyond the Tanabata Bridge: Traditional Japanese Textiles* (exhibition catalogue), Seattle; Thames & Hudson in association with the Seattle Art Museum, 1993

REDMAN 1989
Susan Redman, 'Japan's Third Generation', *Ceramics Monthly*, vol. 37 no. 4, April 1989, *pp. 58–9*

RICKE 1993
Helmut Ricke, 'An Attempt at Rapprochement: Japan's Glass Art from the European Perspective', *pp. 36–40* in *Dusseldorf Kunstmuseum 1993*

● SAKURA GALLERY 1989
Satoru Shōji: Fabric in Space (exhibition catalogue – Thailand), Nagoya; Sakura Gallery, 1989

SALTER 1983
Rebecca Salter, 'Kazuo Yagi', *Ceramic Review*, no. 82, July/August 1983, *pp. 28–9*

SALTER 1984
Rebecca Salter, 'Japanese Black Fire', *Ceramic Review*, no. 85, January/ February 1984, *pp. 19–20*

SANDERS 1967
Herbert H. Sanders, *The World of Japanese Ceramics*, Tokyo, New York and San Francisco; Kōdansha International, 1967

● SATŌ 1974
Satō Shōgorō, *Chikkōgei: Take kara Kōgeihin made* (Bamboo Crafts: From Bamboo to Craft Products), Tokyo; Kyōritsu Shuppan, 1974

● SEIBU DEPARTMENT STORES 1988
Otomaru Kōdō Kaikoten (A Retrospective Exhibition of Otomaru Kōdō) (exhibition catalogue), Tokyo; Seibu Department Stores, 1988

● SEIBU DEPARTMENT STORES (ŌTSU BRANCH) 1991
Gendai Tōgei no Bi: Dentō no Gi (The Beauty of Contemporary Ceramics: The Skills of Tradition) (exhibition catalogue), Tokyo; Sezon Museum of Art and Seibu Department Stores (Ōtsu Branch), 1991

SEKIJIMA 1986
Sekijima Hisako, *Basketry: Projects from Baskets to Grass Slippers*, Tokyo, New York and London; Kōdansha International, 1986

○ SEZON MUSEUM OF ART 1990
Nihon no Me to Kūkan: Mō Hitotsu no Modern Design (Japanese Aesthetics and Sense of Space) (exhibition catalogue), Tokyo; Sezon Museum of Art, 1990

○ SHIGA PREFECTURAL CONTEMPORARY CERAMICS MUSEUM 1990
Tsuchi no Hakken: Gendai Tōgei to Genshi Doki ('Primitivism' in the Contemporary Ceramics [sic]) (exhibition catalogue), Shigaraki; World Ceramics Festival Organizing Committee, 1990

○ SHIMAZAKI 1976
Shimazaki Susumu, *Ko-Kutani* (Old Kutani), *Nihon Tōji Zenshū vol. 26 (A Pageant of Japanese Ceramics)*, Tokyo; Chūō Kōronsha, 1976

● SHIRAISHI 1991
Shiraishi Masami, *Mokuchiku Kōgei: Dentō Kōgei* (Traditional Woodwork and Bamboo Crafts), *Nihon no Bijutsu no. 303* (Japanese Arts series), Tokyo; Shibundō, 1991

SIMPSON 1979
Penny Simpson *et al.*, *The Japanese Pottery Handbook*, Tokyo, New York and San Francisco; Kōdansha International, 1979

SPARKE 1987
Penny Sparke, *Modern Japanese Design*, New York; E.P. Dutton, 1987

STINCHECUM 1993
Amanda Stinchecum, 'Textiles of Okinawa', *pp. 75–90* in *Rathbun 1993*

● SUGAYA 1990
Sugaya Tomio, 'Momoyama Tōgei no Saihakken' (The Rediscovery of Momoyama Ceramics), *pp. 126–9* in *Kawakita 1991 vol. 6*

● SUZUKI 1975
Suzuki Kenji, *Gendai Kōgei* (Contemporary (avant-garde) Crafts), *Kindai no Bijutsu no. 30* (Modern Arts series), Tokyo; Shibundō, 1975

● SUZUKI 1989
Suzuki Masaya, *Ryōran no Shitsugei: Suzuki Masaya Sakuhinshū* (Scattered Blossoms of Lacquer Art: Collected Works of Suzuki Masaya), Kyoto; Futaba Shobō, 1989

○ SUZUKI 1993
Suzuki Kenji, 'Gendai Tōgei no Tenkai' ('Development of Contemporary Ceramics'), pp. 10–19 in *Gendai no Tōgei: 1950–1990* (Contemporary Ceramics: 1950–1990) (exhibition catalogue), Nagoya; Aichi Arts Centre, 1993

● TAGUCHI 1991
Taguchi Yoshikuni et al., *Maki-e: Taguchi Yoshikuni* (The *Maki-e* Art of Taguchi Yoshikuni), Tokyo; Arrow Artworks, 1991

○ TAKASHIMAYA DEPARTMENT STORES 1990
Tōgei no Genzai – Kyoto kara: Jūnin no Tōgeika ga Enshutsu suru Kūkan no Drama (The Now in Japanese Ceramics – Messages from Artists in Kyoto: A Drama of Space Enacted by Ten Clay Artists) (exhibition catalogue), Tokyo; Takashimaya Department Stores Fine Arts Division, 1990

TAKEDA 1993
Takeda Atsushi, 'Contemporary Japanese Glass Art: The Epoch of Fascinating Chaos', pp. 28–30 in *Dusseldorf Kunstmuseum 1993*

● TOCHIGI PREFECTURAL MUSEUM OF ART 1986
Kamoda Shōji-ten (Retrospective Kamoda Shōji) (exhibition catalogue), Utsunomiya; Tochigi Prefectural Museum of Art, 1986

○ TOKYO NATIONAL MUSEUM 1978
Hasebe Gakuji et al., *Nihon Shutsudo no Chugōku Tōji* (Chinese Ceramics Excavated in Japan), Tokyo; Tokyo National Museum, 1978

○ TOKYO NATIONAL MUSEUM OF MODERN ART 1978
Matsuda Gonroku-ten (Gonroku Matsuda Exhibition) (exhibition catalogue), Tokyo; Nihon Keizai Newspapers, 1978

TOKYO NATIONAL MUSEUM OF MODERN ART 1982
Tokyo National Museum of Modern Art (ed.), *Japanese Lacquer Art: Modern Masterpieces*, New York, Tokyo, Kyoto; Weatherhill/Tankōsha, 1982

○ TOKYO NATIONAL MUSEUM OF MODERN ART 1983a
Kuroda Tatsuaki (Kuroda Tatsuaki: Master Wood Craftsman) (exhibition catalogue), Tokyo; Tokyo National Museum of Modern Art, 1983

○ TOKYO NATIONAL MUSEUM OF MODERN ART 1983b
Modernism to Kōgeikatachi: Kinkō o Chūshin ni shite (Modernism and Craftsmen: The 1920s to the 1930s) (exhibition catalogue), Tokyo; Tokyo National Museum of Modern Art, 1983

○ TOKYO NATIONAL MUSEUM OF MODERN ART 1985a
Take no Kōgei: Kindai ni okeru Tenkai (Modern Bamboo Craft) (exhibition catalogue), Tokyo; Tokyo National Museum of Modern Art, 1985

○ TOKYO NATIONAL MUSEUM OF MODERN ART 1985b
Gendai Senshoku no Bi: Moriguchi Kakō, Munehiro Rikizō, Shimura Fukumi (Kimono as Art – Modern Textile Works by Kakō Moriguchi, Rikizō Munehiro, and Fukumi Shimura) (exhibition catalogue), Tokyo; Nihon Keizai Newspapers, 1985

○ TOKYO NATIONAL MUSEUM OF MODERN ART 1987a
1960 Nendai no Kōgei: Kōyō suru Atarashii Zōkei (Forms in Aggression: Formative Uprising of the 1960s) (exhibition catalogue), Tokyo; Tokyo National Museum of Modern Art, 1987

○ TOKYO NATIONAL MUSEUM OF MODERN ART 1987b
Gendai Tōgei no Bi: Kamoda Shōji-ten (Kamoda Shōji: A Prominent Figure in Contemporary Ceramics) (exhibition catalogue), Tokyo; Nihon Keizai Newspapers, 1987

● TOKYO NATIONAL MUSEUM OF MODERN ART 1987c
Ochi Kenzō Sakuhinshū (Collected Works of Ochi Kenzō) (exhibition catalogue), Tokyo; Ochi Toshiko, 1987

○ TOKYO NATIONAL MUSEUM OF MODERN ART 1987d
Mokukōgei: Meiji kara Gendai made (Modern Woodcraft) (exhibition catalogue), Tokyo; Tokyo National Museum of Modern Art, 1987

○ TOKYO NATIONAL MUSEUM OF MODERN ART 1989
Seimei no Katachi: Kumakura Junkichi no Tōgei (Organs that Provoke: Ceramic Works of Junkichi Kumakura) (exhibition catalogue), Tokyo; Tokyo National Museum of Modern Art, 1989

TOKYO NATIONAL MUSEUM OF MODERN ART 1990
Japan's Traditional Crafts: Spirit and Technique (exhibition catalogue – Finland, Norway, Sweden and Denmark), Tokyo; Asahi Newspapers, 1990

○ TOKYO NATIONAL MUSEUM OF MODERN ART 1993
Nuri no Keifu (Nuances in Lacquer: 70 Years of Innovations) (exhibition catalogue), Tokyo; Tokyo National Museum of Modern Art, 1993

○ TOKYO NATIONAL MUSEUM OF MODERN ART 1994
Gendai no Katazome: Kurikaesu Pattern (Contemporary Stencil Dyeing and Printing: The Repetition of Patterns) (exhibition catalogue), Tokyo; Tokyo National Museum of Modern Art, 1994

○ TOKYO UNIVERSITY OF ARTS 1993
Taikan Kinenten: Hiramatsu Yasuki (Professor Yasuki Hiramatsu Retirement Exhibition), Tokyo; Tokyo University of Arts, 1993

TOMITA 1982
Tomita Jun and Tomita Noriko, *Japanese Ikat Weaving*, London, Boston, Melbourne and Henley; Routledge & Kegan Paul, 1982

○ TSUCHIYA 1987
Tsuchiya Yoshio, *Nihon no Garasu* (Glass of Japan), Kyoto; Shikōsha, 1987

○ TSUJI 1994
Tsuji Kiyoji, *Fiber Art Japan*, Kyoto; Shinshindō, 1994

○ UCHIYAMA 1981
Uchiyama Takeo, 'Tōgeika Yagi Kazuo' ('The Ceramic Artist Kazuo Yagi'), n.p. in *Kyoto National Museum of Modern Art 1981*

VARLEY 1979
H. Paul Varley, 'Tea in Japan: From Its Origins to the Late Sixteenth Century', pp. 16–20 in *Chanoyu: Japanese Tea Ceremony* (exhibition catalogue), New York; Japan Society, 1979

WADA, RICE AND BARTON 1983
Wada Yoshiko, Mary Rice and Jane Barton, *Shibori: The Inventive Art of Japanese Shaped Resist Dyeing*, Tokyo, New York and San Francisco; Kōdansha International, 1983

● WAJIMA MUSEUM OF LACQUER ART 1991
Gendai Shitsugei no Ishōtachi (Masters of Contemporary Lacquer Art) (exhibition catalogue), Wajima; Wajima Museum of Lacquer Art, 1991

● WAKAYAMA PREFECTURAL MUSEUM OF MODERN ART 1990
Gendai no Tōgei 1980–1990: Kansai no Sakka o Chūshin to shite (Contemporary Ceramics 1980–1990: Focus on Artists from the Kansai Area) (exhibition catalogue), Wakayama; Wakayama Prefectural Museum of Modern Art, 1990

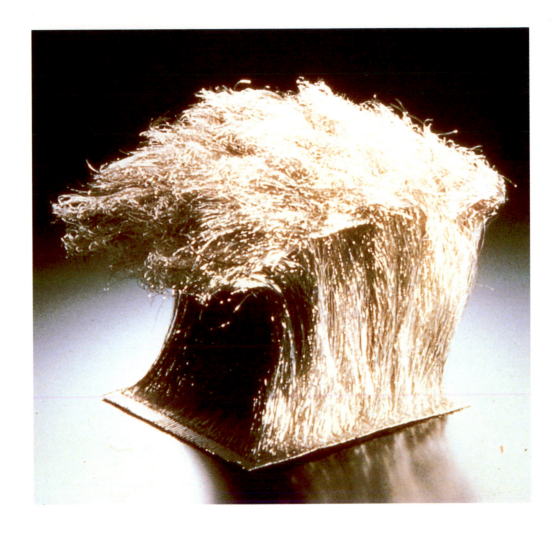

'Blowing in the Wind' by Kumai Kyōko (see plate 78).

WATSON 1990
Oliver Watson, *British Studio Pottery: The Victoria and Albert Museum Collection*, London; Phaidon Christie's in association with the Victoria & Albert Museum, 1990

WILSON 1991
Richard L. Wilson, *The Art of Ogata Kenzan: Persona and Production in Japanese Ceramics*, New York and Tokyo; Weatherhill, 1991

o **YABE 1976**
Yabe Yoshiaki, *Nabeshima, Nihon Tōji Zenshū vol. 25 (A Pageant of Japanese Ceramics)*, Tokyo; Chūō Kōronsha, 1976

● **YAGI 1989**
Yagi Akira et al., *Takagi Toshiko 1924–1987*, Kyoto; Yagi Akira, 1989

YANAGI 1972
Yanagi Sōetsu, adapted by Bernard Leach, *The Unknown Craftsman*, Tokyo, New York and San Francisco; Kōdansha International, 1972

● **YANAGIHASHI 1991**
Yanagihashi Shin, *Shitsugei: Dentō Kōgei (Traditional Lacquer Art)*, *Nihon no Bijutsu no. 304* (Japanese Arts series), Tokyo; Shibundō, 1991

● **YOMIURI NEWSPAPERS 1994**
Dentō to Sōsei – Yūzen no Bi: Moriguchi Kakō – Kunihiko-ten (Tradition and Creativity – The Beauty of *Yūzen*: An Exhibition of Moriguchi Kakō and Kunihiko) (exhibition catalogue), Osaka; Yomiuri Newspapers Osaka Head Office, 1994

INDEX

Page numbers in *italic* refer to illustrations

PICTURE CREDITS

Numbers refer to plate numbers

Agency for Cultural Affairs, Tokyo: **45, 47, 57, 73**

Bierregaard Foundation: **37**

Ishikawa Prefectural Museum of Art: **43**

The National Museum of Modern Art, Kyoto: **66, 85**

The National Museum of Modern Art, Tokyo: **26, 38, 39, 48, 52, 56, 59, 61, 70, 80, 84, 86, 87, 91**

V&A (all photographs by Ian Thomas; details in brackets indicate inventory numbers): **2** (FE.30–1985); **3** (FE.14–1984); **4** (FE.30–1989 *left*, FE.31–1989 *right*); **5** (FE.56–1993); **6** (FE.29–1989); **7** (FE.13–1989); **8** (FE.555–1992); **9** (FE.535–1992); **11** (FE.564–1992); **12** (FE.15–1986); **14** (FE.18–1986); **15** (FE.43–1981); **16** (FE.5–1989); **17** (FE.104–1988); **18** (FE.1–1989); **19** (FE.34–1989); **20** (FE.7–1991); **21** (FE.31–1985); **22** (FE.8–1990); **23** (FE.33–1989); **24** (FE.15–1989); **25** (FE.16–1989); **27** (FE.2–1989); **28** (FE.6–1991); **29** (FE.13–1984); **30** (FE.14–1989); **31** (FE.557–1992); **32** (FE.563–1992); **33** (FE.562–1992); **34** (FE.417–1992); **35** (FE.418–1992); **40** (FE.35–1989); **41** (FE.10–1991); **44** (FE.12–1989); **49** (FE.559–1992); **50A** (FE.423–1992); **50B** (FE.424–1992); **50C** (FE.425–1992); **51** (FE.9–1991); **54** (FE.49–1993); **58** (FE.553–1992); **60** (FE.552–1992); **62** (FE.8–1991); **64** (FE.419–1992); **65** (FE.554–1992); **67** (FE.11–1989); **72** (FE.442–1992); **74** (FE.420–1992); **88** (FE.561–1992); **93** (FE.10–1994); **94** (FE.6–1989); **95** (FE.5–1991).

The publishers would also like to thank the following photographers: Abe Michiaki (**98**); Benridō (**10, 53, 57, 73, 82, 89**); Hatakeyama Takashi (**71, 78**); Hiramatsu Yasuki (**92**); Koike Akira (**76**); Kojima Hirokazu & Saeki Taku (**79**); Peer Van der Kruis (**36**; Nakamura Kimpei, 'Even Stones have Sap', photographer EKWC/Peer van der Kruis (1991), 1992); Miyakaku Takao (**100**); Nagano Ikkō (**77**); Nakatsuka Yoshio (**97**); Nishimura Kōichi (**80**); Onagi Yōichi (**75**); Tanaka Masahiko (**81**); Ian Thomas (all pictures from the V&A as listed above); Unsōdō (**13, 37, 42, 68, 69, 83, 90**); Wakatsuki Hideo (**99**).